RESO

RESOLUTION
Roger Granelli

seren

Seren is the book imprint of
Poetry Wales Press Ltd
Nolton Street, Bridgend, CF31 3BN, Wales
www.seren-books.com

ISBN 1-85411-333-X

*The publisher works with the financial assistance
of the Welsh Books Council*

Written with the support of an Arts
Council of Wales Writer's Bursary.

Printed in Plantin by Gwasg Gomer, Llandysul

I Dani, unwaith eto

I struggle to keep Cath upright as she lurches away from me. She tries to collapse and a moaning comes from so far inside of her it seems like the voice of someone else. Perhaps it is.

I haven't been to Casualty for twenty-five years. The last time, I was a kid with a broken arm, waiting my turn amongst the orderly night-time wounded, with a solitary drunk being shushed by matriarchs. That was a lifetime ago, for me and the NHS. Now it's changed to hell, an abyss of squalid pain that simmers on the edge as we stagger through a gauntlet of night people. As a man holds his slashed face in place with his hands, his eyes glare at me through his fingers. Girls in fuck-me dresses support other injured young men. Lost, loose-bladdered geriatrics wander about, and a lunatic bays like a hound for attention. Staff surf between frantic and cut-off, trying to cope with their charges, a battered confused humanity that has been unwillingly grouped together. Like Poe's ship we plunge into this void, going down.

I push a drunk trailing a bandage out of the way. As he falls he grabs at air with that startled surprised look that all disturbed inebriates own, and creates a path for us.

Cath is going away from me. Her eyes are just white slits as I struggle past more angry faces to the woman on the desk and tell our tale – *she's taken at least twenty, maybe more, no, we can't wait, she might die*, all the stuff the woman has heard so many times before. For one insane moment I think she's going to wave a form at me but she waves us through instead, to one of the inside cubicles. I can almost smell the jealousy of those left behind as we are met by a male nurse, who asks what Cath's name is as he takes her from me.

The cubicle curtains laugh at privacy, conversation is clearly heard from each side. In the right corner two sisters fight over who should have been looking after their aged mother, who has

fallen down stairs and lain alone for hours. She was incontinent, now she's hypothermic as well. Their waspish voices are lasers of recrimination unloading into each other. And in the left corner is an Asian girl battered by her father for having a non-approved man, who comforts her now in soft tones. I catch sight of her as she leaves her cubicle, one side of her face beautiful, the other angry with bruises, one wet-lashed eye alert and shining bright, the other folded under battered flesh.

Like everyone else I shout for attention, and grab a young Chinese doctor as he's about to slide down a wall with tiredness. Mine next I say, mine, mine. The number of pills goes up to forty and Cath is next on.

They use a stomach pump. It sounds innocuous, like water pump, gas pump, but it's an instrument of lifesaving torture. Whole pills are sucked out of her, and identified by the excited staff. The sounds Cath makes reach right into me, vomit noises from the underworld, her husking voice calls me from the other side of the Styx as wails are wrenched from her with the pills. I hope she's not aware of what is going on and that I will be able to paint a kinder picture of this when it's over. I'm good at papering over cracks, smoothing over scars, ignoring shit.

It's over and Cath is saved. I got to her in time. She's quiet now, shivering, wondering what she's done and where she is. Her eyes can't focus on me and I'm glad; I'm in no state to accept them, and not strong enough to take what they might say, not tonight.

There could be liver damage, Chinese says, with so many pills. More than enough to kill, he repeats several times, but he's upbeat. Cath has made his night. She's a break from stitching and bone setting, and a result, a small blip of success. His attitude says she's different, not the usual Friday night special. He sniffs education, imagines money, and thinks that Cath is someone worth saving, someone who can be sent back to the middle classes, with a touch of psychoanalysis to speed her on her way. He's confident that Cath won't be back.

We ride an ambulance to a hospital across town, where Cath will stay for the weekend. She tries to throw up again in the ambulance; she's going for the record, but is running on empty now. The paramedic with us says it's normal, a reaction to the

stomach bruising, the vacuumed lining fighting back. This guy is all concern and kindness, better than me, streets ahead of me, part of the magnificent, crumbling NHS.

I am still dazed. I coped with the saving bit but what next? Nothing has changed, a bitter realisation creeps over me. I watch Cath crouch over her kidney-shaped sick bowl and despite everything she is still beautiful – it fights through against the creased face and distant eyes. Maybe nothing has changed, but a point has been reached.

•

Cath is settled into a women's ward. There are not many beds, and everyone is asleep; she is a discreet, three-in-the-morning admission, bedded by a hushed-voiced nurse, who tells me she'll sleep for a day. The nurse offers me a cup of tea, and I almost hug her and cry, for Cath and myself. My stupid, pricked pride dares to rear its warped and selfish head even here.

Night is ending when I leave, black sky turning to blue then grey as light washes in at its edges, and it's been raining lightly, the tarmac gently licked until it glistens. This is the earliest I have been up in living memory and I slouch onto a bench and savour the novelty, smelling the new millennium as bubbles of rainwater soak into my arse. It smells like the aftermath of nothing, a great, over-hyped zero. The sun starts to stoke up under the horizon and I'll sit here until it shows itself fully and gathers strength.

You alright, mate?

My eyes struggle open, wonder where their owner is, blink against the light, and see a porter standing over me, coming in for his day shift.

Yes, sure, thanks.

I've lost at least an hour. I rub my eyes redder and think of going to check on Cath but think again. Get away, that's my immediate thought and legs take over as I find a phone to call a taxi. The car is parked in the downside of town, maybe with a busted lock and the radio gone. Jesus, I ache for a cigarette and my tongue flicks my lips in a desperate search for old echoes of nicotine, but I gave up years ago.

I've known Cath ten years and it's been a decade of vacilla-tion, fat-hearted good times quickly sinking into yawning black pits. We share a mutual, hopeless inability to let go of something that hasn't worked for years, and all roads lead to last night, to a broken-down casualty unit in a city that could be anywhere.

The car hasn't been trashed but it doesn't start. Bastard. Perhaps it too has been shocked into inertia. I wait for the repair man. Depression is all about waiting, for it to ease, to get better, get worse again, passive acceptance as useless as stout denial. I'm Cath's depression, I know it now. The man comes and the car is cheerily fixed in two minutes. A loose wire.

I'm back in Cath's place, a smallish but now hugely empty flat, part of a refurbished building that overlooks the bay. Jumped up new development with no soul I say, but Cath disagrees. She disagreed enough to buy a place here. The building is spattered with glass and chrome, with a splash of the old red brick retained to show off the past, in minimalist industrial style, and as cold as a witch's heart. Cath likes industrial, but this is an ironic distor-tion of the word. Everything these days is distorted, I argue, spun up its arse and back out again, until fools believe their own prop-aganda. I am told to stop moaning – good advice I never take.

I look out on the river that winds into the bay, lying sluggish and silver in the early light. Usually it's a kind of greenish brown, a sanitised version of its old black-sludge ancestor that choked its way through coalfields and heavy industry. I preferred the old one; what flows now is a sneaky imposter. And they've done nothing about the fetid mess on its banks, which is more notice-able now that it is contrasted with the new river. New River, a good slogan, like New Age, New Man, New Labour. New, a short adjective with an agreeable, positive feel to it, like *future* or *ambition*, and a good slippery word for vacuous times, when there's no centre to hold because it's had its guts kicked out. Well there's nothing new about Cath and me, we are old, well-trudged ground.

The flat is as cold as death, despite the sun that pokes in. Again I crave tobacco as I clean up mechanically, righting furni-ture, putting a few paintings straight on the wall, sweeping up the broken glass. Afterwards I stand on the freezing balcony, a glass of salvaged scotch in my hand. A woman on the next balcony

stares at me. Morning, I say, happy new year, but she turns away.

Cath needs a few things. I struggle to find them, but eventually underwear, make-up bag and dressing gown are shoved into a bag. I sit on the bed and realise how hungry I am, almost faint from it, so I make coffee in the kitchen, and scramble around for breakfast things. The coffee kicks out the faintness but combines with the whisky to make me feel queasy and hot. It's always made me feel queasy and hot, for twenty years or more, but on the far side of forty I'm still drinking it, one of my many qualifications for cretinhood. There's enough milk for a few spoonfuls of cereal.

I notice the photo of us Cath has on her pin-board, one of the better times, when we were tanned and travelling somewhere. I can't remember where but Cath would know, the place, time, weather, what we ate each day, all laid out in that computer-like mind of hers.

It's still very early morning but the day is off and running, I feel cool winter light slant into my face as the kitchen table turns to gold and the central heating fights back, allying itself to the coffee. Time to sleep.

They say the more intelligent you are the more likely you are to remember your dreams but I rarely do – cretin qualification number two. Yet today I startle myself awake in the late afternoon, almost falling off the sofa, and rapid images flick through my head as the dream replays scenes from *The Cath and Rob Show*, a rollercoaster ride for our times at a town near you, at all towns near you. Lousy images, lousy behaviour, in all a tawdry flick of a film.

I'm hungrier than ever and devour a tin of tuna before I go back to the hospital. It leaves a greasy aftertaste in my mouth that my stomach and the Ford churns up. Throw a little coffee aftermath into the mix and I have more queasiness.

Cars fight each other to be first home, as they fought each other to be first to the sales. I'm inhaling the modern world and it's choking me. Near the hospital I stop to buy flowers, but the dishonesty is too much to stomach and I dump them in a bin as I go in.

Cath is awake, just. Auburn hair is matted to her face, which looks rested but not restful and her eyes are far back in her head, as if they are looking elsewhere, maybe another world that

would-be suicides are able to glimpse, that shining tunnel, or just the moment when everything fades to black and stays there in timeless anti-climax. She sees me but snuggles deeper into the bed and freezes when my hand reaches out to her.

Hello Cath sounds so lame, I might as well add *how are you then after your suicide attempt,* or launch myself into a commentary on the weather, that fine British standby for conversation. A nurse at the next bed encourages me with her eyes and finally Cath looks at me, through me at first, then at me, focusing on my face with difficulty. She murmurs something, so softly I think it might be 'sorry'.

Do you want anything, love? the nurse asks Cath's neighbour, someone who looks sixty but is probably more like forty, someone who looks like I feel, wasted body, stretched nicotine yellow face, with all the life smacked out of it, by life. The woman moans and rolls away from the nurse without answering and I realise Cath is in the troubled ward.

We sit in silence for a time and I'm glad of it; this is a welcome touch of peace, but the place is too hot. Christ, don't doze off, Rob, that will never do.

I can't remember much, Cath says quietly.

It doesn't seem the same voice, neither that brisk and sometimes shouting County Clare voice I know decibel by decibel nor its love-soft other. This one has been stripped to a husk of its former self.

They say I took enough to get the job done, Cath says, if you hadn't come back when you did.

I dare a hand again and she turns towards me. Her face is still amazing, its beauty refined by her ordeal, but something is gone from it, the same thing that has changed her voice. She is stained by defeat.

Did many people see me, in casualty? Cath asks.

I took you straight through. Most of them there were out of it anyway, one way or another.

Like me, you mean. It must have been awful for you.

Was this sarcasm returning, a flicker of the old spirit?

One thing I do remember is that tube going down, it was so cold.

She shivers and reaches for her water. I can't think of anything

to say that hasn't been said before.

Why *did* you come back? Cath asks.

I don't know, I was almost out of the city when I turned back, but thank God I did.

She doesn't push and I'm not about to say anything trite like it was a hunch, though that's about the size of it, something different in the way she looked when we rowed, as if she was one step ahead of her temper, and at the edge of a solution. If she'd expected me to come back it was a hell of a fucking gamble. So, what now, we've tried everything.

Silence again. The hospital is early seventies but is already well past it, an oversized relic from tower-block-mentality days, held together by a series of cut-price make-overs. I hear drilling coming from another wing, and know this is the worst place for Cath to be.

I want to sleep again, Cath says.

Fine. I'll go and get a drink.

You don't have to stay.

I'll stay.

Machine coffee again, the tea is empty. This stuff has the texture of thin soup and the taste of cardboard. The hospital is frantic, nothing like it was when Cath was admitted. Now everyone scurries, at the beck and call of illness, and it's all far too public for me. Everything about the last day has been too public; my sense of privacy has been demolished, brought down to earth with a thud.

As Cath sleeps I wander down to the concourse to buy a paper. The news is as stale as the coffee: repeat horrors, repeat sport, repeat life. Same day, same story.

I take my time before I go back to the ward, suddenly I seem to have plenty of it, whole slabs of it heavy in my hands when just days ago it was such a precious, fleeting commodity. I rob time from one project to spend on another, trying to juggle all my schemes, with one eye on encroaching middle age, no, both eyes.

The lift up to Cath stops on each floor and someone is wheeled in with me, an ancient, papery-faced woman attached to a drip. The veins on her hands stand out, startling blue cords against her translucent skin, defiant life pumping through what looks like a dying land. She smiles at me.

Cath is talking this time, but her words have lots of tired gaps between them.

You don't have to stay, she repeats.

I want to, I answer, without conviction. Have they said when you can come out?

Tomorrow, if the tests are okay.

I think of her back at the flat and fight down panic.

Good, home Sunday night. This is your Lost Weekend, Cath.

Sometimes I think you see everything as a film. You can't respond to me, can you, not even now?

Don't shrug, I tell myself, it's what she hates most.

I think it's best if you sleep some more. We can't talk here.

You don't want to talk anywhere, and I feel like I've been sleeping forever.

I fiddle with the paper, glad of something to hold.

You've got your rabbit eyes in again, Cath says. Ready to bolt. I've been seeing them for ten years. Rob, why the hell are you still here?

If I say *habit* I fear she'll fly at me. She's done it before, attacking me with little fist punches, scratches, flying objects. I caught one once, just below the hairline – blood pumped strenuously and painlessly down my face, terrifying her.

I'd taken them before I knew it, Cath murmurs, it was easy after the first few. They chased each other down.

But why? Friday night was nothing much by our standards.

Something got to me, all the nights, all the fights. Suddenly, after you left, I was looking at nothing, just emptiness, and there was no way through it, no way out. I felt there was no point anymore, and no need to keep looking for one. That's the last thing I remember, wanting out so badly.

She lets me touch her, and I put my hand over hers.

I felt so bloody tired, Cath says, and it was such a relief to let go. Each pill increased it, told me it was the right thing to do. Then you came, and jerked me back. Christ. Did I go to Casualty in an ambulance?

No, I didn't want to wait for one. I took you in the car.

But I remember an ambulance.

That was later, when they transferred you here.

Her hand is lost in mine, as if all her strength has been taken.

It was the millennium thing that sparked it off, Cath contin-
ues, all that fuss about new beginnings.

We're talking as if she's had a car accident. This situation
doesn't seem real but the hospital is real, and Cath's presence in it.

The date's not even accurate, I murmur.

What?

The millennium, it's got another year to run.

Why didn't they wait, then?

It wouldn't be so neat, would it?

I catch the look on her face: she's wondering if I'm capable of
delivering a lecture at the hospital bed of a suicidal partner. Of
course I am, but I fight it down.

Food is approaching. We both think it's a good cue for me to
leave but there is little warmth in the parting. Too much stuff is
floating around in our polluted sea, guilt, anger, and the begin-
nings of recrimination. In the car park the car won't start, again.

•

Cath was glad to see Rob go. It was the first time she'd been able
to admit this. It's taken me ten years to get real, she thought, but
reality was pumped through that tube, in all its soul-stripping
clarity. And I *have* been stripped, assaulted by my own stupidity.
No, not stupidity, panic. What a price to pay for separation, my
severance pay.

Cath felt calm, she felt that she'd achieved something and that
a situation had changed forever. How ironic that Rob had been
the one to save her.

God, the bed felt good, a hospital bed, and she was enjoying
it. Was she so desperate for comfort? Tick. Had she been a
bloody fool? Tick. Were Rob and she a complete mess? Tick tick.
Would she be able to move on? Half a tick. A hesitant and frail
half tick.

Someone was offering tea. She took it, and a limp sandwich
which looked like she felt. Her knowledge of Rob was now
complete: ten minutes ago she'd finally accepted he had a
complete inability to change. She'd always known it, from their
first year together, but had never been able to accept it, or even
face it straight on. So she'd stayed around. That's how it had

15

been, ten years of staying around, anger or pleading sometimes winning comforting words. But Rob talked in circles, which she let spin her around. God, ten years of hearing him promise a brighter future, of waiting for action on his part, for commitment that never came.

At least the tea was warm and the sandwich meat free, as requested. The weather was brightening up again outside, the tea-lady said, but still bitter, mind. Cath saw the blue flare of the sky fade into unclean windows. It was now alright to get up and have a shower, if she took it easy. She craved one and felt like a student who's had a weekend of it. I'll take a pill, she thought. No, not allowed, the nurse said. Give yourself a break, with what your system's been through. If the headache kept on they might be able to give her something later, but it had eased by the time Rob left. First time he'd ever had that effect on her.

Cath got up and felt like a newborn fawn, just as shaky, eyes darting, helpless, bright, looking for the instant comfort of familiar warmth, for someone to be there. But this fawn was alone.

She was well enough to be self-conscious, to wonder if everyone knew about her – not that there was much interest amongst her fellow patients. This ward had a wasted feel to it. It dealt with mind problems: the psychotic, schizoid, manic and suicidal, but the milder versions, the ones thought safe to house in an open ward.

The shower was none too clean, its curtain lank and stained at the edges, the grouting in the tiles tobacco-brown. Work was going on in another wing, she heard machines pounding, but it didn't matter, the water was good. The water was fantastic. She felt it was washing something out of her life and for a wild moment she thought of putting some make-up on, then realised she didn't have any, and thought how ridiculous it was anyway.

A doctor came to see her. He smiled as he said there was no sign of liver damage. *You've got away with it*, was the phrase he used which made Cath feel so stupid. He liked this, she thought, it lent authority to his bedside manner and there was more than a hint of admonishment in everything he said, a gentle chiding that he thought was effective. And it was. She was expected to have counselling, par for the course for people like her. A session with the system before it could wash its hands of her. The doctor

was very attractive in a dark, creased sort of way, and she pushed back her hair instinctively, nodded and 'huh huh'd'. It was all her shame could manage. We'll make an appointment, the man said. That would be fun.

By the time Cath settled back in bed Rob arrived, shuffling towards her with that furtive gait of his, looking crumpled. He wasn't very big, something Cath had never really thought about before, but did now. She remembered her large brother Eamonn picking him up like a young pig, when they messed about on the farm. They all liked Rob, liked what he did, what they thought he was. Even her mother approved of him – ironic, considering Rob never earned much money. For him, dream lead to dream. There'd be a modest windfall occasionally, then more scratching around, until she baled him out. Creative people can't be expected to earn, he'd say. It was all part of the romance at first, until it went sour, and began to grate. She'd have the *partners should support each other* line spun then, but Rob always fell down on the *each other* bit. He was talented, but his art did not fit into any niche, his paintings were no longer wanted, and other schemes quickly failed. He told her that all he needed was a bit of success, but he'd had that once and ran away from it. She suspected Rob liked being on the outside, no matter how cold it was, railing at the established order like some prophet. Success meant commitment, complication, and little boys didn't like either.

Rob squirmed in his chair but Cath wasn't going to make it easier for him. Why should she? *She* was the one in a hospital bed. One of his worst traits was to take someone's suffering and make it his own, but now he wanted it all to go away, to be elsewhere. For once Rob had been taken by surprise and it showed. He was a closet control freak who masked it with a cool affability that strangers fell for. *She'd* fallen for it, a twenty-two-years-old Irish girl arriving in the big city, seeing Rob playing the sax in a smoky club and liking what she saw: a hairy, intense man, playing hairy, intense music – a mix of stuff she recognised but with plenty of other unknown influences thrown in from all over the world – that the hairy, intense crowd liked, but which made her feel out of her depth. She was flattered that he talked to her at the bar, the cat moving in on easy prey.

Rob had barely seemed to age since then. If anyone could be furtively good looking, he was it. His hair was still worn too long, without much sign of greying, and his brown-eyes were boyish, at odds with a sharp and knowing countenance. Rob was not much taller than her but she was used to short men back home. The Galbraiths were the only giants in the village. Too much wind blows here, Uncle Padraig used to say, it stunts everyone but us.

She gave him her number at that gig and Rob phoned the next day and came round that night, embarrassing her in her shabby bedsit, eager as a terrier, and not taking no for an answer. He drenched her with his rapid-fire thoughts, wasting no time involving her in his dreams, or telling her how good his paintings were. She was amazed when he reluctantly told her he was over thirty.

You were playing *Round Midnight* Cath muttered to herself as Rob left, a fiery bluesy take on it, as if Charlie Parker had merged with Jimi Hendrix. Rob's sax had been an extension of his body that night and she'd been fascinated, and attracted. With this old image of her former man, Cath closed her eyes and welcomed the sleep that took her instantly. Rob, the world's greatest insomniac, would be jealous.

•

I stop for a drink on the way home, having frozen my rocks off waiting for the repair man. This car's gone twice round the clock, the man says, poking around it like a doctor who has wandered across from the hospital. I'd think about changing it, sir, lots of good deals around now. Yes, okay, thanks, maybe I'll get a Merc, or a 59 Jag with the cat gleaming on the bonnet. It's the same fault as before and the man writes it down for me, so I can take the note to a garage. My prescription.

I have two quick pints and a packet of crisps for insufficient ballast, in a theme pub which used to be Irish and is now Australian. Ireland has been ousted here as number one piss-head nation, green changed to yellow, leprechauns to kangaroos, but the bad, overpriced beer remains the same. This place was alright once, but it's been changed and changed again for

change's sake, a new makeover every decade, if not sooner.

I'm tipsy when I leave and spend just ten minutes in Cath's flat, time enough to set the heating for her return and make sure I've tidied up everything, then I drive the twenty miles out of town to my own place.

I have a cottage built into the side of a valley, late Victorian utility stock, built for farm workers but gentrified by the previous owners. They put down wooden floors, knocked small rooms into one, but kept the chimney in place, thank God; I've reopened the fireplace, and make good use of it. The cottage came with a thin strip of land, too rough to be called a garden, that snakes up the hillside behind the house.

Cath lived with me here once; it was my stab-at-commitment period, but I couldn't hack it. After two years she looked for excuses to leave, starting what she almost finished last night. She didn't like it here, she couldn't stand the night sounds which went from furtive to raucous; she'd had enough of the country in Ireland. She said she wanted to live within walking distance of other people, she liked *their* noises, so she moved back to the city to be amongst them. But of course I was the real cause. I made things intolerable for her, and living together exposed our rot. My rot. Even now it's hard to admit everything is my fault, but it is. Crossman repaid love with diffidence at every turn.

Eight people lived in the cottage once, now it hardly seems big enough even for me, but it is mine, a bolt-hole that Cath grew to hate. Her place in the city is like two fingers wagging under my nose and I think she meant it to be. I like old, she wanted new. My space is swamped with painting clutter; sometimes I feel like Van Gogh at Arles, breathless with excitement but hemmed in by all my useless, necessary junk. Cath's living-space is pared down to basics, with the odd ornament or book to emphasise how little is there.

I find two cans in the fridge and drain one. It looks like snow outside, the hills are full of that still, heavy greyness that precedes it, and the valley is silent. Snow will camouflage limp foliage, give the far ranks of conifers a touch-up. As I'm thinking this a few flakes begin to fall, spiralling slowly down to stick to the window. The second can follows the first and I notice the fridge is almost empty. I'm thinking about food the day after Cath's big moment.

Am I this shallow? Cath would say yes, and with the help of the drink maybe I would too.

As I lie on the sofa the weather tries to make up its mind, a flurry of snow comes, then nothing, then another flurry. Go on, send it down, obliterate everything, make a winter wonderland. Cleanse me. I hum the old tune, hug a few cushions and begin to doze, aware that I'm freezing, but too pissed to do anything about it. Remnants of yesterday's logs lie unlit in the fireplace. The central heating is in need of a new pump but there's no money to fix it. I'll wake a little shaky, deathly cold and suitably chastened. Not much of a penance for what's happened to Cath, but all I can come up with.

I remember a dream, the type in which you half wake up and take part. I punch the sofa, trying to repel whatever I think is attacking me and am reminded of childhood, when in dreamland I was chased by everything that slithered and crawled. Strange they are coming back now.

I'm fully awake; it's nearly midnight and the snow's stopped. There's not much trace of it outside, just a light dusting that the wind pushes around, working it against walls and fences, and the windows of the car. I make tea and sit in the kitchen, trying to cast out the cold that has worked right into me.

Something shrieks outside as it dies. Bloody noises always punctuate the night here. Nature, at least, still tells it like it is. The moon is out, the top corner flattened by night, but enough to light the hillside. An owl floats across the garden, as quiet as snow, its wing span impossibly large and fragile. It nests in a nearby barn, and has survived power lines, contaminated food and goons with shotguns for years. Now it catches the moonlight like the seasoned performer it is, and I track its beautiful noise-less flight, not wanting it to disappear. It makes this night worthwhile.

•

Cath woke at an hour Rob would think obscene; people busy at six o'clock. She smiled at the woman next to her, who stared back. Her neighbour was a habitual half-hearted suicide who was being moved to a secure unit, the real psycho ward. Cath realised she was in the half-way place, where normal people like her put a foot into madness then stepped back, to be treated and sent home.

There was no trace of pills left in her now. She'd been vacuumed, washed, rested and stamped a bloody fool. As she took in her surroundings, realisation came on hard, like the January light that punched through the smudged windows. This time of day reminded her of home. No matter what the weather did later it was often cloudless this early in Clare, as if each day started with a clean slate, and waited to be sullied. Yes, that's the way she must look at this, her clean slate, with Rob and all that he brought to their relationship erased. If only it could be that easy.

I have to deal with it all over again, Cath thought; the bottom of the pit wasn't reached when I popped the pills, but it was when Rob came to the hospital and sat there at my bedside like nothing had happened. Christ, he seemed put out by all the fuss.

Cath sighed, and turned in her bed, wondering at all the wasted time and effort that had led to this. It would take her a long time to get away from those pills. And then there was Rob. She knew what he was like, but even after ten years couldn't be sure what he might do.

•

It takes an effort to get out of bed. I feel like I've been kicked repeatedly. I make a clear circle in the iced window and see everything in soft focus. A fine frost coats the hillside, catching the light and throwing it back at me in my iceberg cottage. The powerless sun is mocked and the sky robbed of most of its blue. I make it my new millennium resolution to get the heating fixed. At least the shower works; I steam under its flow for longer than usual, until I can face myself in the mirror and trust my unsteady shaving hand.

Later I drive down to the hospital in the Granada. The car is too old and too big, a gas-guzzler more suited to second division

drug-dealers. If it breaks down again I'll abandon it. A hospital car-park would be a suitable place.

Cath isn't in her bed. For a moment I think she's left to make her own way home but I see her at the end of the ward, talking to the woman in the last bed. She barely acknowledges me, so I stand there, feeling quite stupid.

•

Let him wait, Cath thought, I don't know what to say to him anyway. At least it looks like he's got the stuff I asked for.

She was talking to Nina, a paranoid depressive. Nina was tiny and dark, not much more than six stone, with a cigarette-worn yellow sack for a face, in which lived wasted eyes, nose and mouth. She had straggly curly hair, and bulging panda eyes which did not rest on anything for long. Nina looked fifty but was not much older than her. They'd compared notes since breakfast and Nina's plight and lifestyle put Cath's into perspective. Her relationships were littered with assaults and violent terminations, to which she'd added self-harm, a life on the streets, and a child taken into care. She showed Cath *Nina* carved on her forearm, wistfully, pride mixing with shame.

I done that, she said, with a giggle. In case I forget who I am.

She brandished her arm like a trophy then went into a bout of coughing.

No fags in here, Nina gasped, and it's killing me. She followed Cath's eyes towards Rob.

That your fella? Cute, inee? Lucky bitch. Why the fuck you in 'ere, anyway? This ward is for the likes of me. People like you should know better.

People like you: a good phrase for disjointed times. People like you finding it harder to connect, people like you trying to balance each part of your complicated lives like crazed jugglers, and hoping someone doesn't kick your feet away. You're people like me too, Nina, Cath thought.

Go on, then, go and see 'im, Nina said, her eyes greedy to be a part of anything, even a strange couple she'd never see again.

Jesus Christ, I never ever 'ad no-one waiting for me, unless it was a punter in the old days, before I got too gross, like.

Cath walked down to Rob. He looked lost, but this was part of his repertoire. Suddenly she was self-conscious in her sheet of a hospital gown. Rob held out a bag.

Here's what you wanted, he said.

Good. I'll go and get dressed then.

You can go now?

Yes, I have to see the shrink again in a few weeks, but I can go. I'm thought to be safe.

I'll wait here, then, Rob said.

The make-up bag was welcome and putting a new face on really meant something today. She didn't look too bad, a bit smudgy under the eyes, hair ruined, but not bad, no worse than a hangover. Rob had moved to the exit door when she came back, he wanted to be away quickly. Cath handed him a bag of her dirty stuff and walked in front of him without saying anything.

She expected there to be tension, that the air between them would crackle with it, but resignation seemed the order of the day. They'd had a decade to deal with tension and millennium night put it all into focus for her, condensing their long-running film into one lousy frame. It was the perfect time for taking stock.

Rob sensed her mood, he always did, then usually tried to oppose it, to shoot it down, or mould it to his own, but not today. She could see he was still fazed.

He drove them back to the flat. That oversized car of his cost him a fortune to run, but it was comfortable. You could camp out in its seats. He drove more slowly than usual, treating her as an invalid. They skirted the river for a while. After the hazy world of the hospital the light was startling. Cath felt exposed, the light told her it knew what she had been up to. Her headache started up again – she had been warned that it might. It began with sly pressure behind the eyes, then became more insistent, pushing, throbbing, punishing. It was safe to take a pill but the whole concept of pain-relief seemed abhorrent now. She was still here, but dug a nail into her wrist to convince herself. The sun smacked off the surface of the river into her eyes, which she closed rather than shielded. She should be sucking up life, rejoicing in it, luxuriating in her second chance. But she didn't feel this way, she didn't feel anything at all.

As Cath glanced across at Rob she began to think in the movie terms Rob always used. She could hear him pontificating, saying they were in a surreal foreign film which was all image and no substance, two figures in gritty surroundings saying nothing to each other in complicated ways, with less to them than met the eye.

We're here, Rob said.

But where, Rob? Cath asked herself. You certainly don't know, but you'll amble along for another ten years if I let you, my suicide attempt alluded to when it suits you, shouted about in mid-ruck.

She was still a little shaky walking from the car, and the weather was arctic after the pumping heat of the hospital. Then they were back in the flat, her flat. She'd bought it last year, fed up with Rob's evasiveness. He hated it.

Rob opened the door for her, with the key she planned to take back. She went to the balcony window to look out over the channel, and down at the man-made bay. On cue, the sun disappeared, making the bay look like a poor painting of the sea. The estuary had been assaulted many times by centuries of industry, now it was locked into a false bay and did not look right. Before the ebb and flow of the tide was stilled, expanses of rutted mud banks caught every nuance of the light, constantly undulating in pattern and form, and dotted with the hundreds of seabirds who fed off rich pickings. But the mud banks were not considered aesthetically suited to the new times and had to go, perhaps because they were too natural and too alive. That's Rob talking, Cath said to herself, but I like living here, for the convenience, the anonymity – and that it's the complete opposite of where I was brought up. Maybe I am living in a development for cyphers, most of whom seem to live in work and for work; people for modern times, driven by money: the need to get it, keep it, spend it. But I have a foot in their camp, like I had a foot in Rob's, his constantly shifting, dreamlike, slothful camp. How he loved to get his teeth into fruitless projects, then float away on the disappointment of their failure. If he'd put just ten percent of that effort into us.

Shall I make coffee? Rob said.

No, tea, green China with jasmine. It's in the cupboard near the kettle.

Cath sat in the chair nearest the radiator. There was no fireplace, which Rob hated, but this was her flat, decorated her way, with her things in it. Rob left a smattering of clothes here, and a few books, never his sax.

The tea was too strong, he'd always made it too strong, as if irritating her gave him a perverse kick, but she didn't say anything this time. She sipped it and put it to one side.

So what did that shrink say? Rob asked.

He ran a few professional phrases at me, jotted things down and chewed the end of his pen a lot. He looked like he needed a good rest.

Is that it?

He wants to see me in a few weeks, a washing-of-the-hands session I suppose, but he wasn't overconcerned. He seemed to think it was a one-off and said I'd be fine now. I agree with him.

Do you want to talk about it?

Not now.

But we should – if I hadn't come back when I did...

Rob said this but Cath could sense his relief at the ordeal he'd been saved.

•

I'm getting used to what's happened. I'd always thought Cath capable of it, her family was riddled with people who were capable of it, and her uncle Padraig did it. He was found hanging from his own belt in the outhouse of his farm, no note, no prior warnings, a single man who farmed on the edge of the Atlantic, his place the last stop to anywhere. We went over for the funeral, my first Irish wake. It wasn't what I expected. There was no maudlin sentiment, not much sentiment at all, just a gathering of red-faced ageing men and their gaunt womenfolk, all of whom bore the mark of the unfettered wind. It came in off the sea straight from New York, blasting the coastline and all who lived near it. Cath's coastal land was a stony, stunted place, and the people matched it, apart from her brother and uncle, who reared up like trees, the tallest men around, a direct line to the Norsemen settlers of a thousand years ago, they liked to claim. Padraig was not a Godly man, the priest said in my ear, and he

did not do a Godly thing. The priest had rotten teeth and breath to match and was unsteady with whisky, and Padraig had been worth ten of him.

Cath was uneasy about going home, she didn't like returning to the insular histories that permeated her family. They liked to talk about struggle, she said, even when they were free of it, and I could sense her nervousness as she pottered around Padraig's house, prodding the peat fire and muttering to herself. Padraig put us up the first time we came over; she didn't want to stay at her parents' house.

I liked Padraig, liked his quiet, constant ways that were so unlike my own, and his solemn but friendly features. He was very different to the other farmers I knew back home. We talked and drank a lot together, looking out through his rotting windows to the huge sea as he showed me his book collection. All of three books, the collected poems of Yeats, a book on horses, and *The Folk Songs of County Clare*, published in London. Padraig knew most of these, but couldn't sing. They came out like Sioux medicine chants but he was enthusiastic, and finished each one with a gap-toothed smile. I doubted if he'd ever had a woman, but he was to prove me wrong.

We've reached rock bottom and I've brought Cath all the way down. Now we might start to float back up, but not together, that's too much to hope for. The thought of a period of solitude that might last the rest of my life cuts two ways: it's an old, beguiling friend, but one which might turn on me and become dangerous. Cath would say that there's not much difference if I'm in a relationship or not, so little do I put into it.

What are you thinking? Cath asks.

About that time we went to Padraig's funeral.

I thought you wouldn't be long in bringing that up.

It was a day like this, cold and still.

Go on then, tell me I'm continuing a family tradition, that I'm another one unable to cope.

She's getting some colour back, little red hands are pressing into her face.

He'd be sixty now, Cath mutters. I wonder if he just did it, some sort of dreadful instinct, cooking bacon one minute, hanging himself the next.

I knew better but kept my counsel.

He must have kept a lot inside, living the life he did.

Not unusual for a bachelor, I murmur.

Padraig's death was not such a great shock to me. Cath's uncle had opened up quite a lot during our drinking sessions. I encouraged the man's confidence. The time I painted his portrait turned into one of our biggest bottle sessions, when whisky and poteen combined to erase the next few days of my life. Padraig revealed his innermost secrets then, and I learnt about his one-man trips to Dublin, when his family thought he was in Limerick looking at livestock.

I met a woman there, Padraig said, as he sat patiently for me, smiling in that vague way he had, I met a few actually, but the rest I had to pay for. I was besotted with Edna but I could never get her to come out to Clare, she was a girl too much for the big city, and it was the sixties, when everything was changing, even in Ireland. It broke my heart when I lost her and can't be doing with that again. The family think I couldn't be doing with it in the first place, but I want you to know this about me, Rob. You can understand. Some nights, alone here, I wonder if I'm better off for having known her or not, sometimes the thought of her is unbearable, like a knife twisting slowly in my guts, other times she buoys me up. I should have left here, gone to Dublin to be with her, but I didn't quite have the nerve.

This knowledge helped me with the portrait, I was able to capture the pain and loss in his face, which I now knew was built on experience and not longing. This loss must have become too hard to bear that fateful morning, the knife too sharp. So he made breakfast, ate it, and went out into the barn.

•

Part of Rob wanted her to open up, Cath knew, wanted her to set out reasons, a formula of words that would absolve him. But she had to find the reasons herself; Rob did not come into the frame, not anymore.

There was no point in him staying. He wanted to go, he always wanted to go and now *she* wanted him to go; they had harmony in this at last. Christ, she needed to think. In the hospital it was

all alien noises, smells, faces. She'd come out of the overdose disorientated, then was aware again, an awful awareness that shrieked at her until she felt like a child singled out in the playground, but without welcoming arms to run to. She wanted the bed to swallow her up as she sank into it, and wondered if they'd appended suicide to her chart.

Cath moved the chair closer to the window, and tried to drink the too-strong tea. Rob had always exasperated her fussiness, leaving doors open, toilet seats up, spilling, dripping and dropping like an infant. Our upbringings were so bloody different, Cath thought. Rob had been so spoilt, maybe by accident, rather than design, but spoilt just the same. He was the victim of distant parenting and free rein in his juvenile choices, whereas she'd been treated like a young adult, at all ages, always helping around the house and being taken by her mother over to Padraig's farm to work in the summer. Her holiday.

The yachts and smaller craft looked lost in the bay, and beaten by winter. She had never seen much activity in them. People took them out occasionally in the summer but usually they served as floating pubs. Abandoned, out of season pubs now, gently rocking, and clinking as the wind got up. Cath sensed it push against the window, thwarted by her double glazing. In Rob's cottage it came straight through his ancient frames. He was a perennial complainer of cold and draughts, but did nothing about it. Rob must have been founded on a core of pure masochism; it took her some time to realise this, so skilfully did he hide it from her. He was capable of revelling in misery, a facet of his character which had been revealed gradually, like a sullied flag being slowly unfurled. Cath knew this and all his other traits now. Rob thought there were still parts of him she couldn't see, but he was wrong. She knew him, and this knowledge overloaded two days ago.

I'll go then, shall I? Rob said. Sure you'll be alright?

She'd forgotten he was there for a moment, so lost was she in her thoughts.

Yes, go, lightning is not going to strike here again. You're safe, Rob.

Look, I find this difficult.

The fact your girlfriend tried to kill herself, or rather ex-girlfriend? What term would you prefer? Partner hardly seems right.

Lover, not really, not ever for you.

You're getting upset. We need time to talk about this.

Cath fought down a scream. Rob had always been able to talk her around, talk them into another sterile period, but as she looked at him now she couldn't believe she'd invested so much time in him. Was that love, a blind contortion of it? If so, love had fled, punched out by each pill she'd swallowed. They'd been passionless for a long time and Rob the great lover was comfortable with this. It freed him up, to do God knows what. She stopped trusting him years ago. Millennium night blew her cover all to hell; she was beaten by a stupid invention for bored and directionless Brits. Ah, you're still thinking Rob thoughts Cath. The country's drenched in tat and gone to fuck, the rudder's lost and we're blindly drifting, so let's have a big party. Even this failed to spark for most people, but it fired her up alright. The end of an era was a perfect time to evaluate their decade together.

I've got to get my heating sorted, Rob said, I'm trying to find someone who's cheap.

For a moment she thought he was going to ask her for money. This had become increasingly common.

I'll go and sort it then. Do you want me to bring you anything back?

No need to come back. Nothing's going to happen. I've told you, go and do what you have to do. I want time on my own. You've won Rob, I'm letting you go. I'll phone you.

When?

When I'm ready.

I'm letting you go, Rob, after ten years. Cath mouthed this to herself as he left. Being alone used to terrify me, my family made sure of this. They couldn't handle privacy, everyone had to live in each other's pockets, and any emotional show was not trusted; it was akin to nakedness for the Galbraiths. So I snatched at the few men before Rob, smothered and rushed them before the relationship had a chance. And I always went for the wrong ones, underdogs, loners, men who were nothing like the Galbraiths, men I convinced myself were creative rather than lazy, individual rather than wilful, and principled rather than slyly ambitious. God, I must have been so easy for Rob.

Cath made some more tea – this time a pot of the correct strength – and used good china. Cath's tea party, by the seaside. Her flat was close to the flooded bay and half a mile from the real thing. She lived in a development which came out of eighties thinking. That she chose to live here baffled and infuriated Rob. He was vain enough to think it a personal affront. How can you live here, he wailed, as he ate her food and took in the view. It's so empty, where are the people? This is a huge, sanitised vacuum, bricks, mortar, steel but no life, there's no life here, Cath. How clearly his words rang in her head, but she didn't care anymore. Rob brought out a latent stubbornness in her and the flat was the perfect antidote to her childhood home, and to Rob and his freaky control games.

She felt ready to face the other night, but would not rush into it. This was being alone in a different way. Rob had disappeared many times, times when she suffered. Pre-pills she always wanted him around, no matter what was happening, but she had changed and felt it in every pore. Something had been taken from her, but something else put back in its place. This was life post-pills.

•

I'm nervous about leaving Cath, but I don't want to stay. When there are problems, get away, that's always my reaction, but she popped enough pills to kill herself twice over. I still have to go, though getting away from myself will be trickier.

I wonder for a moment if I've been talking out loud. Having conversations with myself is becoming common and the cottage is a good place to descend into loner madness. I have many fears, but one in particular: that I'll become a shuffling old loon, none-too-clean, whom mothers will steer their children away from – you know him, that figure on the street who makes you feel good because you haven't sunk that low; that I'll descend into a kind of bitter hell, a place to eke out days with sour memories, chances that got away or which I just imagined, blinding myself until I think it's everyone's fault but mine. Thoughts always coming back to Cath.

Well, are you going then? she says.

Yes, I suppose so.

There's an awkward silence, then I'm out of there. Christ, I can't even begin to imagine what must be going through her mind, what it must have felt like, waking in that hospital bed. I couldn't have taken that kind of exposure, it would have been too real, too out of my control. I wonder if she hates me now.

The weather has brightened, but the city is deserted, as post-millennium emptiness combines with Sunday lethargy. I drive away from Cath's flat knowing that I don't want to go back to the cottage. I park at the other side of the bay, get out, and watch the wind whip up the trapped water, creating wave sculptures on its surface and lacing me with moisture. The fake little sea is a dirty, gun-metal grey today. Most of the birds who used to live here have disappeared along with their food chain, leaving the gulls to it. These noisy bullies are doing well under the new order; it's a good time for scavengers and these birds survive. A few wheel overhead, checking me out, and one squirts shit down onto the recently laid stone. Yes, I agree, mate, an apt comment.

A few huddled couples pass me, thinking it's a mistake to be out. It is. There's a converted church nearby that is now a cafe, a relocated wooden building that looks like it should be on the edge of a fjord, with Danny Kaye waiting to sing to the congregation, fixing everyone's problems with a Hollywood smile.

I walk over to it, directly into the wind now. There's nothing to stop it here, it comes in off the channel with relish, just like the Atlantic squalls of Cath's homeland. Yet she wants to live here. Maybe she has a secret longing for these conditions, some sort of womb-seeking. Maybe it's none of my business anymore.

I'm blown in through the door. A few likewise wind-swept souls look at me with a flash of sympathy before hunching back over their drinks. I sit near the window where I can just see Cath's apartment block. There's a lot of steel and glass on its exterior, like the guts of a factory exposed. Everything is on public view, it's strange how such a new place wants to borrow from the past, but it's more like theft, a sly reworking of an age more despised than loved.

I wonder how I'd be if Cath had been successful, would I be sitting here now, waiting for the guilt to hit, or incarcerated in the cottage? Wherever it was, I'd be hiding. I'm hiding now, and my

thoughts can't be trusted, nothing in my head can be trusted. I have a tremor of shame as rapid images of Cath charge through my mind, some dripping with sentiment, some chased by anger, jumbled, tumbled together. Maybe she's doing the same, but hers would be neatly filed, or discarded for good. I order more coffee; I think I'm beginning to turn into a caffeine junky.

We're closing in a minute, a voice says.

It belongs to a woman of about thirty, face already wearing, dirty-blonde hair tied back, face sweaty from her work. She thinks I'm a little odd, out alone on a bitter Sunday, a loser with nowhere to go, that's what she thinks: shopping for one at Tesco, sitting alone in the corner of a pub, wearing clothes from another age, one stage away from talking to himself. Ignored by everyone. The waitress is anxious for me to go, she wants to knock off and get back to the kids. She'll live in a box on a wasted estate, scrimping through life with no regular man. This is in her face; what's my excuse?

•

Cath watched Rob go, his battered Ford trailing blue smoke into the cold air. Rob liked posing, in an inverted kind of way, slagging off expensive motors whilst making just as much of a statement with his own. He was a great actor, and carried his own stock company around in his head. He'd shown her all the characters over the years.

She looked out of the window for a long time, drifting in and out of sleep. She had a sense of what it might be like to be old, hazy memories bursting out of the past with a subtly rearranged chronology, crushing and usurping the present, life becoming ever more vague.

She doubted if she'd ever talk to anyone about her attempt. Yes, that's what I'll call it, Cath thought, my *attempt*, and I failed, thwarted by Rob. Christ, how *ironic* is that? Why did you come back, Rob? My Uncle Padraig had no such saviour. He had the luxury and pain of true solitude to do the deed. There's a strain of self-destruction in the family, our weak link. They have Scandinavian blood, the Galbraiths, Padraig said, and they are experts at life-taking. When he died there was a morbid family

search, and three more suicides turned up, two men and one woman, my great aunt Sarah, who slashed her throat with her husband's open razor. I thought she was wearing a red scarf, her husband said when he found her. Another lonely death on another lonely farm. I've never told Rob about these.

Cath felt her eyes moisten with the memory of Padraig. He'd been more of a family contact than her own mother towards the end, but she had seen less of him when Rob came on the scene. She'd been in London when the news came, enjoying Rob's one successful year. Rob liked Padraig and for once seemed genuinely upset. He missed the opening night of an exhibition at Selborne's gallery to travel back to Clare with her. Cath thought now of all the things she hadn't said to Padraig in those last five years, the thanks she had not given him for his support and protection, for providing her with sanctuary from the strained atmosphere of the family home. She wished he'd married, had shared his kindness with a partner, and had sons who might have turned out like him, gentle, contemplative, but secure in mind, breaking the Galbraith mould. Cath tried but failed to understand his end, perhaps she did not want to understand it, because it struck at her idea of him, at all he seemed to embody. But she felt a keen kinship with him now, having so nearly joined him in the same act. Cath saw Padraig hanging in his barn, and shuddered at the bleakness of it, the waste of a forlorn life. She fought back tears. Don't feel guilty about still being alive, she told herself, savour it, live it and move on.

Cath went into the kitchen in search of food. Rob must have cleaned it up but he hadn't removed all the pills from the cabinet. These were for him, for the stress headaches he suffered. They had played a great part in their history and Rob would say that fate had conspired with them. He was a believer in both, especially when they lent weight to his arguments.

There was a little Brie left and some crackers, a nibbler's diet. She had lost seven pounds this winter, and was her slimmest for years, but she felt like putting it back on now. When she went on a diet her face became somewhat gaunt and angled, and a certain light went from her eyes. It had retreated even further now. The Galbraiths were endomorphic, built to withstand the Atlantic weather, so perhaps she shouldn't fight it anymore.

Cath made more tea, raspberry and camomile. Rob had a Russian friend once, one of the lame dogs he used to fetch up from time to time. Boris thought the presence of milk in tea obscene, so he'd be proud of her now. Her fetishes were another prick for Rob, first vegetarianism, then politically correct tea. He saw his bacon sandwiches under threat, his greasy hand-held snacking mocked. For someone who affected a casual manner he was deeply intolerant.

From the window Cath saw Rob's car polluting its way down the road. So he hadn't gone home, that central heating stuff was a ruse. She knew he'd never fix it anyway, that would be too logical, too straightforward, and it would cost. Tightness with money was one of Rob's slyest characteristics, he was a closet miser.

For a tense moment she thought he was coming back, but Rob was heading out of the bay. He must have been mooching around outside, maybe keeping an eye on the flat. This time he was going home, to that bleak cottage of his. Strange how Rob had returned to a birthplace he always derided. Cath never wanted to go back to her roots, lest they entangled her. For generations the Galbraith family had eked out a living on the western extremity of Ireland; they had it no worse than most, but certainly no better. Their roots went back a long way, lost in some Celtic and Norse twilight, if Padraig was to be believed. Padraig, family chronicler, hanged man.

Cath was not sure she saw Clare as home now, just the place where she grew up – at least this was how she wanted to think of it. The memories of her birthplace stultified more than inner-vated, and were summed up by that huge ocean that was her constant horizon. It used to unnerve her as a child. When it was angry it was her white whale, the monster that pounded the coastline until it seemed ready to buckle, bringing rain and wind, and defying trees to grow near it. Even in summer she didn't trust it. When it was calm and flat she thought it was trying to fool her, enticing her into its salty maw, so she rarely swam in it, and when she did its waters were cold, even in August. And the vast sky was its ally, creating stunning cloud-sculptures that stretched out over the Atlantic, towering fingers of cumuli that had pointed the way for so many to America. Sometimes fleecy, sun-shot, and benign, sometimes stormy black and evil mael-

stroms, the sky was able to change very quickly to crush out fine weather, and as untrustworthy as the sea itself. But at least her early world outside was fresh; it could blow away headaches, moods and despair as quickly as it created them.

Cath always thought of the sea as a masculine presence. Her whole upbringing was dominated by men and her mother was the only one excused the drudgery of the farm. Her father was soft with her, could never believe he'd netted such a good-looking woman, and her mother always kept this thought in his mind. So he left Martha to her own devices, and she left Cath to hers.

Childhood was a slow turning of time, marked by disappointments, and one major shock: menstruation. She was not yet a teenager. There was no prior warning – sex education in schools was slow to penetrate her part of the world and non-existent in the Galbraith family, so she didn't know what was happening. I can remember it so clearly, Cath thought. That first trickle terrified me, I thought of all the religious icons rammed down my throat, with their open, bleeding wounds, the suicide girls buried in unconsecrated ground. It was a Sunday afternoon, a time when the farm slipped into a catatonic trance, like an animal dropping down with tiredness. I ran to my mother, crying, and on the edge of panic. I didn't want to be marked out. This was 1979 for Godsake, but it might have been the Dark Ages. My mother was on the living room sofa reading when I burst in. She didn't even want to put down her magazine, as I poured out my fear. Then she got up slowly. I could smell the sherry on her breath as she marched me to her bedroom, where she gave me a few things with minimum instruction. I felt I should apologise for the fuss, but really just wanted a cuddle. I'd always wanted a cuddle, not a brisk shake by my father or a piece of wisdom from Padraig, but to share something with her, to feel our warmth mingle, our faces press together, things I saw happen with other kids. In my confusion I called her mum, a word she never liked. My name's Martha, she said, as if I was a stranger in the house. Afterwards I ran down to the beach, to let the wind brush away my tears, and hope that it would cleanse me. I never expected much from my mother again, or asked her for anything, and that day marked my determination to get away.

As Cath sat by the window her thoughts drifted. She felt she

had all the time in the world, and wanted to squander it, then luxuriate in the waste. The sea here did not worry her like the Atlantic of her childhood; this was a puny pretender, cargo ships passed slowly on it, black wedges on the skyline. No-one moved on the concourse outside. A windswept emptiness was at the new heart of this city but if she craned her head she could see a few figures dotted around the church. They always seemed to congregate there, but weather and the time of year had beaten most, especially the time of this year. Another thousand years was beginning, no time at all in the scheme of things but time enough to reshape countless low histories, to wreck or reform a myriad specks like them, all the Caths and Robs in the world.

Another half hour went by and with it came the beginning of rehabilitation, of herself and her history. Cath felt so calm as she pulled herself away from the window, sensitive to everything around her. The light was beginning to fade, leaving a touch of red in the sky as the sun reached out to another place.

Cath ran a bath, as high as it would go. She'd never been much for them, too much early discipline and too little time meant showers, but now immersion was seductive, a way of soothing and preparing her thoughts, the things she would soon have to go over. She sank to her nose and just about kept awake, wondering if that was the phone ringing, and not caring if it was.

•

Cath's not answering. I should sweep into action, gun the Ford and speed down to check on her. But I'm calm, I feel she's alright, I know she's alright. What Cath did has given us relief, she's lanced a long-festering wound, so I'm going to stop worrying about her. As I think this I realise I've also stopped feeling guilty, even though I have so much cause for guilt. I should examine what's happened, but I know my thoughts will always start and end with myself so I don't bother. Cath probably won't even dial 1471 – she'll know it's me.

We're over now. Cath will sift through the last ten years as she undoubtedly did the other night, but this time there will be a different result. I felt her resolve when I drove her back to the flat, there was a strength there I've not seen before.

I'm in the kitchen looking out at the hillside. It's quite desolate at this time of the year; tired, washed-out greens are shot through with sodden brown, the landscape as leaden as the sky. Bare trees clump together, as if for company, and sheep drift slowly across my vision in search of food. Like my tired environment I need recharging, to feel some sun on my back, but there's no money to get away.

I hear an engine approach, it stops outside and there's a knock at the front door. Glancing through the window I see it's Tom Pearson, who farms nearby. He's the last person I want to see, and he has his dogs with him, two wild-eyed collies who hate me as much as I hate them. They sit on his quad, itching to be allowed down. Tom sees me in the window and waves. I have to open up.

Just passing, Tom says, thought I'd wish you a belated New Year.

I mutter something and Tom marches in.

Kettle on?

He'll switch it on himself if I don't.

Lost two sheep last night, Tom says. Stupid buggers went over the crag in that fog. Think they'd know their way round their own patch, wouldn't you? Still, they're only worth a few quid, things as they are.

Don't give me a monologue on hill farming, Tom. I'm not sure how I became friendly with him; I'm not sure I am, it's all on his side. He's a bachelor farmer living with his mother, father gone long ago. Tom's another of life's sideways shufflers, and reminds me a bit of Padraig. It's strange how land-folk like me, I've never really had any sympathy with them at all. I see most of them as avaricious rural capitalists, spouting nonsense about being guardians of the land, all with an inbuilt, die-cast meanness, and all living on handouts. Why does this sound so much like me? I smile at my hypocrisy and Tom smiles back. His is a raw-boned, weathered face, with eyes a clear blue, nose large and fleshy, and strong teeth yellowed by his addiction to tea. I'm not sure how old he is, he could be anything from forty to fifty. Tom is far too jolly for the life he leads, suspiciously upbeat. For a second I see him swinging like Padraig, his corduroy trousers piss-wet, the collies whining at his feet, then starting to bark frantically.

So, did you have a nice time, then, Tom asks, you and the lovely Cath? Pity she doesn't have any sisters. Where is she anyway?

She's still getting over the celebrations, down her place.

How can you stand to be apart from her, you've been together for years, haven't you?

Jesus, I could do without this.

Uh uh.

He wants to know how long so I tell him ten years.

Good God. I'd have wanted to get married after ten weeks.

But you never will, I think, you'll never meet anyone. You'd have to have a large acreage in lush country to have any chance at all, and maybe not even then.

You're miles away, aren't you? Tom says, as I hand him a mug.

He sweeps a hand at my bookcases.

Too much book reading, puts you on your back, that does, same as too much thinking. Is that a new painting?

I forgot it was there and wince as Tom picks up a canvas and squints at it as if it's an ailing lamb.

Can't make head or tail of it, he mutters, lots of nice colour though. Is that a face there?

I survive the next twenty minutes. A grunt of assent, a nod or shake of the head is enough for Tom. He doesn't need anything more – he's able to handle a conversation by himself, which must be a good definition of loneliness.

Well, must crack on, Tom says, got to get up to the top fields, see if any more sheep have gone.

Mind how you go, I mumble.

At least he kept the dogs outside. They run off in front of the quad, one either side, moving low to the ground, their restless heads shaking with the need to herd.

•

Cath was beginning to go back over her time with Rob, picking out the most painful points, and when the memories got too much, balancing these with their rarer good times.

She thought back to when she lost a baby. It was three years

ago and they were on a short holiday, paid for by her. It was very early on in the pregnancy, so early that Rob didn't know. She was waiting for the right time to tell him – once she was used to the idea herself – for she knew he'd panic.

It was just a very heavy bleed. Just. What an inadequate word to use. But despite the shock, she still felt relief, for being freed from what had developed with Rob, from being tied to him, from being stuck like the women back home, stapled to their men's lives by childbirth. Desolation came later, but only a matter of hours.

They were in a tacky bed and breakfast on the East Anglian coast, in a room that looked out onto the flue of a Chinese take-away, all she could afford then. It was the type of place that chained up the TV. She remembered Rob trying to receive a colour signal but not quite managing it – pictures were a muddy brown, which might have been a good way to sum up that weekend. Muddy brown turning to red. They'd had a horrendous traffic-infested drive in her cramped hatchback, then cruel weather blew in from Norway to mock the spring. Rob was adamant he wanted to see the one part of Britain unknown to him, it was one of their many non-relaxing long weekends, which always followed a pattern. With Rob's fractured lifestyle they were so used to snatching what they could when they could, that when a rare block of time presented itself they invariably blew it. She tried too hard, and Rob retaliated by upping his detachment, his iron curtain of phony independence that she didn't know was sham at first, making her feel like his sister, secretary and worst of all, mother.

She kept the miscarriage from him, told him it was a heavy period. But it came out weeks later, it had to; unlike the baby, it wouldn't die inside her, and screamed to be told. Rob didn't believe it at first. They were in mid row, brought on by a visit to friends who had two small children. Rob laid into them as soon as they left, about how they were stuck now, would be broke forever, his usual spite-barbs. Happiness in other people usually sparked him off. She came to see this not as jealousy, more a confusion of every nuance of his character, his emotional strands knotting up in denial of all that he really needed.

Rob was shocked at first, then quiet and sulky, and added to

the performance over the weeks. The miscarriage took on tragic proportions for him. He began to usurp her feelings but she knew if she mentioned trying for another child he would soon shut up.

Cath couldn't say if that started the rot, because they were never right from the start, never whole. Rob hid amongst her dreams for a while, they were perfect cover for him, and he thrived on the possibilities they offered. He allowed her to think what she wanted, to mould him into her ideal and when this façade started to crack she was too far in, and too weak to get out, hoping that things would improve and that longevity would solve all. These were perfect grounds for drifting, and drift they did, lapping up against each other with increasing hopelessness. It suited Rob, using up time without commitment, but as the years mounted Cath felt them accuse her. Her crime was to waste them, on a relationship that was going nowhere, and with a man who was essentially useless.

•

Why did I go back that night? I didn't usually, not after rows like that. It was our millennium special, full of vitriolic reminders of past fights, each of us knowing which cracks wounded the most. I'm not surprised we peaked, all the signs were in place. Christmas was never a good time for Cath, it charged up her emotions and expectations, and made her think too much of what she'd never had, until disappointment became so tangible it stuck in her throat. In her mind our situation was highlighted as the last days of the millennium were counted down. Everywhere, new beginnings seemed to shine down onto our stagnant water, and Cath's anger mixed with my guilt, her despair with my diffidence, until it became a perfect synthesis, guaranteed to explode.

That we had dragged on so long was my fault; I had always been in control – of myself and the relationship, and even at the height of a fight I always had something in reserve, a coldness that even I could not fathom. It seemed to exist in its own place, inside me but out of my reach, and gradually Cath became aware of it. She called it my heart of darkness and it infuriated her.

Gradually, she relied on temper to fight it. If what we originally had was love, it became a strange, contorted kind, drenched in emotional blackmail on both sides until we swam in it.

It started quietly enough. We were determined to sit out something we thought laughable, but an edge was there, honed to sharpness over the years. Cath had bought the flat with the help of a small legacy from Padraig's estate – if a poor strip of land and a ramshackle house could be called that – and the proceeds of her burgeoning career. She had changed course before teaching had taken dread hold, and was at the cutting edge of new technology now – internet serving, website design, terms that meant little to me. Cath had long since outstripped my Luddite ways.

Her flat was at the heart of everything I hated, and it was the wrong place to be that night. New money fisted out all around, while what was left of old money tried to attach itself, limpet-like. The bay was a hard, bright, blinkered place, desperate not to look back, but without any worthwhile future vision. For me it was a workaholic limbo, Consumerville built large and gone ape, addled greed masquerading as worthwhile ambition. An environment which made every negative thought Crossman ever had soar.

As the witching hour approached, tension grew, tongues sharpened, and barbs became poisoned. I remember thinking we shouldn't be alone, that there was safety in numbers, and that we should have gone out, but I'd pulled Cath into my loner ways, and got rid of anyone who might have been a friend to her. We stalked around all the old problems like two rutting cats. I knew we wouldn't be able to prevent what was to come – and it was easy to see it coming after so much practice. Easy to see, but impossible to stop.

Fireworks were going off outside too, at first a desultory bang or line of fire in the sky, then increasing when the professional displays got going at midnight. I saw the look on Cath's face as she opened the balcony door to check them out. It was a look of disgust, lit by the pyrotechnics for one awful moment, disgust for me and for all the wasted effort she had poured into us. And on its heels came the final realisation that it was never going to work.

Cheering started in the other flats and we took off then. Our explosive best. It was nothing new, but the occasion spiced it up and it wasn't long before Cath lost it completely. Her fuse had

grown shorter over the years and I lit it when I said so what, we've wasted ten years, but that's one way to get through life. She came at me then, intent on doing damage. I pushed her off but felt her nails rake my face. She fell onto the sofa and scrabbled for things to throw. For once I wasn't in control and was out of there before it got worse, amazed to find the car keys in my pocket. With two bottles of red and a few inches of bourbon inside me I pushed the Ford northwards, its crappy exhaust adding to the smoking atmosphere. I was weaving all over the place like a tank ploughing through a battlefield as I tried to focus on the road ahead.

I crashed over the kerb and took the middle route over a roundabout before stalling the car, but there were no police around to make my day. They would all be in the city centre, dealing with the happy people. I managed to park up and watch the sky arc with colour, which was reflected back into the bay. Black water turned into a technicolour floor show. Fireworks had fascinated me as a kid, because then they were a rare, once-a-year event, exotic and rich. Now they were fired off at the drop of a hat, and the miser in me thought of the expense of it all. Burning money, ha ha.

I went back, I'm still not sure why. Maybe it was the way she looked when the clock struck, all her anguish in one grimace, maybe just drunken intuition. Maybe I wanted to continue the fight. When I let myself in Cath was slumped on the floor.

I didn't get it at first, I thought it was just the drink, then I saw the bottles, the large one empty, the other with its white trail of pills scattered over the carpet. Her reserves. There was no panic at first, I almost lay down beside her, I was that tired. We'd been here so many times before, but minus the pills. Then I snapped out of it and asked her, over and over, how many she'd taken. I got mumbled garbage in reply. Keep them awake, walk them round the room, slap them. I'd seen it in films often enough. I managed to get her up and out of there, lurching our way to the car, and praying it would start. This was not the night to call an ambulance.

I'm looking at the canvas Tom pawed. Nice colours. I'm getting ever more remote from my art. Selling a painting is a distant

memory, and good ideas are even further back. I have no more illusions to hang on to, money blew them away long ago. It underpins all artistic endeavour, whichever way you dress it up, whatever self-deluding claptrap you use to disguise it, and not having any is the one constant torment of most artists, cloaked by the indifference they – we – feign, making out that poverty is normal, its vile effects stimuli to the muse – all the usual time-honoured nonsense. The naïve amongst us are ruined when they get to this blinding point of truth, the shrewd are aware of it before they start. They become the movers and shakers, arse-lickers and self publicists, elongators of thin talent, the ones most likely to succeed. I almost laugh out loud as I ask myself a question: Then why haven't *you*, Rob, why haven't *you*?

Tom's coming back. His quad is a cheap alternative to the Landrover he rarely uses, and sounds like an old motorbike. Tom waves to me as I stand by the window but thankfully does not stop. He has a fair sized ewe on the back of the quad and the dogs run noiselessly alongside. They are always silent when they work. The ewe raises its eyes as they pass, baleful orbs that register nothing, for there's no future for it to see, and no past either. Lucky bastard. For a moment I see how it might have been for Cath, her eyes staring at nothing, her face pressed into the carpet, her life over. I'm shaken.

Cath was another chance for me, maybe a last chance to get the sharing thing right, to get it going at all, but I was no nearer it after ten years with her. Lots of marriages don't last this long. We're living in an age of disintegration posing as progress, unnecessary changes applying unbearable force to a centre that has collapsed. The phony tranquillity that was invented for Britain in gentler times is gone, that Ark-like symmetry of two parents and two kids, grocer shop values and cosy development, all blown away in the last twenty years. Maybe it needed to be, but nothing worthwhile has replaced it.

So much of me has been revealed to Cath that a kind of inner poisoning has taken place. I can feel its insidious spread. My judgement can't be trusted: it's like looking at a good painting for too long, its power wanes, its perfect lines blur, its colours congeal, and its harmony collapses. Fuck it, time for a walk.

I stride out of the house into a brightening afternoon and

beckoning middle age, with as much to resolve as an eighteen year old. Light picks out the most watery places on the hills, rutted pools shine out in hollows and there's a trace of warmth in the sun as it pushes through cloud gaps. A cold wind competes with it, helping me over the sloping fields. I'll walk down to the village and hope to grab a lift back up.

I'm calming down as the solitude-junkie in me takes another fix, mainlining on elemental open spaces. I wonder what Cath is doing. By not being with her I could say I'm removing the cause of her angst, but I know the easy option has been taken, as always. At least it used to be easy, but I've learnt that too much freedom is as sterile as too little, and that pigging out on it leads to implosion. Rob Crossman, blown into a thousand warring pieces: head in turmoil, arse in a sling, self pity, sloth and inaction working on yesterday's man. Yet I still love being here, being alive, even being me. That's the rub alright. Perhaps Cath is right, I *am* a little crazy, more than a little. Paintings lie unsold – they line the walls of the cottage, deteriorating as damp gets a hold – and I'm almost penniless, but something inside won't extinguish or give up.

A hawk wheels low, followed by another, hangliding their way down the hill, taking seconds while I take minutes. I see the flash of lighter brown as the birds stretch to full wing span, revealing their rippling, feathery undercarriages. They angle their bodies in the air and ride the currents, creatures that know what they're about, that are still in harmony with their changing world, and will hang on no matter how much man confuses the issue. The hawks circle away, descending in spirals as they scan the landscape, hovering in one spot if they glimpse a hit. It's a difficult time of year for them, but one arrows its body and plunges down into undergrowth.

Perhaps I should get a dog. Tom's always trying to unload a pup onto me. I'd have obedient love on tap. Now you *are* getting addled Rob. But least I'm still able to laugh at myself, I think.

•

So, it's January, 2000, Cath thought, three big zeroes in the date, some kind of chronological comment on my state, perhaps. I'd thought of my life as a big zero the other night, a circle that beckoned me into its centre, into an empty, Rob-free zone. It's time to go over what happened, my first step towards exorcism.

Cath sat in Padraig's rattan chair brought over from Ireland after his death. She painted it blue last year, but remembered Rob sitting on the original back in Clare, that first time she took him home. Spellbinding everyone, as he had her, giving a painting to her mother – one of his most conventional, a landscape that looked like a landscape – and showing an easy mastery of Irish tunes as the poteen flowed. He was everyone's friend, and her lover. Even Father Riley was impressed, taking her aside and asking about the chances of a blessed union.

These were glorious unreal days when she thought she'd cracked it. She had the man of her dreams, was doing well in another country, and a bright future shone for her. It was a new year then too, the first of the nineties.

Her mother was taken with Rob, and surprised by Cath's choice. Looking back now she thought Martha saw the real man straight away, but it was not a character that would have worried her. Martha's surprise turned to jealousy before they left, and she tried her best to sow seeds of doubt in Cath's mind, scattering them whenever she got her alone. It was the most interest she'd ever shown in her.

Padraig overheard her once. They were in the parlour, while Rob caroused with the men. Later he took Cath aside, guiding her to a quieter part of the house. Don't mind her, Padraig said, my sister is as deep as a well, with just as much side. I know what it's been like, growing up here, but try not to blame Martha too much. She's a woman disappointed with her life.

Why? Cath asked.

Her uncle spread his hands in his calm, expansive way.

She wanted comfort, he said, a bit of style, what she sees you getting now. And she wanted to be away from here, to Dublin, or maybe further.

Cath nodded, and joined the others, too embarrassed to take the conversation further.

She gained more insight into Martha's character after

Padraig's words. A bit of comfort, a bit of style. She watched her mother flirt with Rob, and turn into a rival, overly made up, in dresses too tight and too young, and openly drinking, something she'd never seen her do before. Martha placed Rob's gift of a painting over the fireplace, and moved the crucifix to do so. Rob loved it. Your family's great, he said.

Cath was putting off the inquest, the sifting of evidence, the arrangement of thoughts into patterns she could deal with, or at least understand. She needed to control the flow-charts of her brain, to become a rational person again.

Her timing was pathetic for a start, but she had reached a point where her knowledge of Rob was complete. She should have been able to let him go, to move on – after all, she was a professional, upwardly-mobile young woman. Strange phrase, *upwardly-mobile*. She was not sure where 'up' was, or what it was.

She should start with the pills. No, first the row, fuelled by drink and all that surrounded the end of the year. They assumed their usual positions, baiting each other with the sharpest quips. She taunted him about his inglorious career. Rob responded with cracks about her figure, jumping on the edge of her weight paranoia. Imagine *Who's Afraid Of Virginia Woolf* condensed into thirty minutes. Two nasty pieces of work clashing. Cath blushed as she thought of how they'd hurt each other. Rob had just about kept his hands off her, though she'd seen his fists ball up and loiter near her face many times. Sometimes she dared him to do it, crazy temper taking over as she overdosed on the miserable spite of their words.

Things were thrown, furniture kicked, a crescendo was reached and she rushed at him. Rob pushed her off and was gone, leaving her cursing shadows, sinking down and hugging the sofa, tears coursing down her cheeks as silly cow mode took over. It was an old scenario, but this time to an accompaniment of noises off, the party in the flat downstairs in full tilt, pyrotechnics all around the bay, people having fun everywhere.

Let's try the pill scene again, Cath thought. In present tense for I want to keep it like this, to think of it like this. It would always be now, not then.

I lie on the sofa for a while, closing my eyes to stop the room spinning. It's just minutes after midnight and the twelve beat

chorus of celebration that rings around the bay. I can hear the cheering as people burst out onto balconies and shout their exhilaration into the night. Bodies are merging. It is so right that Rob isn't around – anything that smacks of togetherness is sure to exclude him – but also so wrong. I hate myself and my forced relationship, and I hate Rob. This startles me, it comes to me in a blinding flash of insight, my own personal rocket telling me that I should remove him permanently, remove the pain he causes. I see the pills on the pine table – headache pills, strong ones, which Rob has left – and something takes hold of me. They look so inviting, stacked up in their brown bottles. There's a full bottle, and another one close by. No more fights, Cath, just a jump into sleep. Padraig doesn't come into my mind, nor anyone else. I'm thinking of myself: for the first time I'm at the centre of my universe. *Whilst the balance of her mind was disturbed*, it's usually written off in this way, but I shut this out. Inquests, post mortems, conclusions, will not concern me.

As I take the pills, handfuls washed down with wine, I feel right about everything, right with the world I'm about to leave. Images of Clare whisk through my mind, but all the sharp edges have been blunted, and my mother loves me. The last thing I remember is a sense of oneness with it all, of being in total control, for the first time in my life.

Then Cath is being shaken, Rob's voice is shouting at her, pounding at her head, and she's being pulled along the floor. Perhaps he's dead with her, taking her to the next place, which must be hell if there's no escape from him.

When she finally comes round in hospital, and knows what is happening, she sinks to new depths. A screwed up, headache-driven despair welcomes her back and she lies very still in the bed, alert to every fibre of her body, each pore. She's alive, and doesn't know what to do.

That was two days ago, now Cath was bursting with reprieved life and even what she was putting herself through was wonderful. She didn't know where she was going, had no clear vision of what lay ahead, yet it was wonderful. She was looking forward to everything, but most of all to starting the millennium on her own. Rob's hold on her had been dislodged for good.

Time had been stretched this weekend. Now, sitting quietly,

she could feel each minute dripping away, a slow, elegant drip that did not worry her at all. There was a pale sun outside, its weak rays brushing against heavy cloud, as if hesitant to light up the new epoch. But she had it all, all the time in the world.

•

I phone Cath again. Maybe it would be better to go down but phoning is safer. If I was geared up I could e-mail her, let thoughts appear on her screen, weasel-words coloured by a few sincere offerings. The phone looks huge. It's a replica of the black police phones of the fifties, that's the 1950s – last millennium. A few days ago it seemed much closer, now it could be 1850s, 1550s. I couldn't stand the digital squealing of new phones, their raucous entry into my space; this one has a kinder ring, a polite inquiry into my whereabouts. Not that many inquire. I doubt if I'll ever be ready for a mobile, messages zapping the cranium, demanding entry. Cath had one as soon as they became widespread, followed by every teenager in the land, it seems, then pre-teens. Luddite thoughts again, Rob.

Shall I try again, press 141, then hang up quickly when she answers, reassured of her continuing existence? What childish nonsense. I should be trying to get my head round what's happened. I was too cocky in dismissing worry yesterday. It's back, ridden by its old pal, guilt. Clippity clop, clippity clop. If I know I'm to blame for Cath's state why do I keep dishing it out, because I'm a sod, waster, cunt, all three, that's why. How about a stunt? You cupid stunt, I remember that one from school. But then comes justification, the laying out of my good side – or what I used to think was my good side – but it's just a small part of me, a yearning for something better. I've lusted after women since I was thirteen, and have left a long, shameful trail of them before Cath. Hurting and being hurt, but mainly hurting, sexist antics gradually running down, close to atrophy now. Cath has put up with such a shitload, and many others: names that march across Europe and America, faces swirling, merging, then fading, in an inglorious line that charts my poor behaviour.

Christ, I'm going for it today, my schizoid brain's in overdrive. Faces start to swirl – good pulp-fiction phrase, that. Rob walked

along, blah blah, and faces started to swirl blah blah. I don't want to continue this self-analysis. I could do with a drink, and some food. I manage the drink part – there's a bottle of bourbon in the pantry. I still call it the pantry, it's that type of house. I take the bottle to the kitchen, where I pour myself a fat shot, feeling like an old time private eye in a double-breasted suit spattered with cigar ash, whose broad has left him, who can't solve the case he's on, and is not likely to get another. The drink burns its way down. I don't like bourbon, never have – it's a poncy substitute for scotch but, like coffee, somehow it is always around.

•

Cath decided to go out, to step out into the new millennium. Her only experience of it so far was ambulances, hospitals and Rob's car. There was a new hotel just over the way, but she'd only been there once, to meet Rob, a mistake. He went into a rant as soon as he saw the place. With a large scotch in his hand he gave her five minutes on the hotel's awfulness, what it symbolised, his usual plethora of bullshit that she was then still hoping would dry up, bleed away into his desert of similar thoughts, maybe even flower into something positive. Rob's desert sprouting with magic growth, turned into a fecund place, where his words and deeds were kind and thoughtful, where he put her at the centre of his universe. Fat chance.

She showered and washed her hair. There was a lot of it to wash, perhaps she'd get rid of this too, for she rarely wore it down. She needed new clothes, she *wanted* new clothes, lots of them. Cath surveyed her wardrobe, it was a bit sad. Each outfit echoed with Rob's words of admonishment, and every dress had witnessed a row. Eventually she found something she still liked, something short. She still had good legs, so why not show them off? She was starting a process of re-evaluation, and sex was as good a place as any to start. As she made up her face, quite garishly, she realised how alone she was, and how alone she had been with Rob.

The hotel wanted to be a club, restaurant, and sleeping place all in one but it was too small. Despite being quite new it had a battle-fatigued feel to it already, surviving on overnight stops for

reps and as a midday watering hole for local business people. She could not imagine anyone staying here voluntarily.

It was practically empty, with just a few suited men at a table working on expanding their waistlines, mobile phones at their sides like chaperones. A younger pair watched an overhead television, light from the screen falling on their faces, as the new messiah in a box spoke to its flock. Cath got closer and saw it was sport – it was always sport, cricket, a blue sunny day from the other side of the world. The men noticed her and conferred. She turned back to the bar and ordered a large G and T. The girl who served her was a little suspicious; it was too early for solitary women. Cath met her stare and sat on a bar stool, knowing four pairs of male eyes were scanning her legs and wondering if.

The gin hit home quickly, making her stomach lurch in memory of the pills. She was abusing it again but ordered another double. By the time she drank it she'd be pissed. She could hardly believe she was doing this. She looked at the bar menu, the usual microwaved stuff dressed up in fancy descriptions. No, eating alone would be too much.

A man came to the bar alongside her, one of the TV watchers. He was hopeful, tallish, late twenties, dullish blond hair, denim blue eyes, a bit overweight but not too bad. He watched her sideways as he ordered two more pints. Despite his youth there was a crumpled air about him. This was a man trying to sell something people didn't want.

Quiet here, tonight, Cath said.

He started, almost came to attention, not quite believing his luck. In the bar mirror she saw his friend watching them, the new messiah abandoned.

Yes, he mumbled, though I haven't been here before.

He had a home-countyish accent, Essex moved further south; and he wanted to stay, wanted to play, infantile fantasies reared up instantly in his little-man head.

Your friend is getting anxious, she murmured. She knew he hated his friend at this moment and wanted him out of the way.

Uh, do you want to join us?

It's said men think of sex every few minutes and Cath wondered if it was true. Yes, of course it was, it's what they ran on. This one wasn't wearing a wedding ring. She chuckled inside

at this observation from Clare, from her parents' world, and wondered if this was the life her mother would have liked to lead.

Yes, alright, she said.

This is Bob, Man One said, I'm Richard.

Hi, I'm Gemma.

Are you staying here?

Yes, just tonight.

Same as us.

She saw two briefcases on a spare chair, a finance company logo embossed on the leather.

There was a moment's silence. Her initial foray was over, now she must plan further manoeuvres. Cath was enjoying herself. Man One was in pole position, the privilege of first contact. She imagined them circling each other, pawing the dirt, wild-eyed with lust and ready to lock horns. Man Two was small, dark, somewhat ferret-like, the runt of the pack. He'd have no chance. She'd forgotten their names already, she'd forgotten hers. Man Two noticed how quickly she was drinking, and his hopes soared. He offered another as soon as her glass was drained, almost running to the bar.

Man One ran Two down as soon as he left the table, a prelude to his banishment to his room, where he'd seeth with jealousy before phoning his wife. Rob's face flashed into view, freeze-framed for a long moment. She didn't want him there, but ten years would not be so easy to wash away. She wondered what he'd think, Cath picking up the type of man he'd always hated.

For a mad moment she thought of taking Man One back to the flat, which would be a crazy kind of exorcism indeed. He was waiting for an answer to a question she hadn't heard him ask, so she just smiled and went to the loo. On a whim she phoned Rob on her mobile. After many rings his voice answered, and she let it ask who it was a few times before she turned the phone off. She was quite drunk now and her face glistened back at her from the mirror. Sweat filmed her makeup; she looked like a drunken tart on the pull. A few minutes ago she felt her speech thicken, and had to concentrate on walking steadily, with the studied effort that always gives drunks away.

When she got back to the bar Man Two was gone. She bet that had been a spiteful little exchange. The place had filled up a bit

but she knew she was the only woman worth looking at, and all the boys agreed. She couldn't quite remember getting to Man One's room. He kept asking about precautions, and the smell of the curry he'd eaten escaped from his pores. But she was in control. Even drunk, it was easy to play with his notions of manhood, to let him think what a hunk he was to have pulled someone like her. How he'd show off with Man Two, living off the glory in his places of work, until his boss started yelling about targets and she became a diminishing memory.

She was using this man. She could hear Rob saying she was trying to be like him, trying to act like a man, raising his voice, as if this would give his chauvinism profundity. Buffoon talk that he'd perfected, that so many men had perfected – all, if her experience was anything to go by.

Man One was finished. Yes, she knew he would – ask how good he was. He probably wanted her to leave him now but she was too drunk to move, and she needed to see him in the morning anyway, a few minutes of humiliation mixed with triumph wouldn't go amiss. She closed her eyes as he started to snore.

It was morning. Cath stared at Man One. He had a lot of birthmarks, fine-haired skin peppered with russet spots. They looked like atolls on his pinky-white body. The foundation of another belly was forming. Too many hotel meals. He slept with an arm over her, which made her think of the flipper of a walrus, guarding its harem on a frozen beach, a vast body of brainless flesh. She slipped out of bed quietly and used the shower. It was early and he didn't wake. He'd want to grab every minute of sleep, before trying to grab her again.

Cath imagined Man One's day. The dash to see clients, to find clients, a toothy smile welded to his face, getting sweaty, shirt-collar chafing, tugging at his tie with each disappointment – and his day would have many. Then the report back to head office, his stomach churned by bile if it had not gone well, laced with a snatched drink and junk food, and all the time the threat of failure stalking him. He was one of the new breed, 'freed' by technology. Cath thought of her own day, and her job, and didn't feel superior. She felt empathy: Man One was in the same boat as her, and each of them was rowing furiously.

Rob entered her mind again, she had to resign herself to this.

Maybe after ten years he'd earned some right to be there. Rob derided Mammon-led types like Man One. She remembered their last argument about it. Tell me another way, she said, and he was silent for a moment, the great Rob Silence, when she was prepared for a thought. She knew it would be about himself.

I want to paint something, he said, that sums the entire fucking thing up, that encapsulates the lousy mess of the world, like the way Guernica said everything about war, yes, a huge canvas, big enough to cover the wall of a museum, bigger. Rob's voice kept her company throughout the shower, an unsilent witness to everything she did.

Cath dressed, and had a much smaller hangover than she had expected. Man One's wallet was on the table and she took a peek, most un-Cath like. She saw a photograph of a woman holding a baby in her arms and on the back read *Nicola and Ryan, aged six months*. She thought of taking a £20 note, which might give this episode some meaning. Man One sighed, stretched out into the empty space beside him. For the life of her she couldn't remember his name.

Cath left quietly, running the gauntlet of leering cleaners and morning staff. She wondered if any of them watched her back to her flat and if they thought she was working the bay. Pre-pills, such a thought would have horrified her, now she shrugged it off. It was not important.

The shower wasn't enough so she ran a bath. Man One would be joined to Man Two by now, wolfing down plates of grease, and wondering where the hell she'd gone. He'd be a lion rampant, a glorious start to his day that might last until mid-morning. She saw his heaving, sweating body one last time, and his grunted words of encouragement, and started to laugh. It was either that or cry.

•

Maybe I'm going mad, maybe I'm already there: I'm beginning to detest Cath. This is twisted logic on my part, but I can't help it. I don't want anyone else to have her. Images of her in bed with another man force their way into my brain, but it's one movie I don't want to see, so I keep slotting in a montage of our decade

together. My mind's a devious bastard, it accumulates the good times until they slyly join together into something akin to happiness. I wallow in the nostalgic myth of Cath and Rob.

I bet Cath's acting quite differently, blocking out the good bits. There's no way back now, not after the pills. The unifying qualities of trauma, tragedy and loss are greatly exaggerated – in the main what they blow apart stays apart. I should try to feel we are both off the hook and think of moving forward, but I can't. Moving forward would be a first anyway. Cath has taken herself from me, deprived me of her, just as surely as if the pills had done their job.

Something is starting to stalk me inside, crushing out reason. I feel its presence behind my eyes, an insistent, malevolent throb. As I scan my unwanted canvases its scans with me. It's laughing at me. Everything is in turmoil as I feel Nemesis stir. I last sold a painting six months ago, one I forced on Tom. It was a rough landscape I'd hurried, bored with it by the time the colours were mixed. Tom liked it: it captured the savagery of the hills, he said. Yes, Tom, yes, two hundred quid, thanks very much. He hung it over the fireplace, much to his mother's disgust. Maybe he thought a Crossman original might be an investment. I was surprised Tom had the nerve to buy the painting, such was his mother's disdain of it, and me. She didn't understand what I was doing back in the area, or how I lived, and she obviously thought I was a bad influence on her Tom. But it's hard to imagine his life any more sterile. This was a sexually inactive middle-aged mammy's-boy virgin, bleating on the hillside. I can still feel shame, and a small flush of it raises a hand in recognition of my cruel streak, no, not a streak, a tidal wave of attitude, spreading everywhere.

It's time to go down to the village. I'll walk, and get blown about by the wind in the hope that it will cleanse. It's a bitter start to the year, but dry, with faint sunlight hinting at its presence behind cloud, and the hills standing out proud against the skyline, sharper than I could ever paint them. I see Tom in the field alongside the lane, and duck down behind the hedge. His hale-hearty but always slightly desperate voice would be too much today. It takes twenty minutes to walk to the village, eighteen minutes longer than in my car, and the cold is into me very quickly – it always is, I lack natural padding. Halfway down I'm

regretting my decision. I'm out of condition and concentrate on the pitfalls of the lane like an old man. Passing forty did not mean much to me at the time. Perhaps it should have.

The village is two-dozen houses, with a garage and shop which doubles as an off license. This is my target – the pub is shut and boarded-up now. The shop is from another age, trying to hang onto comfortable old ways against the shock of the new. It's far enough away from supermarkets to be just viable, and opens on a part-time basis – the whole village operates on a part-time basis.

I grew up within miles of here but a world away in lifestyle. My upbringing was full of the bustle of huddled people, smoking industry, and a past that was dying on its feet. But at least it was going out with some vigour. This place looks as if it has never lived. As always, the woman behind the counter scowls at me, the weird interloper. In her consistency she's a good match for Tom's mother; if I could find one more I'd buy them a cauldron. Her teenage daughter is in today. She's pretty but it's the kind of vacuous beauty that dissipates on closer inspection, and when she speaks it goes completely. Her mother ushers her to the rear room when I enter. I love it, it makes me feel like a lecherous eighteenth-century squire on the prowl, and I wouldn't mind being one; sexual responsibility could be dispensed of with a few guineas. I'd be a cad, a good old word, euphemistic antecedent of cunt. Mother is triumphant when she serves me the whisky: her picture of me is complete.

On the way back I'm lost in my thoughts. They're all about me. I'm still able, just about, to look back over twenty years of adulthood without reddening at all the faux pas, miserable tricks, trails of lies, bullshit and dreaming that make up Rob Crossman. I have a flashback to adolescence, my Sartre period, when, like his Matthieu, I fell through the old trapdoor of freedom. So seductive, and so difficult to land on your feet on the other side.

It's another half mile to the cottage, and my lungs are being vacuumed clean by the wind. This is the longest I've been in the elements in an age. Cath liked walking, I preferred to think about it. Tom appears alongside a hedge and there's no escape this time. One of the collies is with him. We glare at each other and it bares its teeth, making Tom laugh.

The dogs have never taken to you, he says, they probably think you are a sheep rustler.

Better than a shagger, I say.

Been down to the village? Tom asks.

No, I've beamed up to another galaxy, where farmers are kept in zoos. I nod and adjust my coat discreetly, so that the bulge of the bottle is obscured.

I smell rain, Tom says.

Yeah, maybe.

Tom's finishing up his day and he wants to asks me over for dinner, I know the signs. Once last year was enough but I'm running out of excuses. Tom lives in the rarified, viperish air of matriarchal society and that word *cad* almost appeared on his mother's forehead when I was introduced. And *wifeless* cad made *double* cad. She probed me incessantly, much to Tom's glee. I was someone to deflect her fire.

Can't stop, Tom, I say, I'm in the middle of a painting. Just stepped out to clear my head.

I stomp along the lane before he has time to plead, the bottle bumping against my groin. I'm tasting it already.

Tom's forecast doesn't look accurate as the sun goes down, slicing the reddening sky with its last rays. The cottage is etched sharply against the backlight, and looks quite imposing, fringed by spindly, leafless birch and a few chestnuts, the haunt of crows that scratch away at the silence with their ugly rasping cawing. This place exudes loneliness. Orwell could have coughed up the last of his guts here, just as well as on his Scottish island. But at least there's a welcoming trail of smoke from the chimney. I've banked up the fire to warm me in my drinking, now I must remember to eat something.

•

Rob hadn't phoned or appeared. Cath was surprised, but also relieved. For once he'd got it right, maybe this time it was final and they could both get on with their lives.

She was getting back into work. Hers was a busy office, and she was one of the oldest there now. Most of her colleagues were under thirty, but already looking over their shoulders at new

recruits. Cath had a talent for web design, something that irked Rob, increasingly so as his sales dried up. He was a reasonably good artist, but his work reflected his life, it had no consistency, and little depth, but he had achieved good things, in the rare times when he was able to free himself up and use his talent without any bullshit. She had one of his best in the flat, a simple portrait of Padraig which was not really simple at all, the more she looked at it. Her uncle's quiet strength was there but also something at the edge – a frisson of alarm, hidden panic in the grey eyes, a plea maybe – which Rob had captured, as if he knew what Padraig's end would be.

Rob always tried to demand that people like him and buy his paintings. In recent years that demand had fallen on stony ground. Cath wasn't sure how he was going to manage financially. She'd paid for most things in the last few years. It started with the occasional sub, then bills were left on the table. She dealt with them – initially out of a still-smouldering hope, later as a kind of pay-off. It had increased the feeling that their relationship was coming to an end.

She'd had a two week break (the office thought it was a winter virus) and she'd had her hair done, darkening the red. But she hadn't cut it, not yet. She was looking good, better than she had for an age. That night at the hotel finished off what the pills started, a catharsis for the new Cath. She wasn't ashamed of it but it wouldn't happen again. For Man One she'd scribbled down a phone number, a random grouping. She wondered whose confused voice might be at the other end. He'll haunt that hotel for months, she thought.

It was strange not having Rob in the flat; he'd often been there when she got back from work. She'd see the battered Ford outside, grin at the appaled glances of neighbours who looked as if they thought its rust might somehow infect their cars. She'd steel herself as she turned the key, knowing that he'd expect her to make food for him, and that she would.

Cath was learning not to confuse solitude with loneliness. Rob had spouted on about being bred to be a loner countless times, but she thought she'd do better at it. Work was easier to bear because she knew she had freedom when she got home. She savoured her newfound idleness, just being Cath Galbraith, from

the western edge of Ireland, retaking possession of herself, or at least beginning the process.

Rob continued where her mother had left off: she'd been a possession changing hands. When Rob came to Ireland with her a lot of things fell into place for him. He was able to see the environment that had shaped her, all the inadequacies of her upbringing; her family paraded them so proudly. Her father still saw silence as strength, the Galbraith men could out stiff-upper lip any Englishman, when sober. Rob learnt how much she needed someone like him.

She'd had a rare letter from Martha today, a strange coincidence, in the light of recent events. For a moment she thought Rob had spilled the beans – what a mess that would be – but Martha wrote as if she did so frequently, wishing Cath well for the new millennium, and saying a few things about the weather. Cath wrote a few lines back. All is quiet here, she said, and yes, Rob was fine.

Cath was asked to join some of the younger girls for a night out and she decided to go, to see more of the city she was living in. Incredibly, she seemed the most upbeat in the office. The others were all still suffering from the anticlimax of the celebrations, some wanting in or out of relationships. Now Cath was seen as cool, on top of her job, with an apartment in the bay and an artist and weekend musician for a partner.

So she was out with the girls, a new development rather than a revival of past antics. She'd led a quiet life before Rob, attracted by the big city but also submerged by it. Now she was about to become a thirty-something clubber, but suspected she was in better shape than the other girls. They had it all to go through, the pursuit of happiness and the partner who seemed such an obligatory part of it. She'd take a leaf out of Rob's book, at least in looking inward, but with a view to exorcising devils. Rob tended to feed his.

She was in the Charlatan Club, which was more a mind-opener than an eye-opener, blasting out unfamiliar music at stupendous volume. Melanie and Julie dragged her in excitedly. They were all fuelled-up on cheap booze. Inside, the girls shouted in her ear but meaning was lost amongst the thud of the music. Sound bounced off the walls, forcing people onto the

dance floor. Only the most primitive kind of communication was possible or necessary amidst this distortion of limbs, bumping, grinding, slapping together. The club was packed and from the edges it seemed like one seething animal repeatedly trying to thrust its way out of a trap.

C'mon, Julie shouted, let's get some action.

Her eyes were too bright. They flickered in her face like jewels, swirling around with hundreds of others. All the frustration of her job was pouring out of her; to party was compensation. Cath tried to join in but couldn't lose her self-consciousness. She was too old for this. A kid who didn't look as if he'd ever shaved appeared, his hair a gel-sculpture, his tee-shirt another skin. Was he dancing with her? It was hard to tell. She did her best for ten minutes and was exhausted. It was time to retreat into the cramped sitting area, to push her way past slumped figures, and the staring faces of E-driven youngsters. She hoped the girls didn't find her too quickly. At least dancing-boy didn't follow; she didn't want Man One replaced by Boy One.

Smoke invaded her, soaked into every pore, mixing with the heat and noise. She was being assaulted by this bloody place. She heard Rob saying *told you so, told you so, what are you trying to prove, Cath?*

She was found; the girls descended on the table, giggling, holding onto each other, their cigarettes glowing weapons in their hands. They shared the one chair available and tried to engage her in drunken gibberish when there was a ten-second lull in the music. Then they played an old soul tune and the animal slowed down and hugged itself, two hundred bodies smooching around the floor. Cath waited until the girls got up again, then slipped away, winked at by black doormen the size of houses. It was a rude exit, but necessary. She'd tell them she wasn't well. Her short career as a clubber was over.

For the first time post-pills she felt the flat was too empty. This new life would need work. Despite the cold, she stepped onto the small concrete space the developers had described as a balcony. The bay was black under a starless sky tinged orange by city-lights. It was very quiet, but her ears still rang with the echoes of bass and drums, her own band playing inside her head.

•

I'm broke; nothing new, but now there's no Cath to bail me out. This morning I selected ten paintings to sell. They're a disparate bunch; I've lost any purpose I might once have had. Serene landscapes are now fractured by Crossman's slash-and-burn technique. I seem to be painting *The Scream* over local vistas, manically attacking the canvas as frustration mounts, and I'm losing touch with old business-contacts. People who once exhibited me no longer take my calls.

The sax is kept on its stand in the cottage, for company and encouragement. I stopped fantasising about Parker and Pepper years ago, but at least the sax got me Cath. We met in my *jazz-rock* era; a mishmash of words for a mishmash of music, the weaker elements of both forms combining to create pretentious trash: phony music in ridiculous clothes; presenting Crossman in mustard-coloured flares, tower-block platforms and big hair. Perfect.

I pick up my weapon – my axe – and blow a few forlorn lines. Not too bad, I always had decent tone. The sax's gold finish is tarnished in places, the valves stick and, like its owner, it needs an overhaul. But it's a good piece. Some of Tom's sheep are close to the cottage so I open a window and honk a few lines at them. These are creatures of good taste for they shy away at first, then return to the good grass near my fence and ignore me. I sit by the open window, enjoying the cold on my fingers and the heat of the fire at my back, and work my way through a few old tunes, pleased that I can remember the melodies. Old tunes are the only tunes for me these days. I'm lost in the playing, but it's a comfortable lost, a nostalgia where everything makes sense and has its place. If only my life could be controlled so sweetly.

•

Cath was hungover. She couldn't shake off the Charlatan Club, its odour wrapped itself around her head, which still throbbed to the hellish beat. She must be stupid, or desperate, to get in this state so soon post-pills.

Strange, after all the threatened ends with Rob, now that the real thing was here she didn't know what to do. Her mood was changing, getting real; Cath felt she was teetering on the edge of

a void. She had no friends of her own age – no real friends at all. Julie and Melanie were probably glad she had disappeared – she was old enough to cramp their style. Rob had taken a decade of development from her.

God, how appealing self-pity is, Cath thought, if you let it take you over. I can understand now how it destroyed so many of my family: they've festered in it, turned it into an art form. Give it time, Cath, don't get bitter. If you don't get through this, Man One might have the last laugh after all.

Give it time, don't get bitter. Cath mouthed this to herself as she ate breakfast: a pot of coffee to fight the hangover, toast that tasted like sawdust. It was early Saturday morning, the weekend barely begun, but already time was dragging. She played with the channels on the radio, and scanned a newspaper for things to do. Rob had so many interests, but he did his best to crush any of hers, shooting them down with his bullets of cynicism. This morning Brave New Cath was an illusion, the result of a phony pep-talk she had given herself in the wake of Rob's departure.

In the bay, people were messing about in small two-man sailing boats; young couples and a few fathers and sons braved the elements. Strange that as soon as she was alone she noticed people in twos. She was couple-hunting: a stream of them passed by on the concourse below, sharing Saturday leisure time, flaunting their togetherness. I must snap out of this, Cath thought, Rob's the wallower, not me, and what was so different really? How many weekends did I wait on him, wondering what time he'd turn up, if he turned up at all. At least we haven't had to split up a place, or tear a child apart.

A young boy chased his father excitedly. They were wearing matching red anoraks, splashes of colour in the grey morning. As she watched them Cath felt like the old women of her youth, sitting out on hard wooden chairs in the summer, gazing sharply at passers-by. She came away from the window and stalked around the flat, bored, not even dressed yet.

The phone rang. It was Rob. They were both surprised, and waited for the other to start. She beat him to it.

Thought you'd be in touch sooner, she said, knowing he'd tried.

I wanted to give you some space.

Lie number one. Rob's capable of one with every phrase.

Uh huh.

She didn't know what to say but *he* would, if she let him get started. It would be the usual stuff: that they should think again, they'd been through too much to let it all go – all the agony aunt platitudes he used when pressurised. But nothing would change, years would roll by, until she was forty-something, childless and thoroughly Rob-conditioned; kept in line by his subtle and pervasive allusions to her pill-popping – and the fact that he'd saved her. No, not this time, Rob.

Have you been alright? Rob asked.

Uh huh.

Back in work?

Yes, of course, there's nothing wrong with me.

I thought you might want to take a little time after...

No, I don't.

So you're busy?

Everyone's making up for lost time. The office is jumping.

It was a strange conversation, even by their standards. What was unsaid shadowed their words. She should put an end to it now, a final declaration. But she let it ride, this much of Rob has rubbed off on her. The conversation petered out because she allowed him no way in. She thanked him for phoning, and hung up, quite abruptly, feeling like she'd got rid of a salesman.

There was a great temptation not to get dressed, to jack in the job, stay in bed and drift with her thoughts. Become a female Proust. She smiled at the thought that she might have some creative talent. That would finish Rob. The lethargy that gripped her had nothing to do with her night out – that was just a confirmation of it. When Rob's paintings stopped selling he went through a similar phase. Weeks lying around, castigating the world from his couch, not shaving, until the grey outposts in his beard frightened him. That was when she moved into the cottage. Of course, Rob wouldn't consider looking for a new place together, and only his name remained on the deeds.

For Christsake, Cath, will you stop evaluating everything with Rob in mind? That's all your last decade has been, a bloody Rob-zone. Especially the first eight years. She tried to create positive thoughts. She had managed to move on a little when she bought

the flat, and Rob hated her getting it even though they were driving each other crazy in the cottage. Maybe he sensed it was the start of the break-up, a second getaway for her; first a flight from home, from people she had never felt close to, and now from someone she'd idolised, and idealised. For her, Rob had been the perfect ten: romantic, innovative, unconventional, full of zest – the antidote for a lonely, colourless upbringing. She'd been hopelessly wrong, and had been paying the price ever since.

Rob the perfect ten – down to three now, and falling. She'd expected him to be all things to her, but that was her problem. She wondered if every artist in the world was so dominated by self as Rob. He was offered a job teaching once and recoiled from it as if bitten. A prostitution of my art, he wailed, whilst bemoaning the money his refusal was costing him. Avoiding real work was the one thing Rob had worked hard at.

She should at least get dressed, go shopping, go for a drive, do something. She had a few minutes in front of the mirror and saw that she was beginning to wear. Rob-lines had crept stealthily into her face, but she knew she could still turn heads. She had proved that with Man One.

The car was taking her to Rob's valley. She couldn't help it; she was out of the city before she knew it. It wasn't planned. A compulsion had seized her as soon as she started the engine, and soon she was on the narrow top-road which linked valley to valley above Rob's cottage. It was a bright day, but the colour of the sky was confused: greys, reds, oranges were smudged together, the weather as undecided as she was. The night had been frosty here and pockets of ice glinted from folds in the hillside.

The cottage was directly below her now, a faint line of smoke trailing from its chimney. Rob was in front of the house, opening the bonnet of his car and looking into it. She saw him shake his head as he muttered to himself. He didn't look up and went back into the cottage, a can in his hand. She drove off before he re-appeared and almost ran into a farmer. He was driving in the middle of the road, on one of those quad things. Christ, it was Tom, Rob's neighbour. She couldn't get past him.

If there was an award for cheesy grins Tom would win it hands down. He displayed a prime example as he stopped his vehicle. His dogs jumped down and yapped around the car. Tom

followed them and, reluctantly, Cath pressed the window button.

I thought it was you, Cath. Going down to Rob's, are you? Why did you come this way?

I fancied the view.

That's why you almost ran into me, was it?

She smiled an apology.

Look, there's Rob, pottering about the cottage.

Tom pointed down the hillside and she prayed it was too far for him to shout down. He didn't attempt it and was oblivious to her agitation. Mollie, one of the collies, put her paws on the window and tried to lick her face.

Funny they like you and not Rob, Tom says.

This was the first time she'd ever talked to the man alone. Tom had hopeless bachelor written all over him. None of his clothes quite fitted; he was twenty years out of date, at least. A large man, built for carrying sheep and bales of hay, Tom was a few years older than Rob, but his face seemed well sorted by a life outdoors. His eyes were a startling blue, she'd not noticed how startling until now. They seemed at odds with his general demeanour, which was willing, friendly, decent and not too bright. The eyes were alert, full of vigour, but quite cold. They looked at her as if trapped, as if she was their salvation. She liked the way they looked at her; Rob's shady customers darted everywhere.

What was she thinking? Surely she wasn't attracted to bumbling Tom, the butt of so much of Rob's humour. That would be rebound-fever. She realised how much she'd looked at people through Rob's eyes, how he'd influenced her. Tom looked as if he'd missed out on a lot of life but she didn't think any conflicting forces warred beneath his surface. He was steady, nice; and *nice* was attractive right now: a nothing word for something she needed. She fondled Mollie's head whilst Barney, the other collie, snuffled around the car and barked out his jealousy. She wondered if Tom was a virgin. Quite possibly. She couldn't see him disappearing to the city for a quick fumble in a massage parlour. While Tom was talking away about his flock, Rob had gone back into the cottage. She was in a difficult situation. Tom would expect her to drive down to the cottage – he might even follow her down. He had taken Mollie's place, his hands clasped as he leant on the window. They were solid, weathered hands,

and she bet they'd like a fondle too.

I'm going to drive on to the village, said Cath, to buy a few things.

Maybe Tom wouldn't mention this to Rob. It might give him a reason to turn up at the flat. Tom was reluctant to let her go, so she started the car whilst he was talking. He got back onto the quad and drove it up onto the muddy verge, waving her on.

See you then, she shouted

It's your own fault, Cath, she told herself, spies deserve to be found out. She drove down to the carriageway to the city. Nothing had been gained or calmed, and she shook slightly as she drove.

•

I hear Tom working in the fields above. His quad sounds like a mechanical drill when he's on rough ground. He's gunning the motor, climbing higher, chasing sheep around. I'm driving to London tomorrow, and have actually checked the car: water, oil and tyres – the limit of my expertise. I'm chasing diminishing contacts; Crossman canvases will be going cheap, if at all. I've themed a group of paintings: hill-country landscapes full of bold, splashing colour and chunky form, all distinctly average, broody mediocrity posing as something more worthwhile. I have a sour, chewed cardboard taste in my mouth when I look at them; they chart my decline.

Cath gave me a hefty book on Picasso for Christmas. It was his endgame stuff, full of pricks and tits, as the last of his vision burnt itself out. I'm not sure if he was a sensual genius or brain-blasted dirty old man. I don't really care; he went out with vigour, and style, that's what counts. My success vanished as quickly as it arrived, before I had time to adjust to it. Ah, I recognise the mood I'm slipping into, the violin's out and being polished, waiting for the sob stories to start.

Here's one. The bank is getting insistent, very insistent. They sent someone around this morning. You haven't replied to our letters, Mr. Crossman, said a kid in a suit, fingering his tie nervously and thinking of all the tales he'd heard of country folk and their dogs. I kept my tongue on a leash and waffled; I even

offered him tea and smiled at his vigorous refusal. He gave me a final final deadline to start paying up, and informed me that my bank cards had been cancelled. I've been here before and have been baled out before, by Cath. This time I have to sell something; the only other option is work – a day job, any job – what other people do. I can look back on a life of dodged schooling and even dismissal from art college. That was quite a feat in those days. Not many people managed to be denied such a tolerant refuge – in my time they were homes for work-shy dreamers and would-be rock stars.

I have enough cash to fuel the Ford. I'll sleep in the back, if I can make room. I'm taking as much stuff as I can. My main hope is Andrew Selborne, someone I knew in college. Realising his painting was rubbish, he got into dealing and worked up to his own gallery. He's helped me before – he was keen to in my good years – but I'm not telling him I'm coming up, in case he goes missing. I'll try to brow-beat him into taking the work and advancing me some dosh – the sort of ritualised begging that Dylan Thomas specialised in, provincial hack on the slide seeks quick fix from city-slicker. Perhaps Andy will let me stay in his Chelsea pad, depending on who he's with. In our college days he was a closet gay, terrified of his father – until the old man died and Andrew outed himself. Then he played at rampant predator, before fear of Aids stopped him. He's another unhappy bunny with too much money. Nonetheless I envy his wealth. Ah, but he's worked for it, Rob, grafted from the time he hung up his brush.

There's enough food in the freezer for one good meal and I find a bottle of claret I didn't know I had. I use it to wash down mis-matched, tired vegetables and frozen plastic chicken. I evaluate my domain. The cottage has a faded look these days. It's not just my mood, I've done little to it over the years. Cath brightened it up when she was here but, like its owner, it has reverted to type. The place dates from the 1880s, when windows were small, rooms were small and people were small. It was built to keep nature out rather than invite it in. Not much natural light gets through, but there's an extension at the back which I've converted into a studio, putting glass panels in the roof to catch what light there is. It has good acoustics and sometimes I blow the sax whilst working, driving the brush on with the music, each

art flowing with or against the other. When the painting was good the notes were clean and sweet and drew me into fantasy. I was the white genius with black in his veins: Lester Young, Parker, Art Pepper, plus something else, something edgy and indefinable, something Crossman. These adolescent dreams stuck around for a long time. When I lost purpose, the sax wouldn't co-operate, the notes became fractured, weak and formless, as stale as the meal I've just eaten.

The bank's letter has spawned others. Water, electricity, phone; bills pile up, little red bullies stacked neatly on the kitchen table. I've always been orderly with forms so I can ignore them *en masse*. Their predecessors have gone on the fire: these are the last warnings before cut-off and court. At least the Inland Revenue can be easily sorted – I've earned fuck all this last year, not that they'll ever believe that; guilty until proven innocent is their approach. They've been on my case for years, unwilling to believe someone can live on my income – and maybe jealous that anyone can.

The claret has soothed. Warmth seeps in to flush my face and I'm slipping into fuck-it mode. The canvases are ready to go; I look at them more kindly for a moment. One is of the valley. I think I've captured its twisting contours, and the damp greyness that can suddenly be shot through with Turner-esque light, shafts changing the place in an instant, searching out colours on the hillsides. My best sale was a canvas like this. Selborne phoned, forgetting to be cool for a moment, and told me it had gone for three grand. This sparked off a minor run for me, and more followed. I got so carried away I agreed to Cath moving in. I've barely sold a canvas since. When the money ran out she kept me; the only money since has came from the odd paying gig with old contacts – teachers, doctors, plumbers, people wiser than me, who have taken care of business first, dreams later. I used to like hearing them tell me what a nice lifestyle I had.

This day has drifted away. It's dark now. I've never had much of a handle on time – you need a routine for that. My days pass in frenetic work or extreme sloth, there has never been much middle ground. I decide to pack the canvases into the car tonight. I don't want to see them in the morning; they have become burdensome to me.

It's a crisp night, with good visibility under a thin lip of a moon. Tom's farmhouse is just visible through the trees that fringe his place. Yellow light sprays from a window – it's a welcoming yellow; the light of other people usually is. I'm surprised Tom hasn't cracked: no partner, no sex, a domineering mother, and a business that decreases yearly must be a good recipe for madness.

I finish loading the canvases and, on a whim, walk to the edge of his farm buildings, about half a mile up the hill. Then I go nearer. I'm not sure what's drawing me but I'm close enough to see into the kitchen window. Tom is there, sat by the range, dogs at his feet. There's no sign of Mam. I feel like a Victorian waif, clocking warmth and pies in a world that refuses me entry. Perhaps that's what comes of having such a thin family background. I never really knew the old man, he'd gone before I finished junior school – to a new world with a new woman. I'm not sure if he's even alive now. My sister, who died in infancy, was just a thing in a pram to me. My mother never seemed really alive herself after that. It's getting harder to see her clearly. Her image is like it was in life: a fading presence. She was always ill, long spells of inattentiveness punctuated by attempts to smother me. If she had died a year earlier I would have been at the mercy of the state. There's an uncle somewhere, but I haven't seen him for twenty years. That's it, the shabby Crossman dynasty. I was on my own from the age of sixteen. They say it's the first seven years of life that shape you forever. If so, nothing I've done since is a surprise.

Tom's dogs spring up and start barking and I fade back into the darkness. The icy air is invigorating but I know it's fooling me; this place isn't clean at all, just empty.

•

Cath felt she was settling down a little. Already routine had become comforting. She worked hard all day, came home shattered, sank into a bath and attempted to read a book, invariably falling asleep before she turned the first page. The joys of modern living: blink and you miss it. It seemed a short time ago she was in school, dreaming of crossing the water. London was

her Mecca. Her science teacher, Mr. Muldoon, a man marooned on Comprehensive Island, but desperate to embrace the changing times, enthused about the coming computer age, how it would liberate. What a joke. She was one of its slaves.

Today she went to a telephone call-centre, one of her company's clients. She felt like an extra in Lang's *Metropolis*. The place was light and airy but that was misleading. Hundreds of people sat in cubicles, human battery hens all squawking down phone lines, punching computer keys; a cacophony of *how may I help you*s in the air. Invigilating cockerels prowled the aisles, wanting to justify their extra pound an hour. A manager proudly showed her around and she caught the envious glances of the hens. Suddenly she felt conscious of her expensive business suit.

We want our portfolio to reflect all this, the manager said, waving a patronising hand. Something snazzy, immediate, but tasteful.

Of course, always tasteful. It was an important commission for Cath, a major website, so she acted appropriately, spouting well-groomed professional bullshit to which the man was perfectly attuned. He was pleased with her, she was good at her job and easy on the eye. He subconsciously fingered his wedding ring. Stop dreaming, she almost told him, accept what you've got. He had an afternoon smell: old aftershave, new body-odour, and his eyes were full of tiredness. Each battery-hen sat clucking as her eggs were checked. Cath was glad to be out of there. Mr Muldoon would be proud of her, quiet Cath at the cutting-edge of a new age.

She still had time for music, she made time, and it was the one thing she really did have in common with Rob, though her tastes were not his. He required edge at all times, quirky stuff, the more obscure the better. Now that he was gone she could chill-out in peace, without the need for justification. Her music went well with water. She was listening to Preisner, a composer she had recently discovered. She played him on the portable CD player she kept in the bathroom. His *Requiem For a Friend*, sombre, dark, overbearing in places, but exquisitely beautiful in others. Music to float with, to soar with, to cry to. She knew it well now, each shift of mood, every nuance, counterpoint, and climax. There were choral sections she couldn't understand a word of,

but this made it better, increased the mystery, allowing her to give the music any meaning she wanted. Preisner was her friend – and one she was in control of.

No wonder Rob was so lazy; it had a lot going for it. When she was in Preisner mode she was tempted to let everything go, to kick against the work ethic so imbued in her. When Rob had urged her to join him in his sloth, she worried she'd go for it in a way that would impoverish them both. She'd learnt how to snooze in the bath, letting the water cocoon and sooth. In Rob's absence, Cath sought a sense of oneness with herself. Only the music was allowed in.

The next day a software salesman called into the office to see Cath. As he went through his pitch she began to think of him as Man Two. She was starting to look at them as objects, things to desire, fuck, then loath; she was starting to look at the world with man-eyes. He was good-looking, thirtyish, tall, and confident enough to believe in what he sold. As it was nearing lunchtime she asked him to join her. Melanie was close enough to hear and she stifled a giggle. Cath would be seen as a predator soon, or even a tart, acting like a man for a short time was enough for any woman to achieve this.

Alistair was cooler than the hotel reps. She smelt bachelor-hood, and lots of success. He chewed her invitation over, in a way he thought might give him an edge, looked at his watch, then casually accepted. There was a trace of Ulster in his accent, but it had almost been swamped by London. Hers was still very much Irish. She took him to the Deli round the corner, an import from New York, where you could gorge on oversized sandwiches. Alistair chose a large slice of animal in a torpedo roll; she picked at a salad, which seemed to discomfort him. Nothing was going to happen, not this time, but she liked the contact, it was part of her rehabilitation. Alistair was still trying to close the sale and she strung him along for a while. The office needed what he was selling and she'd made up her mind to buy before they left. A piece of beef fell from Alistair's roll. He put it in his mouth and washed it down with coffee.

Watching your figure? Alistair said, flicking a hand towards the salad. Not that you need to, of course.

She smiled and finished her orange juice.

When did you leave Ireland? she asked.

He almost flinched.

I didn't think I had any of the accent left, he murmured. Ten years ago. I came over from Armagh and stayed.

Brought up close to the troubles, then?

Sure, right in the middle of them.

He didn't want the conversation to go this way at all.

I'm from Clare, on the coast near Doolin.

I've never been south.

He said this with a touch of agitation. His mind was closing, for him this was the dread past, back there, back then. She wondered what he might have seen as a boy, what he might have taken part in. Cath had never discussed her fractured country with anyone over here, not even Rob. As with Alistair, it had been shunted to the back of the mind. She had different reasons and a different past, and she knew talking about it changed nothing, but it was abandonment just the same. Cath had let her past be swamped by enthusiastic exile – and by Rob – but it was resurfacing now, with a vengeance. Alistair was going though his watch routine again.

She told him he'd got a sale. His smile switched itself back on. He was lifted now: sales multiplied in his head and commission spiralled.

Shall we get back, she said, you'll want me to sign things.

As they left the Deli, Cath saw him. She didn't quite believe it at first. Rob was across the street, the bonnet of his car up, steam escaping from the radiator. He was in his own personal cloud, stopped in a bus lane and being honked by a line of them. A policeman strolled down from the corner. Her first instinct was to burst out laughing but she controlled it and wondered if he'd changed those balding tyres. Rob looked across the street, directly at her. A smile began to form on his face but it froze as he realised she was with Alistair. She'd seen this Rob face many times before, when he was drinking, and not selling anything: it was the face of the last two years, the one that wanted to own and to blame; but something else was in it now. Rob looked evil: his eyes glared, even at forty feet. The traffic warden and cop arrived in tandem and Rob had to deal with them. Alistair followed her eyes.

Look at that heap, he said. Cars like that shouldn't be on the

road. I bet it's not taxed.

He put his arm on her shoulder to steer her through the crowd. She resisted the temptation to shake it off. She imagined Rob shouting but it was just an old echo in her head.

•

We drilled each other with our eyes. Cheap phrases are getting the upper hand and this is one I can't shake. Cath is across the road with a suit, a tall suit of about thirty. He's got an arm on her. I know she sees me, though she turns away quickly. I think about darting across the street, forcing traffic to hit me or halt, brake or swerve, being struck and landing bloodied at Cath's feet. I imagine her startled face fading from view.

She would have to see me like this, the bastard car terminally ill in the heart of the city. That trip to London was a trip too far. On the way back I booted it, ignoring the protesting gauges. It limped the last twenty miles home and today it limped down from the hills, to fuck up here, in front of Cath. Someone's just told me the engine's seized. Ah, perfect, here comes a young pig. Even his walk is a sneer, a juvenile size twelve strut. I'm confident the *what's all this then* routine of a hundred old films will follow.

Cath's gone, guided away by mystery man. If she's found someone else I'll be finito. I'm burning up, screaming inside. The cop is talking to me. What, causing an obstruction? But it's broken down. He starts to look round the car, at the balding tyres and out-of-date road tax and his face lights up. But I'm not paying much attention, I'm still staring at the place where Cath was. The cop thinks I'm taking the piss. Are you listening to me, sir? Yes, officer, yes. I'm done for one dangerous tyre and no tax, but the cop phones for help for the car. He's quite friendly, now that he's made his kill. I'm asked to produce papers I'm not sure I've got.

Until I saw her, Cath wasn't on my mind, for once. I was trawling a few canvases around local galleries in a last gasp attempt to sell one. The kid-cop looks at them eagerly when he spies them in the back seat, but there's no old masters, just old Crossmans.

Artist, are you, sir?

He says it as if everything is explained. My car, my state, my role in the world. Repair man is here again and I'm towed away. At the garage a greasy youth scratches his head, tut tuts, and looks at the Ford with hatred. He's young and it's old.

This will cost a bomb, this will, he says. Do you think it's worth doing?

Of course it isn't, but I tell him I'll get back to them later. I leave before he can object to the car on his forecourt. I have no intention of retrieving it, or its contents. I'm doing well today, following the washout of London. I got hold of Selborne but he was as twattish as ever; this time he didn't even bother with the bullshit – I'm too unfashionable for that. It was just a would-if-I-could dismissal. Failure is a disease and Selborne didn't want to catch it. He suggested a few names but I know he was relieved to see me go. After seething for a time, I accepted the situation and almost felt glad. Bridges were crumbling in front of me, but at least that meant I didn't have to bother trying to cross them anymore.

My headache starts up again. It's been a constant companion recently. Malignant torpedoes of pain behind each eye try to blast their way out; I feel a nerve or vein or some-fucking-thing throbbing at the side of my head. Tap tap, tap tap, like a finger probing. Anyone in, any blind alleys left to go down? And in my pocket I'm grasping all my worldly wealth, £26 and change.

Getting back to the cottage is an effort. Like most people in the country I am a slave to the car. Without it, I have to catch a train, then bus, then walk a mile. Cath and mystery man dog every yard. My headache stokes up nicely on the journey, throbbing as one with the train, bumping with the bus, striding with me to the cottage. As the drifting rain pats at my face I wonder what the mechanics will think of the paintings. Maybe they'll take them home to their wives and put them up over their gas fires. Maybe not.

Tom is messing about on his quad. *Tom-Money-Loan.* As the thought comes to me the vein in my head stops throbbing. Jesus, an answer cometh; yes, just a grand to tide me over. I look at the dead embers of my fire and put the police summons on top of the pile of bills on the table. It has pride of place.

I am pain-free next morning and it's easy to get out of bed. I don't feel the cold and my mouth doesn't taste like shit. I wake with my idea. *Tom-Money-Loan.* Yes, yes, yes. I'm a man with a plan.

•

Cath decided to go home, take a long weekend in Clare. It would be a way of announcing she was single again, that Rob was gone. She'd lost more weight in the new year, and was back to her fighting best, five five and nine stone. She liked her sleeker look; a latent vanity coursed through her; she changed her hair, and began wearing more black. Rob had always expected her to look like some kind of earth mother, while remaining quite sly about his own vanity.

She phoned home on Saturday. How's Rob? was the first thing her mother asked, so she told her they were over, quite bluntly. Martha seemed to take it as a minor bereavement. Cath felt her instantly take Rob's side. What have you done to him? was implied in her questions. Years ago, she would have been more forthright but there was caution in her now; age was slowing her up. Maybe she thought more of the inevitable end, and of her inexorable move towards it. Her thoughts were settling on loss, on what her life might have been. Cath made the arrangements and hung up, knowing that Martha would think she was running away.

A week later Cath was on home soil, unaccompanied by Rob for the first time in ten years. She drove her small car from Rosslare cross country, taking her time, viewing the bleak mid-winter heart of Ireland and wondering at the roads that changed from good to rough in a matter of miles. She had soon had enough of the tranquillity. As she headed west the land took on a kind of timelessness, but she didn't find it restful, she never had. Ireland was on the up now, confidently embracing Europe and its new technologies, and turning its face firmly away from Britain, but when she got to Clare not much was changed. There were more places catering for tourists, but it was still a de-populated land. Their farm was between Moher and Doolin on the Clare coast, amidst a windswept, treeless, exposed landscape, mapped

out by limestone walls, and facing the Atlantic.

It had been drizzling all day but the sky cleared and the sun revealed itself as she pulled into the car park near the Moher cliffs. Martha was expecting her but Cath was nervous, she needed to collect herself before seeing her mother. The multiple coaches and their camera-happy occupants were missing; there were just a few cars, and no-one to take the money.

Late afternoon on a fine day was the best time to see the cliffs, which could be featureless in shadow. Today sunlight struck them and hundreds of feet of layered age unfurled, a breathtaking display of which she never tired. The cliffs performed for her now: yellow, red and grey patterns etched in the stone, welcoming her back. She walked briskly along the cliff path, letting the wind scour her clean of cities and ferries, of suicides, hospitals, hotel men, and Rob. The coin-in-the-slot telescopes were all out of order and Cath began to feel at home. If she was honest there was still a small piece of pride working somewhere within her, her version of roots. Where she was from was still part of her, and this time there was no running commentary from Rob, on what Ireland was, on what she was. Cath suddenly realised she was free of him and it was exhilarating. This thought soared with the birds that launched themselves from cliff ledges to the sea, white specks against shifting blue. Billions of people crowded the earth but she was here in this magnificent landscape on her own, and it told her that she was important because she was part of it, she counted. Cath knew she could move on, her feet were not glued down with spite like Rob's. Everything here was fresh for her, and spoke of renewal. Gulls flew close to her head as they checked her out for food, but they would have to wait until spring for people to return. In the winter they learnt to be fishermen again, learnt to do it right.

Martha was in the garden, despite the crisp air and the dropping temperature. Cath knew she'd heard her but Martha didn't turn around until she was out of the car and almost touching her. She thought of reaching out a hand but kept it by her side.

You're here, then, Martha said. Is that your car?

Yes.

It's new.

They appraised each other. Martha was looking older, there

were dark smudges around the eyes, and a coarsening complexion which could not be disguised in daylight. There was an unfamiliar, brittle pain in her bright eyes, yet they still looked through her in the same old way. The distance between them flared now, as Cath stood in front of her with her small weekend case.

You're looking well, Martha said. Considering.

She knew she should reciprocate but couldn't find the words. Her feeling of freshness on the Moher cliffs was immediately challenged here, shafted by the past. And Martha was the past now, Cath couldn't see her any other way.

The garden's looking nice, Cath managed to say, after a long moment of silence. Lots of new plants.

You have to pick the right ones, to withstand the wind and the salt. A man comes in to do most of it.

Martha turned and Cath followed her thin shoulders into the house, fighting down the urge to think this was a mistake.

The vast rooms of her childhood had been cut down to size. Once, it had seemed a long way from wall to wall, now they enclosed her with their neat angles. Nothing much had been done to the place in ten years and she recognised most of the furniture, in the usual positions. This was a house of little movement and even less change.

The last of the sun hit the strip of sea visible from the window, and for a moment this silver band brightened the room, highlighting the ageing in Martha's face. She must be so alone here, Cath thought, not without tenderness; they had something in common at last. Cath's loss was recent and raw, Martha's had lasted for decades.

Come through to the kitchen, Martha said. I wasn't sure when you would arrive but I've prepared some tea.

Cath's father looked down on the kitchen table, a framed photograph, taken when he was in his twenties. She was surprised it was still up. It was a confident, handsome face, full of vitality – not like Cath remembered him at all.

She was finding this difficult. The silence became intense and neither of them knew how to break it. Martha had prepared cold meat and salad. She should know by now that I don't eat meat, Cath thought. And the salad was out of season. Cath poked some

of it around with a fork, trying not to make any noise. Old habits died hard.

Aren't you hungry, Martha said, after driving all this way?

I stopped for something.

It was for coffee only. She should be starving but the house and the atmosphere within had taken her appetite away. Yet there was a different kind of hunger in her, and to sate it she'd have to go back thirty years and start again. She'd make this a happy house; the woman sitting opposite her would be a happy woman, a mother who wanted her.

So, what happened with you and Rob? Martha asked.

Cath wasn't surprised the question came so soon. She'd prepared a speech and got into it quickly, before she dried up. She told Martha how they'd begun to drift apart, taking care not to denigrate Rob too much, but she was soon floundering under Martha's intent gaze. She didn't think she'd ever had such attention from her before. Cheers, Rob.

Were there other women? Martha asked.

Not that I know of.

Martha's eyebrows raised.

Was he violent, then?

Only with his tongue. It's just that he became impossible to live with. Everything had to revolve around him and he sucked all the life out of me. I think he thought it was his to take.

Cath was not reaching her; for all her cynicism Martha had very little experience of men, unless she'd started lately.

What's he doing now? Martha asked.

Still in that cottage of his, I suppose.

They took coffee into the living room. Cath was glad to be out of the kitchen. She'd always hated that cold, stone-slabbed place of teenage drudgery. In comparison, the living room was quite agreeable, the lightest in a gloomy house, somewhere she'd slink into when no-one was about. It faced south-west to trap the sun, looking out onto the big Atlantic sky. They were on the edge of a bay here, and from the living room it was possible to see up the coast into the next. This was Cath's special place, her personal and solitary play area. She'd go to this modest curve of sandy beach whenever she could get away from the house. It was untouched by visitors, and not much used by other local chil-

dren. Here, on rare days of freedom, her dreams were given full reign, she brought them to life free of the cloying atmosphere of the Galbraith household. As she grew older she acted out scenes from favourite books and films, her mind transforming her modest beach into the sandy giants of *Ryan's Daughter*. Padraig caught her doing this once. He'd never been to the cinema but feigned interest for her sake. Cath had seen that film recently on television: it was overblown and fanciful, just as her young mind had been.

You always wanted to be out of this house, Martha said, following her stare, messing about on your own on that beach.

Didn't have much chance though, did I?

Martha shrugged.

There was always work to do on a farm. It was the way of things.

I'm close to having a row with her, Cath thought. That's pathetic, it'll just build up the wall between us. I'm cold, almost shivering; this is a bloody cold house in every way, and I don't know what I'm doing back in it.

•

Tom is working his sheep. They are his main source of income. The dogs are herding them towards another field in an arrow of grey wool. There's confusion as they bottleneck at a gate, a few try to bolt but are chased back. Noisy sheep, dogs and a shouting Tom compete with a strong wind which smacks me in the face and pushes the last of a hangover out of me.

Tom's wearing a duffelcoat, probably one of the last in existence. He has the hood over his head, which makes him look monk-like, a mediaeval figure working in an age-old landscape. He doesn't hear me as I come up on his blind side and touch his shoulder.

Good Lord, Rob, you gave me a start.

Tom shouts more orders to the dogs, who, in their exasperation, snap at each other and eye my ankles. The last of the sheep finally pass through the gate and I push it shut with a flourish. Tom grins at me.

Getting the country spirit, are you, Rob?

I fight down a smart answer. I want something, so I must tread softly, a mid-course between obsequiousness and gruff man-in-need talk. But how do I flatter someone like Tom? Congratulate his dress sense, his fascinating lifestyle, his questing mind? His way with women? He's close to me, his weathered face thrust into mine. Tom has no idea about personal space because I don't think he has any of his own.

Well, that's it for this afternoon, Tom says. Want to come back for a brew?

I've timed it well, late afternoon, with the light fading and Tom in need of company.

Yes, sure, get some of this cold out of our bones.

We trudge to the farmhouse, a squat stone building further up the hill. It has always seemed grim to me, built to survive its environment rather than blend with it, a bigger version of my cottage. Lights flicker through its fringe of trees as I prepare to sweet-talk Tom's mother; it will be a challenge, but a necessary price to pay. The dogs run on ahead, their day's toil at an end. They anticipate food and heat, and I wish I bloody did.

Stay for tea if you want, Tom says, as if reading my mind.

It's a large kitchen, not much changed in forty years. Old-fashioned cooking range, old-fashioned everything, complete with old-fashioned mother who glares at me. She knows this is odd, me being here at this time. You're up to something, her glare says. I offer up my best smile.

Something smells good, I say.

Tom's tea.

I've asked Rob to join us, Mam, Tom says, there's always plenty.

The dogs flop in front of the fire and wait for food, their eyes catching the glow of the coals. They too are suspicious of me.

I'll just wash some of the farm off me and I'll be with you, Tom says.

Better sit there, Mam says, pointing to the gnarled wooden table.

I do so meekly.

I hope I'm not putting you out, Mrs Pearson.

She shrugs.

Selling any paintings? she asks.

There's a kind of triumphant slyness in the question.

Can't complain.

Don't look like you're selling any.

Mam and I have one thing in common. Money. A fascination with it, a love and hatred for it, all merged into the need to have. For all her rustic air, she's tuned into the stuff and will be very up-to-date about grants, schemes and whatever else farmers like Tom are entitled to. His accountant, manager and agent rolled into one. She turns away and busies herself on the far side of the kitchen. Perhaps I should have collared Tom in the field, now I have to separate him from this crone.

God, I'm hungry. I've been living on stuff reminiscent of my student days. This morning I exchanged a good canvas for a modest bag of groceries in the village shop, that one with the scowling proprietress and teenage daughter. Bartering is a solid way of going about things, I try to tell myself; it's not a defeat, it's not begging, and the woman wasn't laughing at me.

If Tom doesn't oblige I'll have to consider the real world at last and sign on in town, half a day's journey without a car. The Ford is still at that garage, unless they've scrapped it for a few quid.

Tom comes in, wiping his hands on a towel, and the dogs jump up to fuss him.

Mmm, lamb stew, just the ticket for a day like this. Hope you're hungry, Rob.

I smile as Mam plonks a plate in front of me, hard enough to flick spots of liquid onto my jacket. I broaden the smile. Tom likes me being here, thinks this might be a precedent, a confirmation of our friendship. His mother worries about the same thing. She doesn't join us.

She always eats before I finish work, Tom murmurs.

This surprises me; I'd have thought mealtimes would be perfect for Tom to report back to her, until I see how he eats. He dispenses with all cutlery but an oversized spoon, with which he scoops stew from dish to mouth with slurping precision. Tuck in, is the only thing he says. Mam can cook and her portions are more generous than her nature. We both have second helpings and I feel warmer than I have in weeks. I gesture to a pile of envelopes on the dresser close by.

You're popular, I say.

Aye, with the tax man, vat man, ministry man, and all the rest of them. Running a farm is complicated now, isn't it, Mam?

A grunt of assent comes from the other side of the room, followed by two mugs of tea.

Let's sit by the fire, Tom says, getting up and pushing the dogs out of their place.

Tom is pleased by my presence. I'm company, someone to define his day, make a success of it. He's making me a true friend in his head. Ah, a bit of luck, Mam is leaving the room.

Going to check on the hens, she mutters.

Mam is a woman of few words. I wonder about Tom's father.

Haven't seen Cath around for a while, Tom says.

Here's my chance. Right, assume the position, play the role. Start. I look down into my mug.

No, I murmur.

Is she away, then?

Well, away from me. We're not seeing each other at the moment.

Tom is quite startled, and I can gauge his loneliness by it.

Good God, I'm sorry to hear that. Can I do anything?

I look on this lump of a man, raw-boned, red-cheeked, smelling of his work and beginning to steam in front of the fire, and shame almost makes me jump ship. Almost.

There's been lots of problems, I say, but the main one is money, I'm broke, Tom, absolutely skint. I had to get rid of the car the other day and the paintings are not selling very well. I'm in danger of losing the house, losing everything...

I let my words trail off for effect and direct my stare from mug to fire.

Good Lord, Tom mutters. But you were doing so well, up in London and all that, I remember seeing it in the paper.

That was years ago, things change. Look, I'm sorry, Tom, I didn't mean to come out with it, the way things are in farming these days you've got more than enough problems of your own. I'll get off. Thank your mother for the meal.

A large hand is placed on my shoulder,

You'll do no such thing. I'll make us more tea.

So far so good, the flicker of an idea is in Tom's mind and I'll turn it into a flaming cause. Take as long as you like with the hens, Mam.

•

Cath was walking with her mother. She'd wanted some fresh air and Martha came with her, something that had never happened before. She'd spent the night in the narrow bed of her old room, the room at the back of the house which looked out onto sodden green ground and the limestone heads of exposed rocks. Sea-views were reserved for adults. Like the rest of the house the room was unchanged. The plywood table with oak veneer was still there, a place for homework and sometimes illicit reading, during moments snatched from the tasks of the farm. Her name was still on it: *Cath,* in small straggly letters. Carving it had been one of her small rebellions, now it looked more like a plea.

The sunlight of yesterday afternoon had continued; it was another rare fine day in mid-winter, the palest of skies lit by a matching sun as they walked to the beach, Cath's beach.

You spent a lot of time down here when you were little, Martha said.

Yes.

Cath waited for her to add: on your own, but Martha walked on ahead of her with surprising vigour.

There were small, untenanted islands in the bay. They stood out sharply in the morning light, small green undulations in the sea, miniature versions of the mainland, serrated with ancient stoneworks, evidence of the mystics, priests and fugitives of many ages who took refuge on them.

God knows how they lived over there, Martha said following her daughter's eyes. It was bad enough here.

The world's always been full of people running away. It was as far as they could go; next stop would be to fall off the edge of the world.

Is that what you're doing, Cath, running away?

Cath had tried to connect with Rob for ten years, and with her mother for two decades before that. Was it her? Something unlovable in her, that made her easy to use or dismiss? She was standing on a shore with a woman she'd never known and it was time to know why.

Lost in them, aren't you, Martha said, smiling, and for once

the smile didn't seem fixed. We have that in common, at least.

What?

Dreaming.

Where did you meet Dad?

The question surprised both of them. In the house Cath wasn't sure she wanted a conversation with Martha, for she'd had no experience of it. Martha's face was full of need, eager, as if Cath had only now appeared for her; as if that insignificant girl who had inhabited the house for eighteen years had suddenly taken on form and substance, even becoming interesting.

I should know instantly, shouldn't I? said Martha. But I have to think. Yes, he was sitting on a tractor, which was a rare machine then, a few miles down the coast. I can't remember what I was doing there, but I wasn't interested in him at all. He started coming round to your grandfather's place, presenting himself, offering help. And Dad liked him, which made it harder for me. Your father managed to talk a bit then, he wasn't quite the silent man you knew, and he was solid. He had an air of permanence, of someone who will always be there for you. That's what got me in the end. It beat out my dreams, any ideas I had of taking a chance somewhere else. I was tied to the farm, with Dad practically crippled with arthritis. This place was as unchanging as the islands over there. John was the best bet I had.

What about love?

We had something, but I'm not sure I'd call it love, and your brother was on the way. That was a very big deal then, and meant marriage for sure. Haven't you ever worked out the dates?

No, Cath hadn't and she suddenly felt quite stupid. Her brother Eamonn, gone as quickly as he could, farming with his in-laws in the next village.

Is this why Martha had ignored her? Was it disappointment – or blame even, the realisation that her daughter was another link in the chain she had tethered herself with? Her mother had never said so much to her. Cath felt a pang of longing for the past she might have had, with a maternal presence to soften the harshness of the land. She almost linked hands with her mother but couldn't quite bring herself to do it. So much had changed lately that she needed to take stock. She wondered if Martha shared her sense of loss; a few days ago she wouldn't have thought it possible but now

was not not sure. She walked as close to Martha as she dared. Gulls considered them as they wheeled overhead. The sun picked out all her favourite spots. She began to feel easier with herself, and easier about being here. Fresh again.

•

I'm almost there, leading Tom like a bull to the slaughterhouse. I've given him a few minutes on need, friendship, told him that I might lose the cottage, that Cath is beside herself with worry over my plight. It all strikes home. Figures are flitting through my mind: five grand – no, that's too much, but then again, what the fuck does Tom need money for? What does he spend it on? No, scale it down – two, maybe three. I settle on two and a half. *And a half* sounds better, there's a feeling of hope in the arithmetic.

I've pitched my voice just right: there's manliness in it, but with a hint of desperation, to make Tom feel responsible for my future, his charity vital to my survival. I want him to feel good about what he is going to do.

I need a few thousand, Tom, two and a half, just to get back on my feet. I'll be able to pay it back soon, there's someone in London who wants as much as I can paint in the spring, but by then it'll be too late. I just don't know where else to turn, Cath hasn't got a bean after buying that flat.

Now, stand up, grip the edge of the mantlepiece so that your knuckles show white; turn your face away from him and keep it humble. Uriah Heep, eat your rotten heart out.

Can't you borrow, Tom says, on the strength of the cottage, or future sales?

That's not the right answer, Tom, just give me the fucking money.

I've tried everywhere, nothing doing, especially for an artist. I'd never mention this to you if I wasn't desperate... it's humiliating.

This much is true. My face is close to his now, and I'm so near the fire I'm starting to roast, but I'm not moving until I get a yes. I can see his lips starting to form the words. He wants to do it, he's going to do it. Come on, Tom, you magnificent, munificent bastard.

What are you two doing over there? You're almost in the fire.

His mother's back, I didn't hear her come in. The spell is broken and Tom moves away, guiltily. I'm not going to get the money, my every fibre tells me, screams it at me. The crone stands there, a quizzical, suspicious look on her face. I feel sick.

Uh, we'll discuss this again, Tom mutters.

What's that? Mam asks.

Just talking about Rob's painting.

Oh, that. I thought it was something important.

I want to smash her, to feed her limb by bloody limb to the fire. Tom's hand is on my shoulder.

Are you alright, Rob? You're swaying a bit. Come and sit down.

He leads me to the table and this time I'm not acting, it feels like my heart is about to rip through my chest. There's no pain, but an overwhelming sense of suffocation. Everything is collapsing inside. I ache for Cath, for the stability she provided, for her food, her money – especially her money. But yearning is followed by hatred.

Tom is handing me something, another mug of tea. He must think of it as an elixir, a solution to every problem. His scowling mother hovers close, disdain on her gaunt face. She knows there's something up. I gulp down the tea, the mug shaking in my hands.

I think you're having a panic attack, Tom whispers. Just sit there quietly for a minute.

A last vestige of hope flares up again, that he might stuff a cheque in my pocket as I go out, that this middle-aged oaf will finally stand up to his mother. But no, it's not going to happen. I leave as soon as I can, managing to mumble thanks to the crone, telling Tom not to worry, almost floating out of the farmhouse, so taut are my nerves. Even the dogs leave me alone.

I can't resist a look back at that yellow light again, but this time it's mocking me, sending me down the hill to my desolate unlit house. It's still drizzling but a few stars are visible, cold pricks of light – shining down on another cold prick. What am I going to do now, go under? I'm not sure if I'm talking out loud or not but I feel an urge to talk to something or someone inside me. Anything to relieve the pressure.

I stumble on the rough path, falling against a hedge. Wet

branches catch my face and knock me to the ground and as I struggle up I taste salty blood on my lips. A perfect end to the evening, Rob. I can hear a voice inside telling me all this is richly deserved. *What did you expect, Rob? You're a loser, you've always been a loser.* The voice has always been there but now it's not so deeply hidden. I know it's gaining strength every day.

In the cottage I stare at a wild version of myself in the mirror. A branch end has punctured a cheek with a neat, penny-sized wound, which has bled into my collar. My eyes stare back at me from a haggard face, supporting my unkempt, electrified mop of hair, and my clothes are sodden. I'm still vain enough to be shocked. Cath used to tease me about my vanity and I wonder if it has always been so obvious to others. She was the only one I liked enough to feel any concern about my deficiencies; she showed up my faults for what they were, for what they are.

Christ, it's cold in here – there are only warm ashes in the grate – but I can't be bothered to do anything about it. I look out into the night; vague shapes of Tom's flock are visible in the gloom. One sheep coughs, uncannily like a man, and the sound makes me feel very alone. I look for spare change in a drawer and find some of Cath's discarded clothes instead. A fragrance she used fills the room; I'm holding a blouse like a bereaved mother, smelling a past that seems so much sweeter now than it ever was.

I see Cath as she was ten years ago: innocent, with an open heart – perfect grist for Crossman's mill. A blaze of auburn hair, exquisite skin, emerald eyes from the Emerald Isle; coming my way. I giggle out loud at my nonsense and I wonder if I'm beginning to lose it, control slipping away.

The scent from Cath's blouse stays with me, light and fresh and at odds with what's forming at the edge of my consciousness, a bitter intimation of something evil. I crash out on the bed with blood still smeared on my face, unable to fight back tears of self-pity.

●

Cath's brother, Eamonn, dropped in to see her. The Galbraiths were playing at being a family. Cath wondered at the change in Martha, who seemed glad to have her back in the house. She was

even beginning to fuss around her, taking an interest in her clothes, asking about her work. Cath thought Martha's ability to raise any positive emotions in her had long-since withered on the vine, but she found she was beginning to respond to this new woman. She no longer wanted to cut her out, and Cath even thought it might be possible to salvage something, at least the semblance of a relationship. All this after just one night in Clare; it didn't make sense – but when had families ever done that?

You'd hardly recognise Padraig's cottage now, Eamonn said, since the Mulligans moved in.

They've enough children to fill the place, Martha said.

Aye, I'm not sure Padraig would like that. He was a strange old bugger.

Cath was about to defend her uncle but Martha beat her to it.

No, not strange. Padraig was a dreamer, he should have got away, to Dublin maybe, had some education, done something more creative.

Like your Rob, eh, Cath? Eamonn said.

He reddened at his mistake.

Eamonn, Cath doesn't want to talk about that.

So now Rob was a *that* – and this from a woman who once idolised him.

It's alright, Cath said, I don't mind.

Small talk ensued. Cath listened as Eamonn described his kids, proudly charting their progress, assuming she was interested, as all parents do. Eamonn was a large man, his thickening frame perfect for working the land, a man of unchanging, solid ways who had never been further than Galway. She was doing it again, still influenced by Rob's easy judgements and quick dismissals. Eamonn was steady not stolid and reminded her of a more worldly Tom Pearson. He had everything he wanted here and had no reason to leave or run away. She felt a touch of envy; things had changed since she visited a few years ago, showing off her man and watching proudly as they lapped him up.

Martha wasn't saying much. She sat in an armchair and smiled at them, like the proud mother she had never been. The chair enveloped her figure, which was still trim and shapely, a miracle worthy of Papal blessing here. Most of the farm wives were heavy through childbearing and work by the time they were thirty.

Eamonn left and they settled down for the night. Cath opened the bottle of wine she'd brought, wondering what relationship Martha had with drink now. Remembering the sherry-impregnated air of the living-room of her childhood, Cath had expected her mother to be well advanced down that road by now, but Martha had shown no sign of it since her arrival. She took a few sips from her glass and put it down.

Do you want the TV on? Martha asked.

Not really. Do you watch much?

More than I used to. I find myself looking at it out of habit these days. It's company.

Cath found it hard to imagine Martha being lonely. Her memories were of a woman in charge of herself, not needing anyone, looking forward to her children flying the nest, someone who might welcome the solitude she now had. But Cath sensed a need in her which she hadn't been aware of before. Since leaving Ireland she hadn't been back without Rob in tow; now she was alone and Martha was alone and they had eighteen years of failed communication to contend with.

Cath wondered if she'd have been sucked in by someone like Rob if Martha had been more of a mother. When she met him she was desperate for affection. Another few years and the rift between mother and daughter would have been complete. Now Martha as mother might be back on the agenda. Cath trod carefully as she had drunk most of the wine.

Did you ever really want children? she asked.

The question was blunt and spilled out more aggressively than she intended. Martha was startled; she no longer seemed remote and powerful.

You think I was a poor mother?

You were never there for me.

No.

Cath couldn't believe she agreed so readily. Her head was ablaze with the wine and a lifetime's thoughts. She wanted to shout, scream her old frustrations at Martha; she wanted them to start all over again; she wanted to storm out of the house and never come back; she wanted to hug her and be a daughter. She wanted it all and was trembling. She couldn't help it, a slight tremor that made her put down her wine glass.

Martha played with her own drink.

I started drinking after your father died. Sometimes I was soused when you came home from school. Did you know that? It got worse when you left home, then I stopped, quite suddenly, on New Year's Day, a resolution I've managed to keep. It was bad at first but I got through it. That sip I just had was the first since then. Not bad, for an alcoholic.

Was it because Dad died so young?

Partly. A farm's a bad place to be for a woman on her own, especially if she never wanted to farm in the first place. I felt the trap I had set for myself shutting tighter.

Yes, but what about Eamonn and me, weren't we worth some effort? I had to find out everything for myself. I was no way ready for Rob. He was *my* trap.

For a moment she thought Martha was about to cry; that would set the seal on this strange evening. She didn't, but was closer to emotion than Cath had ever seen her. And Cath too began to feel her eyes moistening. She dabbed at them as discreetly as possible. Things were moving too fast here, as if mother and daughter were seeking instant closure on all those barren years.

I've been very selfish, Martha said quietly. And your father encouraged it. He worshipped me. I liked it at first, it was a kind of compensation, but it became stale very quickly. By the time you were born it had started to grate, it became part of the trap, the glue that stuck it all together. The more I turned in on myself the more unhappy I became. I should have shaken it off when I brought you and Eamonn into my world, but I didn't have the character – how would Padraig have put it? – the *moral fibre*. I stuck at what I knew: being selfish, feeling sorry for myself, and that's when the drinking started. Not much of a track record for a mother, is it?

They were silent for a time. Cath didn't want to say much more now, she did not trust her tongue. She thought finishing with Rob was a watershed but this was just as big, perhaps bigger. Two massive changes which might define the rest of her life.

Cath was ready to turn in but her mother wanted to continue. She was going for it tonight; a last chance to establish something

between them. It could never make up for the past, and any connection might always be frail and vulnerable to breakdown, but Cath was glad Martha was making an attempt.

I liked him, you know, Martha says.

Who?

Rob, especially at first. He was a charmer.

Martha gestured towards the painting over the fire, its colours made warm and satisfying by the glow from the flames.

But I knew him from the first, too, she continued. I knew there was no warmth there, and not much substance under that flashy surface. Selfish recognises selfish, Cath, and Rob was even more self-centred than me. Perhaps that was why I liked him, he diminished my own failings. There was no room for anyone else in his head, I knew that. I bet he told you artists had to be like that.

He did.

Is it really over?

Yes, for me. I think he'd start it all again, if he had the chance. Living must be uncomfortable for him now, and he'll be struggling for money.

He'll blame you for that – he'll blame the whole world and his brother. He'll burn with this but he'll come out of it and find someone else.

I'm not so sure, he's not getting any younger.

He'll always land on his feet, that one, I'm telling you.

Would you have liked a man like Rob?

Martha laughed and her eyes sparkled for a moment.

Of course, for a while. Someone like that gives you free rein to behave as you want, for you can never hurt them. They do the hurting, that's why they always latch onto people like you. You take after your father and uncle, thank God. Don't let Rob change you, there's nothing wrong with the way you are.

If this was a compliment, it was the first one Martha had ever given her. Martha got up to tend the fire and returned to stand over her chair. Cath felt her hand on her shoulder, a light squeeze, then a touch of her hair.

Such beautiful hair, Martha murmured, like my mother's. I'm going up, now. The fire will take care of itself.

Cath was left looking into the flames, which revived, flickering amongst the peat before dying away again.

At breakfast they were both a little awkward. Martha had cooked the eggs Eamonn had brought round but she did not eat with Cath.

I had mine earlier, she said. Getting up at the crack is one habit I can't break. Do you have to go today?

I have to be back at work Monday morning. I'll take the night ferry back.

You won't have much sleep.

I'll catch up.

Cath decided it was best not to reiterate anything. They'd made a start, something which wasn't in her mind at all a day ago.

Do you want to come for another walk? she asked.

No, not really, you go. Get some of that wine out your system.

Martha was right, she was slightly hungover but the headache was soon blown away by the Atlantic wind. She drove down the coast, parked the car, and walked along the headland. In summer the place teemed with tourists, people entranced by Celtic myths, heading for the islands, drinking in the countless pubs; Americans looking for their roots and talking of Irish freedom-fighters, lapping up music she'd always thought slightly phony. But this was Clare's lifeline now, and the locals did blarney well.

It was another fine day, the sun just warm enough to counter-act the wind. She looked down towards the Moher cliffs and the perennial gulls scattered amongst them, no more than moving dots at this range.

A couple passed by – English, in their mid-twenties – arms linked. They bade her hello but were engrossed in each other. I'm not envious, Cath thought, and it was a good thought, she felt lighter and more at ease with herself than she had at any time since she'd played on her childhood beach all those years ago. Her life was moving forward. She felt the soft blue sky and green sea existed just for her. The freshness she'd felt yesterday was all around her, she luxuriated in it. The trip had been a success. You're gone, Rob. Forever.

•

It's ten o'clock on a Monday morning and I've already had an unwelcome visit. The electricity people came to shut me off: one to do the deed, another for support. The meter is now secured by a metal clip. I'm warned about trying to tamper with it. Not that I'd know how. As a man alone, with no kids, I have no come-back, it's pay up or ship out, but I've got nothing to pay up with and nowhere to ship-out to. They're young but there's an air of superiority about them – I'm broke and they're not.

I'm looking at the sax. I could get maybe four hundred for it – enough to live for a few months in present spartan conditions. It's either the sax or the DSS and I haven't been on their books for years, not since Cath came along. It's all changed with that lot anyway, even I'd be hard pushed to blag money with no work. Work, a job – these words keep coming up. For me, it would be something dire; repetitive toil in a factory, under inane radio-attack at all times; watching the clock five minutes into my first shift; the job allotted to me with relish by some hapless minion. I'll sell the sax.

I've toasted the last of the bread, all that's left in the cupboard is an assortment of tins. My thoughts drift back to last night, to the warmth of Tom's kitchen and the food in it, the soaring expectation of that visit, then its downfall. I can't be bothered to try him again; it's a surprise to me, but I find I still have a modicum of pride left. I also have a key to Cath's flat; I had mine copied before she reclaimed it. I turn it over in my hands, wondering if it will be useful – no, not if, *when*.

I'm starting to sift through the Crossman-Galbraith history. My past was something I hastened away from, but now I'm getting absorbed in it. It's becoming easier to think back than forward.

I was on top of things when I met Cath. The painting was going well, doors were opening, and the saxophone was a good back up. I enjoyed my fellow-artists being pissed off that I could do something else. Some of them could hardly walk and talk at the same time, so absorbed were they in their work. I'm tempted to dismiss them all as clowns but I'm one of them, hanging on by his fingertips and doing worse than anyone. When Cath came into my life I was working like a maniac, turning out all that stuff that Selborne would eventually sell. Cath looked good, a head-

turner. I didn't think much further than that, at first. No woman had ever stayed around for long but Cath stuck. Life was no longer clear; she wanted what I was least able to provide: care, commitment, love. There'd been an absence of these things in her childhood as well as mine but this common ground was never fertile for us. Cath sucked my resolve away and her steady earnings became a trap.

I'm starting to simmer, the way I did as a kid when my mother failed to produce a replacement father for me. I had my card marked at school for being different. Two parent families were the norm then. I came to hate the difference, then nurture it with equally destructive fervour. I desperately wanted to be involved in the affairs of my peers, but always made sure I wasn't. In my teens I read what I thought was right for someone like me – any writer who might support the character I was creating for myself: Rousseau, Thoreau, Nietzsche, Sartre, Kerouac, seductive loners who supported my life with their words. Music, though, was the fuel that propelled me forward. I chose the same types here: loser geniuses, smack heads, the forgotten or unknown of the music world, or people discovered after they'd snuffed it. And the artists, what abundant ground there was for me here. Van Gogh: world champion, all-time-number-one ear-slashing loser; Gaugin the syphilitic rainbow-chaser; Bosch with a million demons in his head. My fellows, the inhabitants of worlds into which I was inexorably drawn. And Cath had to try to fit into all this, with the blind enthusiasm of first love. I should be burning with shame inside, for the theft of ten years of her life. But it's anger I feel. It flared up when I saw her in the city, an inner conflagration looking for an outlet.

I can recognise defects but can't change them – there's never been enough will. Ah, the Rob show is on again, in my private cinema, flashing across the screen of my brain with stunning clarity. Crossman emasculated by twisted feelings, living up to his name and dominated by self. There used to be room for Cath and the odd friend to keep my selfishness in check, or at least to remind me of it's immensity. Not now.

I'm at the end of my garden, where it merges with the rough turf of the hillside, marked off by a haphazard fence. The sun's going down and I'm foraging for stuff for the fire, a very old

activity for the new millennium. I've burnt an assortment of things in the last week, even coal which I found in the outhouse. I don't remember buying it so it must have been there for years, a discoloured and mildewed plastic sack stashed amongst assorted junk. I can just remember the cloth hundredweight sacks my mother had delivered, in the days when Coal was King. I can't resist mouthing this slogan. It was true only a few decades ago. Not that I was ever much interested in the associated culture or communities. I was away as soon as possible, and when I came back I chose a solitary cottage miles away from the valley villages.

I take the last of the coal back to the house to bank up the fire. My life is becoming bizarre: I'm sitting here gazing at a spluttering smoking ancient fuel like a derelict entranced by its glow. I have the right look: three-day-old stubble, unkempt hair, and unwashed body – all I need is a bottle of Thunderbird. The stubble is spattered with grey; I'm under age-attack, first hair and now beard.

I scour the house for booze – finding the coal makes me think there might be other stuff around I'm unaware of – but I don't strike lucky twice; Bleak House is dry. Yet despite the lack of drink I feel like I'm pissed: I'm light-headed and drifting with my thoughts – one half of me warmed by the fire, the other feeling the chill in the far reaches of the room. I've got the sax on my lap with just the fire to illuminate it, but it's enough to make the instrument gleam as I give it a polish. I attach the mouthpiece and play a few figures, old stuff that is so far away from what's going down now I wonder if I've become the old fart I derided in my youth, hanging onto what's safe, shunning innovation, and telling myself the incoherent mix they call music now is just babble.

I'm sinking into *what if* syndrome – it's becoming one of my favourite states. I wonder what might have happened if I'd gone into music fulltime; would it have spiralled upwards for a time before subsiding so quickly I couldn't be sure if it had happened at all? Like the painting.

The light's going and it's time for the candles. I've gleaned an assortment of these from all over the house; Cath was always keen on them. With the coal I also found an oil lamp, but have

no fuel for it. Now I'm really slipping back in time: coal, candles – if I knew anything about the countryside I'd trap game and complete the rusticity. Two tins of tuna have to suffice for a meal.

Another utility company chases me the next morning. A man stands at the front door, his suit obscured by his warm anorak, just about managing to look uncomfortable, but not guilty. I have until the end of the week to pay my water bill. Not having water would be too much to bear. The sax will have to go. I've just enough change to get down to the city tomorrow to do the deed.

I'm in a music shop, not far from where Cath works. Good job they know me here; I look so much like a rough-sleeper I might have been denied entry. I threw some icy water at myself when I got up, not having the will to make another fire and boil a saucepan on it, so the beard is still defiant and I'm definitely getting crusty. It rained on me as soon as I left the cottage, and walking down to the village along the muddy passage hasn't helped. But at least the sax looks good, burnished up, in the red satin of its case.

A young assistant tries not to laugh when I ask for the manager. I know the man, or rather he knows me. He came to see me play quite often in the old days, and has dealt with enough artists to understand when I offer him the sax. He asks after the painting as he examines it and I ask after his business, neither of us remotely interested in answers.

Well, it's in nice condition but the market is depressed at the moment, he says.

Aye, so am I mate, I say to myself.

You'd pay over a grand for that new, I mutter.

Absolutely, but...

You can get five hundred for it easy so give me four and we'll both be happy.

Ah the joy of haggling. I used to like it and be good at it, but it was a game then. Now it's survival. My opponent stands away from the counter in mock shock but I let it fly by me. I'm enjoying the heat of the store. Water has seeped through my shoes and into my shirt through my once-waterproof coat. I settle for three fifty; it's the most I can extract from him.

Now I have cash in my pocket I get out as quickly as possible,

past the rows of bright guitars, woodwind, keyboards, all begging to be bought. There's nowhere quite as optimistic as a music store, and nowhere quite as shameless. I force the sax out of my mind and force myself past two pubs and into a branch of my bank, a rare visit indeed. Here I pay off half the water bill, which will get them off my back for a while. If I paid the other stuff I'd have nothing left. There's two-hundred notes left in my pocket and I'm as elated as a kid with his first paycheck. Now for the pub, one of the last old-style watering-holes left down here. I allow myself a tenner's drinking – I've earnt it.

It turns out to be much more – of course it does – daytime pints are chased down by double scotches, all on an empty stomach – completely stupid, but necessary, and very Crossman. I survey my watering-hole, the reddened faces of the aged soaks I drink with, old style drunks glad to have new blood in their midst. One sorry looking sod falls over and crawls around the floor in bemusement, attempting a shambling apology to the wobbly-jowled woman with him. She slashes at him with her tongue.

I wake on a park bench half a mile from the pub, with no idea how I got here. Short-term memory-loss is humiliating. I feel like I've been violated. I'm so cold I think I'm dead. As my mind begins to stir I remember the money and grab for it in my pocket. It's still there, what's left of it.

At the third attempt I manage to get up from the bench. There's instant pain in my right ankle; there's pain everywhere. I must have fallen over on the way here. It's late afternoon and getting dark as I stagger past a woman and her two children. She pulls them away from me. It's alright, I want to say, just a drunken artist passing. But I concentrate on reaching the bus station and getting back. Self-pity wells up. I try to dismiss it but it allies itself to the cold and my thumping head and smelly body. If Cath should see me now. Her office is between here and the bus but I don't have the energy to walk a longer way round. She's the cause of this. The thought comes easily. *Cath's alright*, says a voice, *she's going places. You were unwanted cargo and she's jettisoned it.*

I'm near her office, where she was talking to that guy in the suit. I wonder if she's with him now. Why shouldn't she be? She's free – free of me. But the thought overwhelms me; it's all I can

do to stagger past the building. There's an urge to enter and confront her, but I don't trust myself.

Next door is another music store. In its window a row of saxophones mocks me, trumpets blow me away; the loss of the sax hits home, cutting through the fug of the drink. I feel like every musician who's ever pawned a piece, like I've sold a child and everyone in the street knows about it, knows I'm a failure. I almost grab the arm of a passer-by and yell *I'm still worth something* in his face, as I've seen wine-soaked losers do so many times, rabid men stripped of all dignity raging at ghosts. Men like me.

I get away and reach the bus station, where a bus is waiting. Miraculously I find my ticket, hand it to the driver, get to the back and slump down. If anyone else is on the bus I haven't noticed them, I just want to cower, and escape. And I want to make Cath pay, that's my last coherent thought as seats and lights and pieces of the city revolve. The bus takes an hour, an hour of warmth and sleep.

The driver wakes me. I'm the last one on the bus and the man wants me off before I throw up over his seats. I make it to the village shop before it closes. For once my disdainful friend there loves serving me; she stands behind her till, hands folded in superior fashion. All her ideas about me are confirmed as she takes my money. She can't wait to tell the next customer. I'm not even sure what food I've put in the basket. I know there's a bottle of scotch there, and paraffin for that lamp.

Struggling up to the cottage is great fun. I manage to stay on two feet, despite the mud-slide of a lane. Further up the hillside I can see the yellow spots of Tom's farmhouse windows. I push open my own dark door. Home sour home. I'm starting to link Tom with Cath – poison is like that, spreading insidiously, gathering force. And it's got a voice now. It might be the drink, but I feel something's starting to control me, talking to me, pushing me in a certain direction. I've changed forever and what I'm moving towards is not comforting.

•

Cath was invigorated, her head clear as she squinted against the sun, taking in the magnificent four-hundred-foot drop of the cliffs. Memories of Rob had slipped down a level; the thought of meeting up with him didn't panic her now. She knew all his moves, could anticipate anything he might do to get back with her. It was doubtful that they could remain friends – he'd never cope if she found a new partner – but perhaps they could at least tie up a few loose ends without bitterness. If he asked for money she didn't mind giving him some, for ten years' old-times-sake. And he was sure to need it. There was nothing much wrong with his painting, it was his personality that was flawed – that way he had of getting in everyone's face, demanding attention, approval, success. Most of the other artists he'd introduced her to were like that, permanently stuck in childhood, unable – or refusing – to grow up, and too weak to face the consequences of their behaviour. But none so spiky as Rob, so destructively negative.

The weather held but it grew chilly. Cath followed the gulls with her eyes, picking one out as it drifted against the red sun towards its roosting spot on the cliffs. The birds were much quieter than they were in summer. Like her, they were waiting for more clement times. She stood on the edge of the Moher cliffs and let the wind introduce itself to her.

Martha opened the door as Cath drove up. How she would have loved this as a child – seeing an adored figure framed in doorstep-light and warmth, waiting for her when she was dropped off by the school bus – rather than the soggy traipse into the kitchen to make her own tea, bolted down before the men returned from the fields.

It's turning colder, Martha said, there's more red in the sky.

She tapped Cath on the shoulder as she passed and, instinctively, Cath turned and hugged her. They held each other for a long moment, exchanging body warmth, then went into the kitchen without saying anything. The room Cath had hated as a child now seemed welcoming. She concentrated on keeping tears at bay. Her mother's eyes were bright, too, and Cath knew she was doing the same. They had a unity at last, but were not yet ready for such a mutual show of emotion.

Martha had prepared tea and Cath realised she was getting her appetite back. Lately, food had been a chore. Now the simple

fare her mother offered was full of flavour, from the rich nutty bread to the vegetable casserole. She had made no concessions to Cath's diet before.

They didn't talk much more before Cath left, as if neither wanted to break the spell. They stayed in the kitchen, close to the fire. Cath watched her mother trying not to doze.

She left shortly afterwards, brushing Martha's cheeks with her lips and giving her another hug, this time less shyly.

Take care of yourself, Martha said, and come back soon.

I will.

Martha walked with her to the car and for the first time in her life Cath knew her mother didn't want to be rid of her. She sat behind the wheel and Martha reached into the car for a final squeeze of her shoulder.

We've made a new start, she murmured. Thanks for giving me the chance. So much time has been wasted.

At least we've recognised it now, Cath said.

It was late when she got to Rosslare, after a tortuous night-drive across Ireland. She had made this journey many times, full of bitterness and regret, and these memories still persisted; one positive weekend with Martha was only a start, but one she never thought would come.

At this time of year the ferry was almost empty, with just a few crumpled truck-drivers and bored families slumped on the recliners. Cath braved the cold and stood on deck for a few minutes. Most of a moon shone, brightening the wake of the ship until its white furrow was lost in the dark sea. Cath still found it menacing. Once, on a trip back with Rob, a man fell overboard. The ferry turned around in a vain search for him and she went through all possibilities in her mind: a drunk toppling over the rail, a suicide, even murder. The man wasn't found and it seemed an awful end, so cold and alone. She thought of her suicide attempt and was filled with fresh shame as she went back to the warmth inside. She had a choice of many seats and slept the sleep of a child.

•

The moon is working up to full size. I've been looking at it for some time – the mountain ranges shadowed in grey, the areas of deep-yellow – wondering that something so dead can be so vivid. I'm standing behind the cottage, surrounded by the scratchings of furtive animals that use my garden at night, and the soft movement of sheep in the field alongside. A plane flies overhead, I can hear its faint drone and I search for the winking lights. Silver and red dots disappear over Tom's farmhouse. We're on the flight path of the coastal airport and there's usually one just after midnight, taking people to the sun. I'd like some of that on my back now.

There are more lights flickering further down the valley but only the faint gleam of an oil lamp strays from my cottage. On the hill, Tom's farmhouse is in darkness. It's way past his bedtime, and he'll be sleeping a sound, uncomplicated sleep until rising before first light. Not long ago he was a figure to pity; now his life seems to have purpose.

I've drunk enough scotch to be oblivious to the biting cold, but I know it's there, breathing on my burning skin, waiting to come in. Frost attacks the turf, fringing it with sparkling white, and the darker areas of the sky are intensely blue. Nature sprawls all around me but I'm not sure I want to be part of it. Sometimes I think I wouldn't lose any sleep if they concreted everything over. Cath would disagree strongly.

I'm changing. Before, drink never affected me much – dreams simply became mellower, easier to believe in; but now it's making me bitter. Fuck it. I'm over, sprawling on the cold ground, what's left of the whisky slopping around in the bottle. The sky's askew; I'm looking at it sideways, sliding into its vastness. Christ, I've fallen over a few times lately. I used to be nimble on my feet, pissed or sober.

I'm in no hurry to get up. I like it down here, despite the frost starting to eat into me. It would be so easy to sleep, to shut everything off for good. Images run through my mind so rapidly I can hardly get a hold on them; Cath's in them all, each one a wound I can't heal. I start to rearrange memories, making her responsible for every failure: if someone reneged on a painting sale, it's Cath's fault; I had a wretched gig, her fault; my lousy upbringing, her fault; my lousy character, all to do with her. The voice

tells me that all my energy went into her, leaving nothing for the art. Her fault.

I know I'm lying to myself but want to believe it so much I don't care. Cath is the evil witch. Yes, that's it; why did she have to come along? Everything would have been fine. I drain the bottle, lean back and throw it over the wall where it lands with a glassy thud, scattering the sheep. I'm disappointed that it didn't smash. Christ, I'm pissed. I want to close my eyes again, lay myself out, arms neatly folded across my chest, acknowledged by the moon and sanitised by the frost. I want to let go like Cath did. I wonder if she felt like this that night, each pill spurring her on to a resolution. Desperate, afraid, but exhilarated, the mistress of her final adventure. Jesus, I'm even jealous of her experience of suicide. Something gentler tries to break into my mood but it's dismissed. *Crossman, you don't do gentle anymore.* The voice seems to be at my side now, an invisible entity, but very tangible. I want to follow it, I want to do what it says. It's my friend.

Something slithers close to my face. I crawl into the house, to the fire of scavenged coal. Cath's face will not leave my mind. Each portrait is beautiful but terrible, the face of the enemy. Her eyes haunt me; I can't get away from them. I'm on all fours, a drunken beast indeed. I find myself at eye-level with a canvas I had hoped to finish with my few remaining materials. It's a piece of crap with no heart or energy; I assault it, tear it apart and feed it to the fire. There's blood on my hands. I let it drip, let it catch what light the lamp gives. Someone is starting to make plans in my head and they terrify me.

•

Cath was owed another day off and decided to take it. She wanted to extend her Irish weekend, take stock of her time with Martha. For the first time post-pills the flat was genuinely welcoming. She pottered about, enjoying the sunshine streaming through the windows. Cath was feeling increasingly good about herself. Clare was very much with her, but she hadn't returned depressed as she had so many times before, promising herself that it was not worth going back again.

She took her time over coffee and scrambled eggs and read

the newspaper. Someone had been killed in a road accident near Rob's village. It wasn't him but for a moment she was tense; the way he drove was always cause for concern: talking constantly, haranguing other motorists. She began to wonder if Rob had ever had a moment of pure joy in his life. She certainly hadn't given him one. She wondered how she'd have reacted if it had been Rob in the accident. Who would be there to make the funeral arrangements? Who'd turn up? Tom the farmer, maybe a few musicians and painters, and herself. No family. It was thoughts like this which had kept her with him for so long.

Cath turned to the jobs section of the paper. She had trained as a teacher. When she met Rob she was enjoying working in a crumbling Victorian primary that served a wasted estate. It was a kind of therapy, a step forwards after the difficulties of Clare. She put more into her charges than had ever been invested in her. But Rob did not take long to undermine her commitment with his cynicism. He seemed to have slogans for every situation. They ran through her head now: *they see an act of kindness as weakness; they bleed you dry; there's nothing coming back* – and the one he used the most – *the money's shit.*

She'd only been up for an hour and already Rob had pushed into her thoughts. But he no longer brought anguish. Rob hadn't had a chance to develop. Without guidance he had become the impossible mix that he was, unable to really see anyone but himself, unable to connect emotionally with others, covering up his defects with all manner of personae, adopted and discarded at will. Now she was free of him everything was so much clearer. Rob still had a few things about the flat. She decided to bag them and put them in the garage – an act of severance. She doubted that he'd ever collect them.

Cath returned to the teaching ads. There was one for a school in a rundown area, somewhere that would not attract much interest, especially from people with experience. It was first-job territory: a challenge for the keen and young. As she went for a jog around the bay, an idea began to settle in her head. Jogging was a millennium resolution. Two teenage boys whistled as she passed them and she loved it. Energy was returning, and with it appetite and enthusiasm.

After a shower she rang the number listed in the paper and

asked for an application form, then she phoned Martha and talked with her for ten minutes. Nothing much was said, yet each word was important. Cath asked her over as if it was the most natural thing in the world. Martha agreed to come in early spring; there was girlish excitement in her voice, as if she too was being set free.

Forcing Cath out of teaching was one of Rob's first successes. He approved of her work in advertising. She knew he liked its glossy image and money, even if he sniped at its moral implication. She made up her mind about the teaching job. She was not going to let it get away. Tomorrow, she'd be trying to close deals for the company, but her thoughts now were with dilapidated buildings, difficult kids and their difficult – and sometimes dangerous – parents, long thankless hours and stressed colleagues. She couldn't wait.

The phone rang. She answered, knowing she was ready for Rob. There was nothing left he could try – she was a graduate of all his deceits. But it was Tom, that farmer neighbour of his. Cath thought it was bad news, that Rob had gone one better than her, such was the hesitancy in Tom's voice.

Hello, Cath, I hope you don't mind me phoning, I got your number from the book.

Yes, this was just the way Tom would break bad news.

It's just that I was talking to Rob the other day and he told me, well, that your relationship is... is...

Over.

This was meant to help him out but it tied up his tongue even further. Tom wanted to know if there was anything he could do to help; he'd be in the city tomorrow, a rare event for him. It was laughable and she should have been annoyed, but he meant well, and she found herself touched. She realised how few people she could talk to in any depth, and instead of kindly brushing him off she found herself agreeing to meet him for lunch near one of the few city landmarks Tom knew.

When Cath put the phone down she was suspicious. Was this a Rob trick? Would he be there instead of Tom? No, Rob had too much pride to involve someone else. But there was still a part of her that wanted to know how he was.

Cath sat in a coffee house with an expansive window. Tom was

103

coming down the street, wearing corduroy trousers and a bulky anorak. He looked out of place on the pavement and reminded her of a bullock that had escaped from its final trip, looking around wild-eyed at a new world. Tom stopped and stared at the name of the cafe then saw her at a window table. He mouthed hello and came in, approaching her table and bumping it as he accepted her invitation to sit, disturbing the froth of her cappuccino. She half expected him to bow and was slightly embarrassed as she gestured him into a seat.

Sorry, Tom says, I'm a bit nervous.

What do you want to drink?

Can I get tea here?

Well, they specialise in coffee but I'm sure you can.

She called a girl over and ordered Tom a pot of tea, feeling like an adult in charge of someone's child.

Does Rob know you're here? she asked.

No, of course not. I haven't seen him for a few days, not since he came up for tea.

Rob came for tea?

Yes, that's when he told me about you two. I wondered why I hadn't seen you around the cottage.

She wondered what the hell Rob wanted with Tom if it wasn't to use him as a go-between. With some concentration Tom poured the tea neatly into his cup. Cath was still influenced by Rob's endless put-downs of Tom and was careful not to patronise him. He was clumsy, inexperienced in most things away from the farm, and somewhat unformed.

Cath tried to put Tom at ease by asking about his work on the farm.

I just wanted to see if I could help in any way, Tom said, it must have been hard for Rob to ask me for help like that.

She was annoyed at herself for being so eager. Rob always did have the ability to catch her on the hop, now he was doing it through Tom.

For help? she asked.

Yes, it was very difficult, for both of us. Rob asked for a loan to tide him over. I felt awful – I'm in no shape to give him one. Mam has some savings but it would never do to ask her. To be frank, she doesn't seem to like Rob.

There's a surprise, Cath thought. This was almost funny. She tried to visualise the scene: Rob in humble mode – if that was possible – trying unsuccessfully to squeeze Tom, with his formidable mother looking on. She imagined his rage and the wake of bitterness that always trailed from it. And no Cath there to take it out on. She was well out of it.

He's got rid of the car, you know, Tom said.

Has he?

Tom hung on her every word. He'd finished his tea and did not know what to do with his hands; they disappeared under the table, came back up again, linked with each other and played with his cup. Coming down to the city must be an expedition for him, a surge in social experience. He was a bashful man who'd be more at home in another age, but Cath sensed there was need in him, that he wanted to be part of something that didn't involve his bloody mother. He was good friend material, but he'd have no chance with Rob now, unless he pushed money through his front door.

You're worried, aren't you? Tom said.

What?

About Rob. I am, too.

You say he hasn't got the car.

No, it broke down once too often, I think.

Tom finally took off his anorak to reveal a tweed jacket with leather-patched elbows, thick check-shirt, and a neck strangled by an ill-fitting tie – ridiculous but also comforting. She was in the presence of a safe man, and doubted if Tom had ever been this close to any woman apart from his mother.

Tom was stuck. He wanted her to lead the way, to save Rob from himself, to make things like they were. This was how Tom wanted his world to be, as unchanging and safe as his clothes. Cath wondered at his future, how he would be when his mother died, alone on the farm with the dogs, maybe beginning a desperate search to replace her. Maybe beginning it now, for his eyes were examining her; despite his shyness he was making the most of this opportunity. She remembered their meeting on that mountain road and the strange feeling that ran through her for a moment. There was an echo of it now as Tom's ruddy, open face faded to a ranting Rob. Opposites indeed.

Well, Tom asked, what do you think we should do?

So it was *we* now.

I appreciate you coming down, Tom, but you must realise my relationship with Rob is over. There's no going back, not for me.

I thought it might be something that could be patched up.

No, not at all.

Oh.

Rob will be alright. There's lots of things he can do well, he'll start playing again, probably.

Cath resisted the temptation to say Rob might even get a job, she didn't think Tom would understand. For him, Rob was an exotic presence. She glanced at her watch.

Am I keeping you? Tom asked.

I have to be back in work soon.

Right, I'll be off then. You didn't mind me coming down, did you?

Of course not.

There was minor turmoil as Tom struggled with his coat whilst trying to avoid the small chrome tables.

I'm like a bull in a bloody china shop, he muttered.

They left the cafe and when Cath took Tom's hand and gave it a squeeze she noticed he was in no hurry to take his away.

Well, take care, Tom, and keep in touch.

Right, I will, and you're sure there's nothing you want me to tell Rob?

Absolutely. Look, I think it will be much better for Rob if you don't mention this meeting.

Alright, I'll be getting off, then.

Right.

Tom managed to go at the second attempt but not without coming out with something he'd planned in his head for days, what he really was here for.

Look, if you ever want to come up the farm, for tea or anything... no, you'll be too busy, I know.

I'll phone you, Cath said, not sure whether she meant it or not.

•

There's just £30 left from the sax sale. I'm in the village, gazing longingly at the boarded-up windows of the pub, willing it open again. On the pub's wall some kid has drawn a heart with a shaky arrow through it. The names have been worn away by weather.

It's spitting rain at me, as it has for most of the winter. I've just done my shopping. I've become expert on prices; every few days I come down off my hill, get a soaking, warm up in the shop, trudge back up and eat. Not being able to use the fridge is not much of a problem now, but when spring comes it will be.

Last week I hauled a canvas around the few local businesses, one most likely to please: a hill pasture dotted with sheep under a serene sky. It almost makes me puke to think about it. I knocked the price down to £50 for the last prospective buyer and he wavered, for one glorious moment he took it to the window and considered it. It might be okay for the office reception, he muttered. Yes, it would, it would, I almost cried, the perfect piece of crap for your fine establishment. Maybe in a few months, he said, when things pick up. But it's only 50 quid you useless moron I yelled inside as I left. Only 50 quid.

Hapless artist dashed on the whim of local burgher returns to lonely garret where his genius festers. I'll be believing it soon. That voice is creeping up on me like a shadow, taking over subtly. I'm aware that my actions are getting crazier, yet I still find reasons for my behaviour. When I'm sober I can rationalise what's happening to me, but only just. It's futile anyway, because I can't seem to change anything. I'm losing it to my secret stalker; that seductive wordsmith is pushing me on. And his road is attractive, leading me to a place where depression and pain demand their own actions.

I walk back up to the cottage. The lane is saturated. Rivulets run down each side so I keep to the muddy middle, but there's still enough water here to work up over my boots. If it doesn't ease up soon the tarmac will begin to disintegrate and we'll have another stream. For once I'd be grateful if Tom appeared. He's made himself scarce since I tried to put the bite on him. Bastard, I know he lied to me. He must have a tidy sum stashed away – farmers are expert hoarders, especially unmarried childless ones. I imagine his mother sitting on their heap of gold like the dragon she is.

Patches of blue sky are fighting the rain; there's even a hint of sun – but that's all we get, a hint. They reckon mild wet winters will be the norm in the new millennium. I won't mind the mild part. Freezing my rocks off as a kid is an unshakeable memory; my pipe-cleaner frame mocked by the cold as I enviously regarded the chubbier schoolkids with their warmer clothing, warmer houses, and warmer parents. I went to a birthday party once, God knows who asked me. The food on display was an eye-opener: some people really did live like those in magazines. Home seemed an even barer place after that, somewhere to avoid as much as possible.

Blue skies are winning and the sun dares to stay out for a while. It forms a rainbow over the hillside, hesitant at first, as if it doesn't want to be here, then getting stronger, showing the full band of colours, teasing this solitary pot-of-gold hunter. I'm muttering to myself again – I'm doing it all the time now. Water soaks into my socks and I squelch the last few hundred yards as the humble road refuses to change to yellow brick.

In the cottage the fire is small and sad, having consumed most of the wood I loaded onto it. Coal would last longer but there's no chance of getting any more of that. The fire is voracious and I have to make regular sorties into the surrounding woods for fuel, destroying my own small forest. Environmental issues were of great concern to Cath; she was a strange mix of bleeding-heart liberal and clear-sighted realist – clear-sighted in everything but me. I thought that my true character was impenetrable, but she learned to see me in the end.

In my wood-basket I have a few logs which I put onto the embers. The heart of the fire turns red again and flames lick the sides of the logs as they start to sizzle out sap. Rainbow and blue sky have been vanquished and the rain's back, coming down harder than ever. I can't be bothered to go out for more wood or eat any of the food I've bought. I prefer to sit and look at the flames and drink from the half bottle of whisky and listen to the swell of the rain against the cottage roof.

I'm fingering the key for Cath's flat again. It's a bronze-coloured Yale, almost the colour of the whisky in my glass. There's promise in this key, and challenge, and it's in my hand for a purpose. I'm dozing, something I specialise in now, but am

stirred by knocking at the door. I put the key into my pocket, an instinctive action of guilt, and check the window. It's Tom, who else?

I take my time in answering, but the dogs know I'm in. I think Tom is shocked by my appearance when I open the door.

I thought you weren't here, he says.

I gesture him in and turn my back, letting him stumble around in the gloom.

Can't you turn the light on? Tom asks.

No power, I say.

What, a fault?

Yip, a fault in my wallet, a massive fissure, you might say.

I strike a match and light the oil-lamp. Tom looks bemused and awkward. He examines the oil lamp.

I haven't seen one of these in years.

It's what all the best artists are using now.

Look, Rob, I'm sorry about that money, it's just that...

It's just that you have no spine, I say to myself. Or that you are not as stupid as you look. Or both. I smile a magnanimous smile.

No problem.

I don't know about that, you've no electricity – is there water?

Oh yes.

How do you heat it?

I manage. A kettle on the fire and the old top-and-tail wash, and as you can see, I've stopped shaving.

For once I'm not irked to see Tom. His failure to give me the money seems to have given me the high ground, that's the way Tom's mind works. He'd like to ask me up for a bath, more food, keep the relationship going. If I hung in there I'd get him to pay the bills, put the electric back on. But it's not going to happen. I offer Tom the armchair by the hearth. The fire is working its way through the wet wood.

This puts out a good heat, Tom says, this is a good chimney breast. My grandfather built it.

Really?

Yes, this was one of the farm labourers' cottages originally, before the farm was split up. Lots of people worked on the land then.

I make and serve the tea, and find a few biscuits to go with it.

Tom is my first guest since Cath went. It's quiet for a time, but he's working up to something. I know the money thing is dead in the water so I'm intrigued.

So, you busy then? I ask.

Always. Well, not so much right now, but it won't be long to lambing time – though whether it's even worth taking them to market this year I'm not sure.

Tom's about to have a spasm of farmers' woe but stops himself and gazes at the lamp. He realises I'm a long way below him in the solvency stakes. I need a drink but won't share with Tom, there's only a few fingers left and the store won't be open until the morning. This is how it's been going, finishing a bottle in the afternoon, sleeping it off and waking with renewed thirst in the evening. Last week I washed out an empty bottle with a little water and drank that. The desperation of a drunk knows no depths, especially a penniless drunk. Yet the hangovers don't diminish; I thought I would have built up a tolerance by now but each one is wretched. Every morning after a drink I throw up what little food I've eaten, take the strongest headache pill available, then hurry to lay the fire so that I can boil a kettle for tea, lots of sweet, strong tea. It's the nearest thing to a routine I've ever had.

You're not saying much, Tom murmurs.

Ah, silence, it's the one thing Tom can't handle. I'll milk it a little more, try a shrug and a kneading of the hands, that man Heep again.

One of those days, Tom.

Oh.

More tea?

No, I'm alright. Um, I don't suppose the light's much good for painting now.

That's a moot point. I'm not working. As you can see, the house is full of unsold work.

Tom's face creases further with consternation. He's afraid I'm going to try to force a painting on him and perhaps I will. Fifty pounds would last me another few weeks, until the back of winter is broken. I'm more than a little drunk and concentrate on not slurring my words.

I'm lying fetid, Tom.

What?

Your fields lie fallow, I'm lying fetid – oh, never mind, I'm rambling.

Tom's aware of the whisky aroma around the house now, I can see his nostrils twitch, like one of his sheep smelling new grass.

But you said you'll be able to sell your paintings in the spring.

I'd forgotten this and answer with a shrug.

That's not looking so good now.

Oh. I see.

I'm trying to think up another gloomy pun to hurl at Tom and it's more than a few seconds before his next comment sinks in.

I saw Cath the other day, he says quietly.

At first I think I've misheard him but his face tells me I haven't. Well done, Tom, you've surprised someone, for the first time in your life. I just about manage to keep my voice below a shout.

Cath? Where? How?

Tom's face is as red as it gets now.

Well, I phoned her up actually. I was shocked when you told me the news, and wondered if I could do something to help.

But you hardly know us, you pathetic denier of money. You just want to zone into other peoples' lives, into any life that will add colour to your own. I'm holding it together – just – but I feel that guy inside stirring. If I launched myself at Tom he'd be lost, he's twice my size but he'd be lost. Last spring I saw one of Tom's flock letting a dog rip its throat out. The sheep was vastly stronger than the dog but savagery was not in its soul, it was confused, beaten by genetics, and accepted its fate. Tom came running over the fields with his shotgun, shouting at the dog but unwilling to use the gun, or unable. I know the owner, he gasped. The dog had seen us now and sloped away to the village and I sensed Tom was glad it was out of range. I'll go down and see the man, he muttered. If he keeps the dog in, it might lose the taste. I'll have to shoot it next time though.

Crossman frustration equals rage equals violence: my lifetime syndrome. It began early, whenever I was thwarted in the class-room or playground. Rapid fists were the answer to everything and my temper often held sway over bigger boys. Like the sheep, all they had to do was stand up to me, but they never did. At

seven I knew my classmates had much more than me. I desperately wanted to belong – to fit in, not stand out – but it could never be, so I made an art form of being different. Like a cancerous cell my persona developed slowly; negative characteristics joined together to form malevolent clusters spreading outwards. I went through a phase of petty thieving; if I wanted someone else's toy I'd find a way to get my hands on it. I became expert at this and often let the blame fall on other boys. If another suspected me I answered with incredulous rage, which had potency even then, and my accuser would back down, confused and guilty for thinking it was me. Once I got my booty home I'd lose interest in it, the thrill was in the taking not the having. Every so often I'd hold a ritual burning in the back garden, watching another boy's pride and joy crumble and melt in front of me. My mother never said anything.

Tom's waiting for me to speak. Good old Tom, I'd have taken *his* toys. Maybe this is why he gets up my nose so much – he reminds me of all those cheated boys, with their open, stupid faces, and of my burgeoning selfishness that has gone unchecked ever since.

I don't want Tom here, I want to be left alone to sift through my past, to wallow in memories of my poor behaviour, then grow sick with despair. But Tom has news.

You went to see her, I said slowly.

Yes, I had a bit of business down there so I thought it would be the ideal time.

Liar. You never have any business there, your mother does it all for you.

I see. How is she?

Tom is searching for the right words. Surely Cath would never use him as a go-between.

She seemed okay. I'm betraying her confidence telling you this. She told me not to but I didn't feel right about that. Now I don't feel right telling you.

Christ, I want that bottle. I push my furred tongue against my teeth and taste the residue of whisky, and it's torture.

You don't mind, do you, Rob? I don't know what I expected to achieve.

No problem, Tom. I appreciate the thought.

Of course, I'm being slow. He fancies Cath and he's sniffing around our aftermath like a fox, even if he doesn't quite know it himself yet. I manage to suppress a laugh, which is followed by frustration – and frustration equals rage equals violence.

Sit there quietly Tom, whilst I fly off in search of another gut-gouging memory, anything to counteract what he's told me. When I had that good year I expected money and publicity to replace my permanent restlessness with an uncomplicated, reciprocal love for Cath. But it didn't happen. The money was a prick to all the years I'd been without: *too late, too late*, that inner voice said, *too late for you, sad bastard*. At Selborne's gallery one critic took me aside, leant over me with his sweet-smelling breath and called me promising. I took his drink from him and tipped it down his pink shirt. Selborne was baffled and alarmed – then was on the phone to his journalist friends. I got into a fight later that night; I remember knocking on Selborne's door, trailing artistic lines of blood from a smashed nose. Selborne was alarmed again.

Everything is crumbling. Perhaps this is my payback for asking Tom for money, my nose rubbed into the reality of my situation. Tom lives a blank life but I know he's a better man than me, by far. And I hate this knowledge; I hate his normality, his fucking ordinariness – and the superiority of his fucking ordinariness – and the thought that he's been anywhere near Cath.

He sits there awkwardly in the armchair, long arms hanging down each side, apelike, illuminated by the fire like some avuncular figure from a Christmas card. I realise I didn't give him a thought over the millennium, not even a card, though there was one from him to Cath and me, and a bottle of scotch left outside the door.

I'm acting out one of my films again. This time I'm making the room my private slaughterhouse, picking up the axe I use for wood, casually approaching Tom and smashing his head. I stand over him like some wild Raskolnikoff as he sinks to the ground, his incredulous eyes losing their light. The room lurid with the deed. Then going down to the city for Cath, driving crazily on Tom's quad, like a mad child on an overgrown trike. I've forgotten his mother – yes, she might as well get it too. A clean sweep.

I'm intoxicated, shaking with the imaginary action. I can feel

it coursing within me, ever nearer the surface, trying to break through, resolution so close I can taste it, sweet, inviting. It's all in my head, but I'm not sure how long I can keep it there. Tom is watching me and I notice his eyes for the first time: they're a clear blue, at odds with his weathered face. There's a depth to them too, something's in there that he finds hard to release.

You sure you're alright, Rob?

I'm fine. Fine.

I'd better get off then. I just wanted you to know, that's all.

Sure, I appreciate it.

Look, about that money...

It's alright, Tom, really. Let's not mention it again, things will work out, they always do.

For a moment I expect him to ask if there's any message for Cath and my right hand flexes around the handle of the imaginary axe. I see Tom to the door and know that the power I once had over him is waning. It's strange how this can change so quickly; Crossman's impenetrable fortress is proving to be a collapsing pack of cards, and the jokers are hitting the deck one by one.

Christ, I'm gagging for a drink, not just the last shot I've got left but a long session with a new bottle. I've become infatuated with the process, ripping off the seal, delighting in the promise of that first smell, delighting at the liquid that cascades out into my one good tumbler – and *cascade* is the right word, a flowery word for a heavenly process. Then the taste, especially if it's a good malt. Smoky echoes of peat bogs, lochs, highland water, and all the other advertising bullshit I'm willing to believe. Beautiful burning bliss.

In the kitchen I try to savour the last of my cut-price scotch, one sad swallow. It's too late to get any more in the village. For a while I tough it out, hardly realising I'm walking around the house. There's a pub on the hillside in the next valley, but it's a thirty minute walk. I stopped there with Cath once, in better times. It had an agreeable open fire which gave agreeable warmth to the agreeable well-heeled people there. I'm out of the front door before I have time to dissuade myself.

A cold night. Check. A wet night. Check. Par for the course, the Crossman course. I almost shout at myself to leave it out:

repulsion is snapping at me, screaming at my whining. Rain blows down off the rise into my face, and my ungloved hands are soon numb. As I skirt Tom's farmhouse, violent imagery is still in me. His mother is framed in the kitchen window, about to serve him up a meal. I throw the axe at her, her skull comes apart and a grey trail of her brains spatters the wall.

The going is easier as I descend the other side of the hill, easy enough for me to slip and slide my way along. I'll be muddy and unkempt when I reach the Farmers Arms but I couldn't care less. All my thoughts are focused on the warmth of the bar and the amber in the glass.

I'm there, outside the pub, looking kindly on its swinging, badly-painted sign, entering the light of its entrance as if I'm about to perform, then helped through the door by the gusting wind. There's a scattering of people in the bar, all men. Talk stops as they look at me in surprise, for they've heard no motor. As I shake rain from my eyes I see farmers and a few country newcomers, people with second homes in the hills, badged by their green wellingtons. I know one of them – I tried to sell him a painting for his office.

I nod but am not acknowledged as I approach the bar. There's a moment of panic as I reach into the folds of a pocket for my money but can't find it. I've never carried a wallet and so I often lose money, usually in times of excitement or drunkenness. The barman is young, and there's a cocky sneer on his face, but I don't blame him when I see myself in the mirror behind him. I'm pouring with sweat, sodden with rain, and wild of eye and appearance.

What'll it be, sir, Cocky says, with emphasis on the *sir*.

I have another dig in the pocket as his eyebrows rise, then a frantic search in others, where I'm certain I didn't put the money but where I find it. I just about stop myself waving the note about the bar. A large Grouse, I say, hoping my voice isn't shaking. And half a Guinness. He serves me and makes a show of holding the note up to the light before giving me the change. A third of my money is gone.

I sit in the corner, where burning logs fill the large fireplace. Slowly the conversation starts to grow again. I'm an oddity, to be ignored, and worse, tolerated. But we'll see.

I'm starting to steam, and there's a smell, which I realise is me. Lack of hot water is starting to take effect and so is the drink. As I approach the bar again I can feel it confusing my legs.

Same again, I mutter.

I'm serving this gentleman – sir.

The man who turned down a picture is at the bar. He moves away from me quickly and seems glad to carry his tray back to the waiting table. Something is said there and his friends chuckle. I'm served and drink the whisky down in one. It hammers the back of my head and attacks my empty stomach. Walking home will be a challenge. I take the Guinness with me to the source of the laughter and sit down unasked in a spare chair, sucking at my drink so that it leaves a froth moustache around my mouth.

Three men look at me with distaste. One is openly hostile and asks if he knows me. This is my man.

Crossman, I mutter, and thrust a hand so close to his face he can't ignore it. He grabs it warily and releases it as quickly as possible. He's a farmer; I've seen him talking with Tom a few times.

Terrible night, I say, giving No-sale a nudge. He spills his beer slightly.

You're drunk, mate, the farmer says.

No, but I'm getting there.

Look, this is a private conversation, you can't just sit down.

Seems like I just have. Anyway, we're all friends here, keeping a collective welcome in the hillsides, eh?

I nudge No-sale again, harder this time.

Have you changed your mind about that painting? I ask him. I'm an artist, I explain to the table, using my broadest smile.

Aye, a piss-artist, farmer says. Look, you're not wanted here.

It's not much of an insult but enough for me, what I was waiting for. The monkey on my shoulder starts to applaud as something evil slips to the surface. The farmer gets what's left of the Guinness full in the face and the table erupts. I erupt it. No-sale gets quickly out of the way, helped by a kick from me, and the farmer tries to grapple with me. His arms look capable of hoisting a heifer over his shoulder but grappling is not good enough. I'm able to land two good punches into his red face but

he's too strong to go down. He manages to get hold of me at the second attempt – a grip I can't break – while someone else pins me from behind. I'm being dragged towards the door, down the steps and thrown onto the muddy ground. I feel my cheekbone jar as it makes contact.

He's a nutter, someone says, call the police.

No, says another voice, probably the farmer's, he's not worth it.

I can just about make out the cocky barman, slick hair slicked further by the rain.

You're barred, he says, for good, and aims a weak boot into my ribs. Just as well I'm amongst civilised society, a rougher crowd would have kicked me shitless.

Getting home is complicated. The rain stops and it gets colder, but not cold enough to cool the burn in my face. I turn to look back at the Farmers, like the outcast of so many old tales. Wolf-faced, a vile mix of shifty and bitter, planning revenge and mayhem against honourable folk.

It's uphill to Tom's farm and my shortcut is not a good idea. I can feel my saturated clothing starting to freeze as I struggle through undergrowth, almost on my knees in places. I'm winded and need to rest when I reach Tom's farmhouse. Leaning against one of his outer walls I jealously regard his sheep in an adjacent field, still concerned with their stomachs at midnight, untroubled by the conditions. They are heavy with the lambs they will soon produce. Something moves to my right, quite close, and the sheep scatter. It's a fox, on its rounds. I'm upwind of it and for a moment it's not aware of my presence and comes close, just feet away, before it senses me and turns to stare. If I was a man with a gun it would be dead but it's in no hurry to get away. It turns its black eyes on me, a long unblinking stare, and for a moment I feel it's looking into my soul, and finding it bleak. It's a vixen, in the same state as the sheep. I watch until it glides over Tom's yard and through the fence at the other side.

My chest is on fire as I descend the hill, but I'm still freezing. Gaps are appearing in the cloud-cover and I watch as stars are revealed, with the same wild imaginings that man has always had. I hate them for their irreverent immensity, their mocking of Crossman's foul speck. I hate them for making me feel so fucking lonely.

In the cottage there's a glimmer of fire left, which I manage to stoke up with a motley assortment of wood: bits of fence post, one bona fide log and some shavings. I stoke up the heat with a bellows much older than I am; it's an ornate brass one, another relic found in the cottage outhouse. Soon the heart of the fire is a solid glow, like my head.

I'm sobering up and don't like it. I want a bath, and certainly need one. An image follows this thought. I'm in a foot of water, fragrant, candle-lit, a book propped up on a soap rack. Bastard. I've never wanted anything more but can do nothing except sit unwashed on a stool, as near to the heat as I can get: out of place, time, luck; and maybe out of my head. Vaguely, I think of axes again.

•

Cath got an interview for the teaching job. It had been arranged quickly and she guessed the school hadn't been overwhelmed with responses. On Sunday she decided to drive across town to have a look at the place. Despite its commercialisation, Sunday for her hadn't lost its Irish feel; it was still that stagnant band of time to be negotiated at the end of each week, unease always ready to turn into guilt, the church beckoning with gloomy hand. Her mood was permeated by reluctant Catholicism. She had turned her back on it years ago but could still feel its presence. She knew its power was derived from its tenacity and that one day it might get her again.

She was entering bandit territory, the signs were everywhere. Abandoned cars, some burnt-out hulks, litter, dog crap, and an air of decrepitude in the people and infrastructure. She drove slowly past a line of terraces that blended into the edge of a sprawling estate, looking for the school. A few kids stood around, impervious to winter in their tee-shirts. They scowled at the new car that passed, and one of the older ones worked his tongue into a frenzy as he noticed her. She would have been intimidated when she first taught, now it was laughable, even welcoming, ill-formed youth aping film images of another world, one they'd like to be part of, a place where they could turn their deprivation into an art form.

Here was the school sign, a new one, standing out proud against wasted dross. It was a sizeable Victorian building, what else, which looked as if work had been done on it recently. The roof was new, which was good. Dripping water was one of her earliest teaching memories. The drip of despair, her first Head called it, before he took an early pension and ran. The iron gates were padlocked and having been hit by more than one vehicle over the years they held loosely together like a twisted sculpture, all gaps and buckles and flaking paint.

The school housed infants and juniors and had a tarmac yard, vast slated roof, lots of brick and piping, and a century's histories. There was a small patch of earth to one side which must have been the garden: tiny, defiant and ridiculously out of place, but she liked it. In the spring they'd plant it with hope again. She should be examining her sanity for even thinking of coming here. She didn't have the excuse of ignorance, and that first blind flush of enthusiasm was crushed long ago, but something was drawing her here. Maybe it was to do with Rob and his decade of control, maybe she wanted to conclude unfinished business. But this mustn't be a penance, she thought; that would be to hand Rob his greatest victory of all. No, this was to fulfil a need in her. Her thoughts were in overdrive – ha, a Rob phrase. He used to say that, when pontificating from the sofa. Do the interview first, idiot, she told herself, and take it from there.

Two kids were looking at her, they appeared like ghosts alongside the car. She imagined coins run along the bodywork, tyres slashed, but at seven or eight years old surely these were too young. No, of course they weren't. She pressed the button to glide the window down and the nearest boy was impressed.

Smart motor, he said.

He waved a grubby hand towards the school. We go there, he said. Cath didn't want to think Rob thoughts. He'd hated the class that spawned him, yet affected solidarity with vague socialist notions whilst pursuing a life of self-centred narcissism. He'd like her to sink without trace here, but that wasn't going to happen. She knew most children were alright, given a chance.

The more timid second boy approached her. He was dressed in cheap nylon sportsgear inadequate for the weather, and his nose had been running all morning. There were smudges of snot

on his face, and more gum than tooth in his hesitant smile. He could be a waif from any age – he'd peered out of Victorian workhouses, was rickety in the 1930s, and was here still. The new millennium: what a joke.

Got any sweets? he asked.

Don't you know you're not supposed to take sweets from strangers?

That's only men, pervs. Got any fags, then?

If she got the job Cath wondered if these would remember her. The teacher they asked for fags outside the school gate.

Sorry, boys, I don't eat sweets and I don't smoke.

She almost reached into her bag to give them some money but realised what a patronising start that would be.

The boys' attention span had been breached, Cath was no longer interesting and they faded away from her. It was time for her to fade away too. She headed out of the estate by another way and in seconds was in lusher pastures, amazed by how conditions changed so quickly in this city. She'd get this job; she was not going to let it get away, God help her.

She drove back to her own world, or a world she tried to convince herself was her own – but the school and its environment were closer to her upbringing than where she lived now. Maybe the flat was bought more to spite Rob than anything else. Those two kids were everywhere in Clare: same clothes, same snot, and she was angry to think they were still around, that they could still exist within sight of so much money.

Cath checked the answerphone and Tom's voice was on it; he'd rung off the first time, then, at the second attempt, asked her out, in halting, embarrassed tones. She was impressed with his new found nerve, but not surprised. He couldn't take a chance she wouldn't get in touch. Before she had time to talk herself out of it she rang him back and fixed up a time and date, leaving an overjoyed Tom to count down the days. She couldn't believe she'd done it and had a quick sift of motives. Well, Tom was solid, and she needed solid at this time – it wasn't a quality she'd experienced in a man – and that word *nice* kept cropping up. Perhaps he'd surprise her by having something worthwhile to say, or do. She thought of the encounter they'd had on that mountain road and smiled: there was not much Tom would have

to change, only his dress-sense, outlook, work hours and mother. But nothing else was happening in her life, and, as she was finding out, thirty-something was an awkward age to be on your own. Part of her was thinking children, security, the things Rob had denied her. She was aware of the clock ticking. In a poor contest, Tom came out ahead of that abysmal disco.

The interview went well. Cath talked with the Head, a senior advisor and one of the governors. The Head was in his late fifties but looked much older. A short, bullish man from another age, more suited to stalking polished corridors with robe flowing behind him than trying to maintain a presence in modern times. His worn-out countenance told her he'd like to get back to that past, to a time when teaching commanded a modicum of respect, and he had control. He seemed grateful she had even attended; Cath found out that this job had been advertised before. Her rivals were all NQT's – newly qualified teachers. Not much competition there.

Cath made all the necessary responses and sensed they were taken aback when they realised her enthusiasm was genuine. The advisor, a woman not much older than her, was puzzled. She asked what Cath's salary was now and there was a pause as she worked out how much it would drop. Cath was a woman prepared to come to the school for less. The advisor wondered if there was anything hidden in her past – Cath knew she'd bring this up with the others when the interview was over, but still felt she'd get the job; they couldn't afford to let her go. She'd had five years in the front-line, came armed with good references and the right attitude, and was single with no kids. The Head wanted an injection of new blood in his tired staffroom before he jacked it in, and the governor liked her accent, and her legs. It was hand-shakes all round and the interview was over.

A girl in her early twenties waited in the secretary's office. She looked tired already and picked at a spot, stopping quickly when she saw Cath.

Good luck, she murmured, and the girl grimaced a response.

The kids were out in the yard and Cath made her way through them, glanced at by the male teacher on duty. He'll probably be the only man here, she thought; most primary schools don't run

to more than one or two: this was a world where women acted as nurses, shrinks, social workers, security guards, even decorators, as much as teachers. She was parked alongside the row of teachers' cars, a motley crew: a few bangers filled with rubbish, once-expensive cars past their sell-by dates, and some new models that flaunted it, saying they were not part of all this, their owners were just passing through. Parked away from the others was a Volvo estate, old but well cared-for, which would be the Head's. On her own car there was a new scratch, six inches of venom etched into the driver's door. Good, it was just the start she needed to keep both feet on the ground. She'd know about the job within a week and would start at the beginning of the summer term if she was successful.

•

I've got Cath's door-key in my hand, and am treating it like a piece of jewellery, polishing its surface with my fingers. It's always on my person now. I want to throw it away. I've tried to throw it away. I've walked out into the moonlight many times, prepared to hurl it into the darkness; it's even got as far as the bin, but always ends up back with me.

It's mid February and there's a hint of false spring in the air. I'm about to indulge in barter again and have twenty old vinyl records to take down to the city. They are rare and collectable and a man there will buy them. I've stacked them in a box which will be heavy to carry down to the village.

I'm making an effort today. I shave off whiskers with water that's actually hot, have the nearest I can get to a good wash, and wear the least grubby of my clothes. If you hadn't seen me recently you'd still think me rough: you'd note the wild hair, the face crumpled from lack of sleep, the fidgety gait – but I'm a king compared to yesterday. I've managed to get some food into my stomach, toasting bread on the embers of the fire. Despite the wash, I know I still smell of woodsmoke; it's impossible to eradicate now.

Tom is the last person I want to see but I can hear him coming down the track behind me. It's too late to duck into the hedge as he's alongside, flashing that bashful grin at me, filling my chest

with the fumes of the quad's exhaust.

Hello. Oh, records, I wondered what you had in the box.

I feel obliged to answer the unasked part.

I'm taking them down to sell, they're not needed anymore.

Tom eyes the names on the record spines, but they might as well be names from another world for him. They *are* names from another world. Mine. Despite the hot water there are two shaving cuts on my face. One did not want to stop bleeding and I've left a dab of tissue on it. Suddenly I'm conscious of it, with Tom. I can't fucking believe it, but I am. As deftly as I can I remove the tissue and hope the thing won't start seeping again. Tom watches my every move. Just say something stupid, you bastard, I think, regarding his hardy clothing with envy. Have I lost this much confidence, that a nerd like Tom can make me react like this, can make me so instantly angry that I want to go into axe mode? Who's the bigger nerd here anyway?

I've only got a few minutes to catch the bus, I say.

No problem, I'll take you down.

I accept and sit next to Tom with his growling dogs inches from my neck. I can feel their breath and put my hand over the cut. Tom prattles on about his daily round, his preparations for the lambing season. I'm screaming inside for him to shut up, for him not to be here to witness my further humiliation, but he's oblivious to what it means for me to be skulking down to the city to sell my past, the closest thing to heritage I have. At least that's how I used to see it. Records were like children to me but now I know it's nonsense, a pathetic substitution for the more substantial stuff concerning Cath. I'm carrying twenty pieces of outmoded junk, which play on an outmoded machine I can no longer power.

You're quiet, Tom says.

Not used to getting up this early.

He laughs but Tom's laughs are a series of disguises, for shyness, diffidence, the inability to deal with much that is outside the farm. He's another lost soul, swimming around in another solitary sea. In this way we're soulmates, Tom and I. Now I'm swinging from hostility to harmony. I prefer hostility – anger is keeping me going, washing through me with the whisky. I enjoy nurturing it, keeping it down, building up tension, letting it rise,

gambling that it won't get the better of me, wondering if I should let it.

Tom drops me off at the bus stop, a metal post with no shelter. I lean against it and wave him away, the records on the ground at my feet, the goods I'm taking to market.

It takes an age to travel down to the city. The bus meanders around the hills, picking up solitaries like me, the car-less people who live out in the sticks. A couple sit in front of me and talk about the city as if their journey is a lifetime's dream. I'm drifting off into a light sleep and their chat wanders in and out of my head. It's easy to think time has moved back a hundred years or more, to when personal travel was bizarre or exotic. The not-so-old woman talks of things she needs to get for others, and has a list she goes through with her partner. I bet she'll have a pen too, to tick off each purchase.

We're there and the bus parks in an area reserved for it. Other buses jostle for position. Like all cities, the bus depot is in the crap end, an area which has known better times and has watched the city grow away from it, devouring new land, ways and opportunities. I'm not too far from Cath's office. I have always judged distances here by using her place as a landmark. I carry the records at an angle under my arm and make for the mainly-junk antique market, where my saviour has a record stall.

I'm suited to this part of town, my scruffiness blends in with it, and there are worse than me about. I pass a number of street dwellers and feel it a triumph that none of them asks for money. A large girl, not yet out of her teens, points out the records to her friend and they laugh at the strange discs. I smile broadly at them, take the top record from the box and threaten to use it like a frisbee, which stills the laughter. Insanity is respected on the street.

The market has swing doors which keep out some of the cold and I'm glad to step through them. This year I seem to have spent my whole time being cold and protecting myself from it. It's a perfect companion for poverty. As I approach the record stall I'm spending the money already: a plate of grease first in the cheap cafe here, then a few drinks, of course, before going home with most of the hundred pounds still in my pocket. But even as I tell myself this I know it's a far too ordered train of events for

my current state. The money will scald my hands and leap out of them into the hands of others. Suddenly the cottage seems a long way away, and getting back there not a priority. Ah, here's the stall, and here comes the sales pitch again.

Alright?

Yes. Alright?

Modern communication is taking place. The words means nothing and no-one takes much notice of question or answer. I know the record-dealer; he's older than me, and has that vaguely haunted look of all specialist stallholders. He's a big man made bigger by his multiple clothing, he smells of yesterday's booze and his bleary face is a good match for mine. He scans the records as he drinks the tea he pours from his flask.

Great stuff, this. I haven't seen this one for ages. You playing these days?

I shake my head.

No? It's a shame there's no outlet for your stuff anymore. It's all this thump-thump crap these days. My kids play it all the time, drives me nuts, I was saying to them the other day...

How much for the lot?

Well, it's lovely stuff, as I said, but there are fewer and fewer people after it. Most of my customers have replaced their collections with CDs.

Why?

He doesn't answer, and makes two piles out of the records.

Look, I don't want to take anything back, all these are collectable, and you know it. I lean forward, so close to him his tea spills.

He has a sharper look at me, checking out my eyes, the way I'm dressed, his merchant mind evaluating my state. He puts the records back into one pile.

You can get twice as much as you'll pay me, I say, the world's full of anoraks.

He agrees and obviously thinks I'm one of them and he's not. He's reaching for his wallet, a bulging piece of leather he treats with reverence. Five twenties are extracted and a gloved hand extended. I take the ends of the notes and pocket them quickly, this time memorising which pocket. Record Man seems easier now, he's done good business with a challenging punter and will

turn a good profit. We've enacted an age-old scene of commerce: he's the one with the power, I'm the one with the need.

Food is forgotten and I'm out of the market and into the first pub I see, so quickly I don't even notice the name of it. It's full of market types, the four Ls: losers, loners, louts and layabouts, all lounging together in a lobotomised herd. I'm at home and quickly down my usual Guinness and large scotch chaser. I start to relax, no longer in any doubt I have a drink problem and not caring overmuch. This is a good way to spend a day, but I'm thinking ahead before I let go, dividing the money up, putting three twenties in the deepest recess of an inside pocket. If I'm pissed and forget it's there it should be safe when I come out of the other end of the drink – unless I'm rolled, which is quite possible in this place. With my century of notes I'm easily the richest here. I recognise the girls from the street, sharing a pint and a roll-up, skinny piebald bitch at their feet under the table. It settles baleful eyes on me but sees I'm not eating anything and looks away in an unending stare at the wooden floor. I know how you feel, mate.

An hour's passed and I'm still in the corner of the pub, not sure if I can stand, well pissed after two more rounds of drinks. I order a suspicious pie as a gesture to my stomach. Apart from being told to fuck off for refusing to buy the street-girls a drink, I'm having a good time, hitting well-chilled whisky mode and gazing with benign countenance at my fellow no-hopers. I wonder if, like me, they once had hope, fuelled by big dreams and small talent. My hand is being tempted towards another note but closes on Cath's key instead. It feels unnaturally cold in my hand but the image of her that comes to me from our early days is warm and vibrant. I want to crush it out quickly, it doesn't belong in the world I live in now. I don't want it here but it lingers stubbornly.

An old man falls against me and I'm attacked by his amazing halitosis. He's blind drunk and giggles inanely, as his drinking-buddies castigate him, and a toothless shapeless mass masquerading as a woman tries to get him up. She turns to me.

Does it all the time, he does, love, disgusting old sod.

She tries to tidy her hair and straighten her clothing and gums a smile at me. Time to leave. I can stand, if a sideways lurch can

be called that. Outside I'm almost run over by a taxi; the driver is about to shout at me until I hire him, an instant decision, with Cath's key in my hand.

To the bay, I say.

I'm dropped off a few hundred yards from Cath's place. She might be there so I must be discreet. Discreet, when I'm staggering along like a blind man. The wind off the bay seeks me out – identifies, punishes – and it's drop dead cold again – but only on the outside; hell's burning in Crossman's interior. It's mid-afternoon, midweek, so she should be at work. I'm not sure what I'll do if she's not. The key still turns in the lock, but why shouldn't it? Cath has no idea I've got this spare, that I could be this low.

I'm in, no alarm has gone off, and Cath hasn't appeared. The flat is empty and warm, without being orderly: magazines and files are strewn around, but not like the bleak mess that is my cottage. This is comfortable to come home to.

I go to the bathroom and take a leisurely piss whilst smelling clean air traced with the perfume she's used today. Then I have a swill in hot water, and sift through her linen basket whilst sitting on the side of the bath. I'm not sure what I feel, certainly not sure what I'm doing, but I need to hold clothing she's recently worn. It's worse than bereavement because nothing is over for me, there is no closure on Cath. She's gone, but only from me, and I can't handle it – from day one I haven't been able to handle it. My only response is anger: to rage against all that I know about myself – and my inability to blank out this knowledge. With the rage comes the need for resolution. I want to fall into the gaping pit and let the blackness cover me, but I want to take Cath with me. *Yes*, that inner man says, *yes, yes.*

I'm getting sleepy and the temptation to have a bath then get into bed is great; into the king-size bed we bought together. There's a picture of Cath's mother on the bedside table. I pick it up and see that it's a recent one – strange, for there's no love lost between them. Envy surges as I realise things might have changed. I have to get out of here before I crash in the bed.

Before I go I turn Martha's photograph towards the wall. It's stupid, but I have to do it, it's a kind of calling card that my vanity demands. As I go out I see the woman from the next flat, she looks at me strangely and hurries past. I'm not dressed for

this part of town. I'm still feeling the drink but can walk better now, which is just as well, for it's a two mile walk to the bus station – good exercise for a drunk.

.

Cath received a letter from the education authority the week after the interview: the job was hers. She went to work elated then underwent a few hours' doubt as she looked around her, checked her monthly payslip and told herself that however stressful her current job was it wasn't as stressful as teaching. But this didn't last. The perfect antidote arrived in the form of an obnoxious money-driven ghoul still living in the eighties who treated her like a fellow-traveller. She dealt with him, then took a long lunch to compose a letter of resignation. Each word was a thrill.

Today was Tom day. He was coming down to town in his muddy jeep tonight. Cath had given him directions to the flat which he took down very seriously – she sensed him furiously writing, as if he was Livingstone and she was unknown Africa.

Cath booked a restaurant near the flat, knowing that Tom would find it difficult to sort one out. Tonight would be a first for him, and would be strange for her. Amusement mingled with trepidation and she still wasn't sure why she was doing this. Maybe Tom was a way back, or at least a safe signpost on the road. If so, she was using him and Rob would approve. Take what you can from everyone every time was his motto. He was an instinctive taker, and had taken from her for ten years but this was the first time he'd come into her head for a while, which was good. Cath wanted him to steadily fade, especially as he'd kept away. This quite surprised her. Pride must be conquering his weakness for once. Maybe he could create something else for himself. She'd like to see his work sell again, otherwise the second half of his life would be barren – but whatever he did she was out of it, for all time.

Martha was coming over this weekend, actually flying. Cath would meet her at the local airport, like a normal daughter with a normal mother. She wondered what Martha's reaction to Tom might be, he was much more like the men back home but she might see that as a negative.

Cath left the office early and delegated the locking up to a junior. The girls thought there was a new man in her life – it was the only thing to which they could attribute her lightened mood.

She'd booked a table for 7 o'clock – too early, but Tom had to be up at unearthly times in the morning. Already she was thinking of him as someone who needed looking after. This was the only type of man she'd known, maybe the only type that existed.

There was time for tea before she showered and changed. Cath sat in the bedroom and read a letter from Martha she hadn't had time to open yet. It was full of her excitement for the weekend, written in a scrawly hand with occasional spelling mistakes. She couldn't remember the last time she'd had a personal letter; her mail was usually junk or electronic these days: quick, convenient, and soulless. If she hadn't been thinking of her mother she might not have noticed her photograph had been moved. It was turned to the wall and she turned it back without much thought at first, but then was puzzled, for she couldn't remember touching it. There was nothing nearby, so it was strange the picture had been disturbed. Cath had a vague sense of unease and began to look around the flat but everything was how it should be. This meal with Tom was making her nervous, she must have knocked the frame around on one of her rare dusting excursions.

She changed her mind twice about what to wear. The black number was not right for Tom, the party frock definitely not, so she settled on a business suit, which was apt, for she wouldn't be surprised if Tom thought of this as a business venture. He rang the doorbell dead on time and if anyone could be beaming and bashful at the same time Tom was it.

He looked around wide-eyed as she gave him a brief tour of the flat. Like a magazine, he murmured. Tom had tried to dress to impress but had bizarre notions of what might impress her, or any other woman. The shirt and tie were new, straight from Marks and Spencer, white shirt, golf-club-type tie – which was alright because Tom would never set foot in a golf club in his life – and trousers which for once were not corduroy. He wore charcoal-coloured wool which slimmed him down quite a lot.

We can walk to the restaurant, Cath said, it's only two minutes. It's Italian, that alright?

Yes, great.

She fetched her handbag from the bedroom and laughed at herself as she checked Martha's photograph again.

What Cath expected to be an ordeal turned out to be quite a pleasant evening; although this was new territory for Tom he was determined to learn quickly. He was clumsy and totally un-streetwise, but she liked his bluff honesty and the way his confidence grew from nothing until he actually made a stab at conversation. She was still close enough to her own shyness to know how crippling it could be. Hers had needed tackling in order to escape Clare, but Tom had stuck with his, letting it trick him into thinking it a natural state, until he was at its mercy – abetted by that mother of his. He was disconcerted by her choice of veggie food.

Don't mind me being a farmer, do you, raising all that meat? he asked.

His outdoors face was redder than ever from the one glass of wine he'd carefully sipped.

Cath thought she might mind but said something to put him at his ease. Relieved, Tom ordered steak. She was determined to keep Rob out of the conversation and to her surprise Tom didn't mention him either – another small step in his exorcism. She told Tom about the teaching job and he talked about the running of the farm. She was amazed he could cope with it all with only his mother to help him. She almost asked if she knew he was here. She did ask about his father, and found out he was killed ten years ago.

Ten years ago next week, in fact, Tom said. The tractor turned over on him in the top field, the steep one. A lot of farmers are killed like that. I was away at the market and Mam couldn't contact me, no mobile phones then.

Tom laughed.

Haven't got one now, be at mam's beck and call too much.

Cath was glad to see this glimmer of resentment, of normality.

Were they very close, your parents? she asked.

Tom shrugged, an action which moved all his body. He was a powerful man and his frame rippled as it strained to get out of unfamiliar clothes. He fingered his tie as it bulged against his bull-neck, determined to keep it in place. Cath knew Tom would

have no idea how to take this relationship forward; if she wanted it to develop she'd have to take charge.

Tom insisted on paying for the meal. Initially Cath resisted, then realised that to do so would destroy his newly-found confidence. He fumbled for his wallet and carefully counted out the notes. Cath added a tip.

Oh, I should have done that, Tom said, I didn't think of it. This is all new to me, bet you couldn't tell that, eh?

A Tom witticism, maybe his first ever, and Cath liked it. They walked back to the flat but it hadn't even crossed Tom's mind to come in. His shyness came rushing back, as if he was in awe of what he'd achieved tonight. He mumbled goodnight, reached for her hand, shook it and strode to his Landrover, which stood out, real and necessary, amongst the gleaming off-roaders her fellow residents used for shopping.

•

It takes me a long time to get from Cath's flat to the centre of town. I manage to stumble past the new pubs in the bay area. The first one of age I see attracts me. I need to feed the fresh anger building in me.

More Guinness, more scotch, more money used, and a bag of greasy chips from a Chinese to follow. They sink like concrete into my stomach, then I spark out on a bench until woken by shouting kids. This is getting to be a habit.

A shambling trek gets me to the bus station ten minutes too late. Crossman has ruined another brave new day. For a moment I think of blowing the rest of the money on a taxi back to the hills but resist the temptation to press any more destruct buttons. I wouldn't be able to bear going over every stinking detail next morning, with empty pockets mocking me.

I stagger through the city, in that limbo between pissed and sobering up. It's jumping, people transferring from pubs to clubs. I'm in the thick of them, youngsters mostly, youths in short-sleeved shirts, girls in shorter dresses, protected from winter by the booze inside them. It's inside me too but I know it's winter – by Christ I do – perhaps this is the difference between young and old drinkers. And I feel old, suddenly the years mount

up and smack me in the face. I smell my own mortality, as I smell the grease of the chips and the sour sting of old whisky. I throw up suddenly into the doorway of a bank and look round shamefully. There's no need to, others are doing it up and down the street, giving it the late night special treatment of piss, vomit and blood. It seems a short while since I was one of these clubbers, but it's been twenty years, half of which was spent with Cath. Someone bumps into me and actually apologises. *Sorry pop*, rings in my ears like a condemnation. I think I'd prefer a kicking. At least I'm sobering up.

Pushing a way through crowded pavements I head north out of the city. At traffic lights something beeps at me and I hear my name called. I take no notice and walk on, wondering if this is the onset of my first bout of DTs. Then a Landrover pulls up alongside me and I'm looking at Tom's stupid grin.

I thought it was you, Rob. What are you doing here, where are you going?

I can't believe my luck, this is the first time I've ever been glad to see the man. I was just about to start sticking out a thumb.

Been drinking, Tom asks?

Jesus, I don't want to endure questions like this for half an hour. I tell him I've been seeing some artist friends and that I missed my connection. I climb in, hunch up and pretend to nod off, and for once Tom's also quiet. Slyly, I take a closer look at him at the next lights. He's dressed up and in the city. Maybe he's got it together to try to find a woman – or pay for one, more like – but I don't care enough to ask, and my pretence at sleep becomes the real thing.

Tom drops me off at the cottage. I mutter thanks and am inside before he can ask any more questions. I don't want to sleep now, I'm wide awake, adrenaline is surging and there's no way of dissipating it. I start a fire with what's left of the wood and check to see I've still got the rest of the money. It's there and I find comfort in putting the notes on the mantelpiece. I sit in front of the fire and poke at it idly, enjoying the sparks I make, rearranging the logs.

It was hard leaving Cath's flat; the urge to stay was strong. I feel part of my mind is working independently, it thinks of Cath, it rages, then shame clicks in and the mix becomes confused, but

even more potent. Then I'm calmer and there's a brief period of introspection. The vicious round continues until my head splits and the voice starts again. I can't break out, can't rid myself of this demon. Cath was the escape for miser-loner-loser-bitter-twisted-bastard Crossman. Yeah, that about sums me up. Maybe I should talk to someone, try to get help.

There's no more wood so I use an old unfinished canvas. I break it up and watch pieces of landscape burn, the oils melting into better shapes than I could ever paint. A bit of mountain sinks into the flames, sky combusts. It warms me and serves a useful purpose. Soon I'll be ready for bed. After another few weeks of eking out today's money, maybe I'll have lost enough pride to approach social services. The artist as deserving case: *And what have we been doing for the last twenty years, Mr. Crossman?* God knows when I last paid any tax, national insurance, stuff like that. I'd be manna on two legs for them if I slipped back into the system.

I'm thinking about the men Cath might be with; it's an exquisite form of torture, pure masochism, but I can't help doing it. Maybe that suited goon I saw her with, or maybe she's taken up with someone safe, secure, the antidote to Rob. Someone like Tom – God, what a thought that is. Paranoia flares up again and targets Tom. What the hell was he doing in the city at that time, dressed up like that? No, that's ridiculous Rob, even by your standards.

•

From the viewing area Cath saw Martha exit the plane, moving quite jauntily down the steps and looking around her with interest, younger in manner than Cath ever remembered. They greeted each other with a hug. Others were doing the same but this was a first for the Galbraiths. Cath drove back to the flat, answering a flood of questions on the way. She doubted they could ever make up for the lost years, but the change in their relationship had come at the right time for both of them.

Martha liked the flat.

And you have such a nice view, she said. Look at the sun on that bay.

Not a patch on back home.

But you're in the heart of the city here, in touch with everything. This is a modern place for a modern woman.

They stood on the balcony, excited by the presence of each other, but also comfortable with it. Cath hadn't told her mother about the teaching job yet. She made them a light meal. They were dining out tonight – she'd booked a table at the new Japanese restaurant nearby; it was overpriced but she wanted to give her mother new experiences, to add to the new experience of being with her daughter. Cath felt a fledgling warmth for Martha developing.

After the meal they took their drinks to the sofa Cath had positioned to look out across the bay. Martha sat back and sighed.

You were right to get away, she murmured, a woman can be herself here.

It wasn't easy at first.

No, I can imagine, and all those years with Rob. I never thought you'd finish with him.

Neither did he, but it's over, really.

I didn't think he would keep away, it doesn't seem in character.

No, I expected to be phoned a lot, at least.

Well, be glad he hasn't. Let the wounds heal now.

They finished the wine and were both a little affected by it. Cath used to hate her mother's drinking, with all the righteousness of youth, but now it was healthy, and healing, an act of a union rather than escape. Martha was no longer a sherry-sodden woman trying to get through blank days.

Do you feel your time with Rob a complete waste? Martha asked.

I did at first, when it ended. He was hardly good partner material – not even good *man* material – and he was only focused on himself.

Men are generally selfish, Martha muttered, I should imagine creative ones even more so.

But it was an art form with Rob. God, he was such a timewaster. It was the only thing he ever had any real energy for, he'd chase dreams, projects that were dead in the water before they got started. I think that he had a need to suffer. I don't know, I'm

starting to talk like an agony aunt.

Martha smiled and finished her wine.

But you are talking, and that's good. Cath, do you mind if I have a lie down? The flight was short but getting to the airport was tiring, and this wine has finished me off.

Martha was using Cath's bedroom and saw her photograph on the dresser.

You framed it, she murmured, touching Cath lightly on the shoulder. Wake me up in good time, I want to look my best for this new experience.

A possible new man and a new mother in one week, a social whirl indeed. Cath was beginning to see Tom in this way. The challenge he might present would be of a different order, nothing like Rob; he wouldn't be big on surprises (or secrecy, or putting himself first at all times) but she found it hard to visualise a future with him. Stop thinking ahead, she said to herself, you'll come unstuck. Rob was good at that, especially when that phony existential crap of his wore thin. His idea of security had been to keep her working and paying, so that he could get on with the living. He'd make an ideal politician, she thought, so able was he to believe his own propaganda.

Cath gazed out over the bay, and saw again the look on Rob's face when she told him about this flat. For once she'd surprised him; this was the start of her breakaway, and his exclusion. He knew the game was up even if they took another year to stop playing it.

Cath had never realised how graceful her mother was. The waiter took them for sisters and for once she didn't think it was bullshit, nor an insult to her. Tonight they *could* be sisters. Martha looked many years younger than in Ireland, she had kept her figure trim and her hair long. It was the colour of Cath's own but was not out of place on a woman of her age.

People think you should cut your hair when you start getting on, Martha said, but I've never accepted that. It seems like a form of giving in to me, accepting that you should change, whether you want to or not.

Martha handled the Japanese food as if she'd eaten it all her life.

What would the lads back home say to this? Cath said, gesturing

to their array of plates.

Oh, your father wouldn't have served this to the cattle, and Padraig, well, he wasn't as innovative as he liked to make out. He'd have made a short speech about trying new things, poked the stuff around, then joined forces with your father. And they'd call this saki stuff poor quality poteen, but I like it, Cath, and I like being here.

Cath thought it was time to tell Martha about the job.

Finishing with Rob is not the only big change in the offing, she said. I'm going back to teaching.

I thought you liked advertising.

Not really, it was more to please Rob. He hated me teaching, kept going on about it being useless, especially the school I taught at.

Have you got a job, then?

Yes, I start in the summer term, at the same type of school as before.

You're not making it easy on yourself. Are you sure this isn't a reaction to Rob?

I've thought about that, and it isn't.

Well, if it's what you want, you did train for it.

They walked back to the flat. It was a bright night but no-one was about, there rarely was in Cath's part of town.

Strange, we're in the city yet it seems so quiet, Martha said.

Only this part of it. People here mainly lock themselves away at night. All the action is in the old part of town.

You'd think it would be the other way. It's funny, there are not that many people in Clare but this place seems emptier.

That's because you expect it to be different. The people who have moved here aren't interested in making a community.

And you don't mind that?

I haven't yet, but I don't know if I want to stay here for much longer. I don't even know the name of the woman next door and, on a teacher's salary, the flat will be too expensive.

Martha did not stay up but Cath sat on the sofa for a while, watching the lights work their patterns on the water outside. The man-made bay was calm as always; a charcoal table of reflected night which she found soothing. Sometimes it bored her, though, and she longed for the crashing breakers of Clare, the sound of

water being sucked back from the pebbles, so strong she thought it might drag her childhood bed with it; to feel the moon's pull on the earth and the land flex its muscles around her. Perhaps she would go home, one day. There were schools in Clare.

Cath looked in on Martha as if she was the mother and Martha the child. She was sleeping soundly. They'd taken another step forward today and old wounds were healing.

•

Foraging for fuel has become comforting. I've used up the loose wood that lay in the copse near the cottage and am moving further afield. I need a saw. The axe is alright to smash up half-rotten logs but I want to size them up to fit the fireplace. Tom has lots of saws, but he hasn't called in for a while.

It's a week since my foray into the city and I'm still trying to eke out the money. Physically I'm feeling better; there's been a spell of dry weather, biting cold but refreshing, and whatever I drink in the evening is driven away when I'm out in the open. If my brain's in overdrive I try to shut it down by exhausting myself, gathering mounds of wood which I carry in an old fertiliser sack. But there's so much going on in my head that I feel like a bystander watching all the traffic rushing through, powerless to stop it. Occasionally I encounter people from the village, and always make a point of acknowledging them, but they pass by quickly, especially the women. I must be getting a reputation: that guy who paints, the loner, the drunk whose power has been cut off; the one living like a wild man of the woods.

I'm working in shirt-sleeves cutting wood about a hundred yards from the cottage. It's a still day, with a flare of blue sky above me, but the sun is not quite powerful enough to burn off the frost. Even so, I'm hot and my thoughts are sweating in my brain. They never turn off now, and I know I'm talking to myself. Sometimes I catch myself at it: a question lies in the air, awaiting an answer. Usually I think about my inglorious career, and the chances blown whenever they were within my grasp. When the paintings started to sell, I sat back, enjoyed it, and didn't consolidate. I thought that success would continue to flow into my lazy

arms, and my time in the sun was soon cut short by my attitude. This used to gnaw away at me, but at the moment I have only to think of food, shelter and survival, like any other animal. The years of struggling seem without consequence now – they are gone, lost, like Cath.

Tom's on the quad somewhere up above, I hear his motor chugging. This time I'm determined to see him, and make my way up through the fields, axe over my shoulder. The noise of the engine makes him oblivious to me. The dogs see me before he does and come bounding up, though they are wary of the axe. He's wearing a check lumberjack coat and matching cap, and a few inches of red neck is visible between cap and jacket. An image comes into my head, I'm bringing down the axe onto that neck, a graceful arc of death that will bite through to the bone, the dogs going mad but not daring to get too close. My hands are closing on the axe when Tom turns and sees me. He's startled, and so am I.

Rob, I didn't see you. You're coming up a long way for wood, aren't you?

I was getting logs from the copse and heard you up here.

Tom's uncomfortable and I'm trying to think why. Maybe he's still embarrassed about refusing me the money, maybe his mother has forbidden him to bother with me any more. At forty-odd he probably still obeys her. He turns off the engine and sits on the quad awkwardly.

Everything alright? I say. I haven't seen much of you recently.

Yes, fine, fine. It's a busy time, you know, just before lambing.

Tom, could you let me have the loan of a saw for a while? I need it for the wood.

Relief floods his face.

A saw, yes of course, I've got half a dozen in the barn. Jump on and we'll go up.

Tom picks me out the most suitable tool, wiping a greasy cloth along its blade. We stand in his farmyard, which is cobbled and encrusted with generations of shit. Things are not the same between us. Something has changed and I don't seem able to dismiss him so easily. He's grown in a way I can't fathom, and doesn't fawn over me like he used to. I can't see the crone but feel her eyes on me, watching from the kitchen window and

wondering whether to come out and interfere.

Tom feels obliged to ask me in for tea but I refuse. As I leave, he tells me to take as long as I like with the saw. I will, I think, as I walk back down to my place of work. I've doubled my equipment and feel quite secure. Chopping and sawing logs is work I can see sense and purpose in, it has a beginning and end and benefits me immediately, but it's intensive labour. I've realised how much wood one man needs in the winter. No wonder people hack down whole forests.

There's a kind of solace in the way I work the wood. I'm getting good at it and have mastered various cutting patterns, then the chopped logs are sawn into precise lengths to fit my fire grate. My thoughts follow the rhythm of this work. I see each log as a part my past, so much the better to lay into; peoples' faces appear in the wood, chop chop; Tom comes up a lot, chop chop; and always Cath – and a sad trail of lost friends and old contacts, all of them going under the axe, usually in precise chronological order, the clothes and hairstyles changing over the years. I thought I was grunting with exertion but it's talk, I'm talking at the faces, even shouting sometimes. I chop them away, then start again as they reappear in the next log. They always reappear.

•

Martha's plane was taking off, sun flashing silver off its fuselage. Cath watched it from the observation lounge, letting her hand wave discreetly, sign of a successful weekend. She'd phone Tom when she got back, and see where the call took her. This was an instant decision, and it brought Rob's valley into her mind. As Martha's plane disappeared, the valley's layout unfolded in her head, its green undulations, unspoilt contours and uncrowded landscape only miles from the concrete sprawl she knew. It might be wise to leave the place behind, and the men who lived there, but, like Rob, she was stubborn. Something still drew her to it. Maybe Tom was a catalyst, maybe just an excuse. Even here at the airport, when her mind had been free of him for some time, Rob demanded entry, diving back into her consciousness no matter how much she resisted.

With luck Rob might move on; he was capable of finding a

bolt-hole anywhere in the world, maybe sniffing out one of his former lives. It was not as if there was anything to keep him in the cottage now. Rob could live anywhere – be *Rob* anywhere – it didn't matter much to him.

When she got into work Cath handed in her notice, causing a minor flurry amongst the staff – something for them to talk about on a wet Monday. They thought she was moving on to something better, poached by a rival; a concerned boss came to see her. Cath felt quite wanted as he listed her qualities and reasons why she should stay. When she told him she was going back to teaching he was baffled, then relieved that she wasn't jumping over him: status was maintained. He became formal, assigning her plenty of work for the next month. Her strangeness was confirmed in the eyes of the girls: first she didn't like clubs, now she was leaving for an uncool profession.

Cath's notice period passed quickly, and she left with quick goodbyes, before anyone could organise a do. She'd given herself a week between jobs, to prepare for what was to come. At least she had the advantage of knowing what to expect. Every stroke kids and parents could pull had been pulled before; she'd been punched, head-butted, charged at once by an irate woman-mountain mother. This had been her apprenticeship. At the interview the Head stressed how much behaviour had improved at his school, but she took that with a pinch of salt.

Cath was on the balcony of the flat. It was just warm enough to sit out, a clement April day full of false promise. Optimistic men in shorts dotted the bay area. On the table in front of her was her future, the requirements of the National Curriculum, reams of it that hadn't existed before. It was a shock at first and she went through a period of trepidation, wondering if Rob was still jerking her chain in some perverse way, as Martha had suggested. But she fought off all the negatives and began to wade through the paperwork, knowing that she was no longer upwardly-mobile, yet finding comfort in this. She felt released.

She'd seen Tom twice in the last month, hardly the start of an impetuous relationship. He knew about the teaching job and seemed quite impressed – though it didn't take much to impress Tom. A woman teaching was old-fashioned, something he could understand: this was the problem, everything about Tom

reminded her of her Irish past. She knew he'd treat her like her father had treated Martha, a mix of unhealthy worship and spoiling. This idea had appealed for a time – it was a good antidote for the pills – but she'd had enough fantasy with Rob to last a lifetime. Tom would simply be another kind, the kind that had ruined her mother's life. Nice was not enough after all, she realised.

The second time Tom came down she took him on a tour of the bay, and felt like she was showing an uncle around. She cooked him a meal, which he ate with complimentary enthusiasm and later squeezed her hand, his first move of intent. Tom was setting out his stall and Cath made a decision about him after this. Her first instinct had been right, he was friend material only. Now she had to find a way of telling him this before he dreamed too deeply.

She had found most of her old teaching stuff. It had almost been thrown out, under pressure from Rob. His junk was always vital, hers detritus which sometimes disappeared when she was at work. She'd try to rejig her notes to suit the new ways. Thumbing through the files she'd picked up from the school it didn't look as if she'd have much spare time, but maybe this was a good thing. She could immerse herself until the end of summer term, then go home exhausted, perhaps take Martha somewhere abroad. She'd have to phone her, tell her to get a passport. It came as a shock to realise she was looking forward, that the couples on the concourse below no longer worried her. They were all taking a chance, jumping into pools of infinite possibilities, joys and disasters. She had overloaded on the latter, but perhaps a counterbalance lay somewhere ahead.

There was another message from Tom on the answerphone. He was getting more confident with the machine; at first he'd reported into it like a policeman. He offered to come down again but she decided to go up to the farm, she wanted to explain to him the reality of their relationship on his home ground and she wanted to meet his mother, let her know her son could have a woman friend.

Tom had told her his routine and she knew Sunday was the best time to catch him with a spare moment. With teaching due to start the day after it was best to get this over with now. Cath

had nothing to feel guilty about but she still felt bad, so much so that Rob didn't come into her mind until she looked down on the valley and his cottage. The hillsides around her were plumping up, taking on new growth, but his place still looked bare and isolated. That there was no old car outside made it seem even lonelier; she couldn't see any chimney smoke either. Maybe he *had* taken off – if so, she was certainly not going to bring it up with Tom.

She drove into the farmyard where the dogs greeted her, yelping around the car, their tails working overtime. Tom's mother came to her kitchen window, then to the step outside. Mrs Pearson was as territorial as the dogs and she assumed intruder alert position, with hand on hip, an inquisitive squint and then the question.

Yes?

Is Tom here?

You want my Tom?

I'm Cath Galbraith, Mrs Pearson, you might remember me from...

I do. You were with him, down below. Not with him now though, are you?

Cath was being appraised as Rob's woman, which she'd always be for her, tarred with the Crossman brush. She was right, Tom was far too close to old territory for it to ever work, even if she could be attracted to him in the way he wanted. He drove into the yard on his quad, breaking the awkward silence.

I thought I saw your car, he said to her, as he bounded up.

He was caught between two women and was flustered. He obviously hadn't told his mother anything and she was still waiting to know what Cath wanted.

Uh, do you want to come in? Tom asked.

Tom offered to show me around the farm, Mrs Pearson. I'm sorry, I should have phoned.

Yes, you should have.

Mrs Pearson turned and went back into the house, telling Tom that his dinner would soon be ready. His mother had been caught off guard, but she'd soon start to wonder why Tom had asked Cath up, and when.

I don't know who's more surprised, Mam or me, Tom said.

Thanks for saying what you did.

I thought you might have mentioned me.

He flushed a dark red.

No, I haven't got round to it. I suppose you think I'm a bit wet.

Not really.

It's just that Mam can be a bit awkward, specially about anything new.

This was good, she could end this before Tom's mother knew anything.

Well, come on then, give me a ride on that thing. The dogs can come too.

At least she'd get him to ignore his mother's precious meal times, encourage one small revolution. Tom drove into the sun, which competed with the keen wind that was always here. It shaped the turf and stunted trees, making them bend to its will, reminding Cath of her west coast. Tom drove carefully along the ridge, pointing out the new lambs.

It's been quite a good year, he said, we haven't lost many.

Rob's cottage was on the periphery of her vision, and she fought down a desire to stare at it. As she fondled the head of one of the collies the other pushed into her hands. Tom was tense, as if he sensed something was about to hit him.

You've got two good friends there, he said.

Stop here, Tom, we can see all the way down to the sea.

That's right, it used to fascinate me as a lad, because we never went there. I used to sit up here and look at that grey strip whenever it caught the sun, and wonder if I'd ever get away from the farm.

Did you want to?

Sometimes, but dad died and that was that. I was the one left here, and Mam wasn't getting any younger.

So you care for her and the land.

I'm not sure I'd put it like that. She does all the bookwork, that's why I couldn't lend Rob that money. She's in charge of it all.

You don't mind that?

Well, it's the way it's always been, just the two of us, until now, that is.

Again his face flushed and a hand reached for hers.

I came up here to talk about us, Cath said.

She wanted to make it kind, and brief, but the two qualities rarely went together. Rob would spend hours bullshitting around a situation like this, trying to make the woman feel he was doing her a favour by dumping her. Tom turned off the engine and watched her intently with an open face, innocent of guile, the antithesis of Rob's.

For once, they were almost matched in inexperience. Cath's former relationships had been brief, fizzled out after rows or unreturned phone calls. She was still patronising Tom, treating him like a child. Get it done quickly and get away from here was best, for both of them.

I've enjoyed your company, Tom, you're a very nice man, but I think you're getting the wrong idea. I'm not ready for another relationship. I should have told you this straight away but it's been a difficult few months for me. There are too many memories down there.

She flicked her head towards the cottage, without turning.

A friend would be nice, though.

Tom was silent for a long moment, and she wasn't sure how he'd react, or what he was thinking.

A friend, right. Look, I haven't insulted you, have I Cath, been a bit too pushy? I know you might think it's a strange set up here, just me and mam, but I did think about Rob, you know, being so near and that. Yes, friends, maybe that would be for the best...

He trailed to a halt. Cath couldn't think of anything else to say that wouldn't sound crass or feeble, and wished she hadn't called him nice. Tom didn't wait for the silence to intensify, he started up the quad and turned back for the farm, his face set. When they got back his mother didn't appear but Cath knew Tom would be bombarded with questions as soon as she left.

Do you want to stop for dinner? Tom asked, there's always plenty.

She liked him for having the guts to ask, for braving his disappointment and his mother. Sadness welled up in her. Life was so poor at matching people up; she felt sorry for Tom and for herself too, if she was honest, but didn't show any sign of it – that might encourage Tom to maintain some hope.

No, it's a bit early for me, she answered. Look, I'll be busy settling in to the new job for a few weeks but let's get together after that.

Right. As friends.

She was taking the cowards' way out for she knew that he'd never phone again. And she'd lied about the food – she was starving, but they'd have nothing for a vegetarian, and she'd choke on it anyway, with Tom's mother glaring at her. At least she'd given Tom one tiny adventure; perhaps he could go on and have more now. As a goodbye she brushed his cheek with her lips and felt the need in him surge. How he longed to hold her, in the way she'd always wanted Rob to.

Cath took the top road out of the valley but changed her mind and turned down the lane to Rob's cottage. It was an instinctive, unavoidable action. She was taking a chance; he could be anywhere, even walking along the lane, but she drove past the cottage, slowing down for more than a cursory glance. It looked empty; appropriately, the sun clouded over, darkening its windows, and casting the interior into gloom. Rob used to refer to the place as Bleak House to annoy her, and it was living up to its name now. For a moment she was tempted to seek him out, to put a final seal on the last ten years, but she went on, ears ringing with all the rows they'd had in this place. Its masonry must echo with Rob's rants, she thought, that hectoring, pleading, snake of a voice in full flow. Cath shook it off as the cottage diminished in her rear-view mirror; tomorrow she was starting a new chapter, moving on.

•

I'm working neat cuts into the thicker logs, full-blooded swipes then rapid short strokes. Making patterns is becoming an art form: Rob the log-artist, the axe-sculptor – maybe there'd be a call for it in this age of crap posing as innovation. I could invest it with mysticism, perhaps add a religious connotation or two, and create another career for myself. My mind's wandering down the nonsense road again. I'm woodcutting on auto-pilot, yet when I surface there's a pile of logs, and I still have all my fingers.

I'm eating very little and not drinking much for there's no money for that either, yet I never feel quite sober. I float through my days, having engrossing conversations with myself, in which

reason debates with anger. Anger always wins. To greet the spring sun I've made an effort to shave today, scraping a week's beard from a face that I no longer like. I don't like its red-eyed squint, its matted hair, its creased, yellow skin. Sometimes, I try to surprise it in the mirror, glancing at it slyly, suddenly, but it's always ready, and stares me out every time.

For weeks I've been hungry, trying to sleep with it, waking up with it, trying to fill my stomach with cereal, bread, potatoes, the cheapest stuff. Cath would approve: there are no dead animals in my diet, they cost too much. Each day I will myself to get help, to get a job, to approach the state, but it's always better to do it later, and later never comes. My system seems to drift in a permanent state of *mañana*, until everything is dreamlike, and less urgent. I think of old days constantly: that first time in Spain with Cath, driving away from the other tourists in a battered Citroen estate, another of my monster cars. I thought I could invest in Cath what no-one had ever invested in me. For a few weeks the fantasy was maintained and I glimpsed what life might hold if I could sort myself, but when we got back the real Rob returned, and happy, optimistic, even *kind*, Rob was left behind in the Spanish dust.

I'm enjoying the spring day, the sun on my back, the simple task of woodcutting, but the axe is losing its edge. I'll have to go up to Tom's and borrow a sharpening stone. They'll be having Sunday lunch up there soon, lamb probably. I'm tasting it, tangy with mint, nestled in gravy, alongside a small mountain range of new potatoes. My stomach starts to pay homage to this image, cramping on me, telling me how much I'm abusing it, willing me to go up that hill. It even wants me to sit with the crone, to smarm all over her so that it can eat. I toss it another cruel image, heavy desserts, the type she'd specialise in, the only type she'd know. Spotted dicks, tarts swamped with thick custard, and bread puddings. I settle on the latter, golden brown crust, soft underbelly eyed with currants, with perhaps a dash of double cream over it. That would be the right fare for a woodcutter.

The logs are starting to resist the axe-blade and if the edge is not put back on it will be permanently damaged. I'll take the axe up to the farm with me, sharpen it there, let Tom see my worsening plight, and stare at his mother through the kitchen window

with the axe over my shoulder.

There must be a phrase for it. *Bolt from the blue, hammer blow*, or the up-to-date *gobsmacked*, but no, even all three combined would be hopelessly inadequate. I'm walking up to Tom's, about to push out of the copse that obscures this part of the hillside, and see Cath going past, on the top road in her red hatchback. It is her, I can see her clearly behind the wheel. She's coming down to the cottage, down to me. Christ, my head's reeling, everything will be alright now, and life will resume again. I'll have comfort, warmth, and money. But at the junction of the two lanes she turns up towards Tom's farm. Maybe she's going to plead with him, get him to give me the money. Hang on, Rob, Cath doesn't know anything about it, she's finished with you, remember, since millennium night, when it all blew up in your face.

I slump down, my body sags to the cold ground as if my legs have being kicked from under me. I've been drifting for weeks, in ever decreasing circles of existence, fed on routine woodcutting, daytime dreaming, and solitude. Now I'm jerked out of it, Cath's bursting into my life again, but in a way I can't fathom. I'm still holding onto the axe. It's cold in my hands, but comforting. It's been with me all this year, supporting, cajoling, giving me a purpose. The saw is just a tool but the axe is a friend, part of me.

I follow Cath's progress and have a good view of the farmyard. The crone's talking to her – and there's Tom, arriving in that stupid quad of his. He seems agitated, his body language is obvious, even from here. The poor bastard is shy. This must be to do with me, why else would Cath be here?

She's getting in the quad with him and those poxy dogs. That's it, he's bringing her down to the cottage, saving her car from the morass of the lane. I prepare to dash down to meet them, to shout and wave the axe, but they turn up the hill and go back along the top road. I get up and try to follow, keeping inside the cover of the copse. The quad outstrips me so I throw down the axe and run. I thought woodcutting was getting me into shape but I'm wrong, within seconds the steep incline has destroyed my chest and I can taste salt and blood, but I'm desperate to keep up. I don't know what the fuck is going on here but I'm desperate not to lose sight of them. They stop and my shattered

lungs are grateful as I slump down in undergrowth, my eyes fixed on them.

They talk for a few minutes and Tom gestures over my hiding place, which makes me sink down even further, but he hasn't seen me. He's pointing down to the coast, as if he's showing off his territory. Cath doesn't want to approach me without some current knowledge, and Tom would be a likely source of information, living so close. Yes, of course.

I'm calming down, starting to plan my response, when Cath turns up at the cottage. I'll be cool, but with a hint of victory. Money, Christ, the thought of it. We'll go on holiday, a long weekend in Barcelona, drinking cheap brandy in the Ramblas, eyeing up the best looking working girls in the world – or maybe Amsterdam, lots of stuff to relive there. All my crap about the solace of being alone flies away, and I wave it goodbye, full of plans that Cath will pay for.

I must have blinked, maybe even looked away for a moment. When I focus again Tom is touching her, putting one of his hands over hers. I'm sitting up now, my eyes unflinching as a hawk's, as sweat turns to ice on my back. Tom doesn't do shit like this. The man I know would never have the nerve to touch Cath, for him that would be like exposing himself. He'd never touch her, unless he'd done so before, exposed himself before. A fat, slimy penny slowly begins to drop, edging forward in my mind towards the precipice but I don't fucking want it to drop, what I'm thinking is impossible. *No it isn't, you stupid bastard.* The voice inside snarls at me with disdain. But Cath couldn't, not with Tom – *yes of course she could, it would be the payback of all time, confirmation of her hatred for you.* Images of them together flash through me, I can't stop them. What was Tom doing down in the city that night, and why haven't I seen him lately? The voice is in full flow now, castigating, teasing, shaping my every thought. My stripped-down lousy soul can't hide from it; it flays me, then asks me what I'm going to do about it. *What* are *you, Rob, what* are *you?*

I don't fucking know, leave me alone, let me think, my head's splitting. Cath through the years appears, at her loveliest – but Tom is with her, at *his* loveliest, rough, weather-worn skin, ridiculous clothes, beast-like gait, gawky behaviour, street-cred

zero. It's impossible but I know it's happened. I shouldn't have let Cath go, the bitch. Tom must have stood up to his mother, a ridiculously late stab at maturity, at independence, at happiness. And I asked the man for money. How they must have laughed at that. I smile a bitter smile and my lips are almost split on my clenched teeth. *What you gonna do about it, Rob, eh, eh?*

It seems like I've been here an age but it's only been a few minutes. The quad starts up again. There's been no more touching but there was something very intimate in that hand clasp, a shared confidence, a consolidation of what has gone before. The penny's gone, tumbling down into the Crossman pit.

They turn round, heading back for the farm. I follow, hoping the dogs don't spot me, another marathon for the lungs. Cath doesn't go into the farmhouse, she leaves Tom outside and gets into her car. Fuck, she's coming down to the cottage, I know she is, and I'm stuck on the hillside.

I rush down the fields as she heads down the lane, gaining on me all the time. I try to shout out but don't have the breath. Cath will see I'm not there, she'll wait, I'll shout then, and wave from the fields. Tom was her go-between, that's it, she's been using him to keep tabs on me, until she felt ready. Everything's going to be fine: this message attaches itself to my rhythm, drums out the inner voice. Fuck off, you evil bastard, get away from me, get out of me. Everything's going to be fine, it really is.

Cath's car disappears then reappears as it negotiates the twists of the lane. She reaches the cottage, slows down outside, but doesn't stop. She's going on. I try to shout, but a feeble croak comes out that wouldn't startle a rabbit. The voice comes screaming back, reverberating around my skull. *She's paying you back, paying you back, she knows you're watching, you were right the first time, you fool, you stupid dreaming cunt. Listen to me, to what I say, I'll tell you what to do, I'll sort it.*

I collapse and after some minutes sucking in air I go back to look for the axe. For a moment I think it's lost and experience real panic, but it's there, its red handle visible in the grass. I grasp it to me and feel calmer, but my head's shot. I lie on my back and watch clouds scud over me. The voice calls me all sorts of names for letting hope creep in. I was destined to catch Cath with Tom and I'm being told what to do, how to extinguish the pain that

grips me now. It has always gripped me. I lived with it as a kid but there was no-one to tell. I dreamt of being alone even then, becoming a tramp, idler, monk, anything that involved minimum contact with my fellow human beings. I'm seeing Tom's face in the sky, his homely friendly mug taunts me. I'm Winston looking at Big Brother, loving and hating, wanting to belong but desperate to be outside it all, chasing illusions of happiness until they become warped and hopeless. Am I mad? I ask the clouds; *are you mad*, says the voice, *don't be so fucking stupid, it's the world, not you.*

I haven't released the axe. I don't think I can. I'm working the head into the ground, carving out a small furrow, ruining the edge still further. It will be hopeless now, for wood that is.

I stay on the hillside for some time, trying to blend with it, be part of it, wanting the anonymity of something wild. It's late afternoon when I get back to the cottage, I relight the fire, and make black coffee, the strongest drink in the house. After piling the grate with wood I sit very close to the fire, letting myself roast, as if heat might burn out all the demons. It wasn't long ago I did this hoping for answers and feeling so alone. But I don't feel alone now.

As the light fades outside so the fire gains ascendancy. I place the axe on the hearth and the red handle glows with firelight, as if it's dripping blood. I'm not hungry or cold anymore. I'll go up to the farm tonight, talk to Tom, get to the bottom of this – just talk, get things sorted, give him a chance to explain. Good old Tom. *But take the axe, you wouldn't want to be without that now. It's your friend, you'll never be alone again.*

•

It had been a strange day for Cath, dealing with Tom, and being so close to Rob's place. Driving past the cottage was a final test, to know for sure she could finally let Rob go. His upbringing had made him the way he was, it wasn't his fault, but it wasn't hers either – or the rest of the world's. She could never get him to accept this, and he'd hated her for trying. Nothing was ever enough for him – whatever she tried, however she behaved, he wasn't satisfied. There was a black hole in Rob that no-one could reach, let alone try to fill. Cath had learnt over the years how

much he loathed himself. Rob couldn't face this truth, hence his self-destructive anger. Now she wondered if he hated his very existence, the life that had given him so much pain. She pitied any woman he got his hooks into. She'd write to him tonight, set things straight once and for all. He'd never agree, but staying away is all she could do to help him now. She doubted he'd ever appear at the flat again.

Cath sat on the balcony, with a glass of wine in her hand, late afternoon sun on her face. She realised her future was a clean slate. She'd wiped it clean herself, and felt good about this as she thumbed through the education files, with interest rather than resignation. Unless they had greatly changed, primary schools hardly abounded with eligible men, but she thought it might not be too long before she was casting her eyes around. She wanted to test out the new Cath with a man who was relatively normal. There must be some still around.

Sun had followed her down from the hills and it drew people to the bay. They were milling about below her, stopping for eats and drinks, ferociously in love with life. She liked watching them. The sun had the warmth of summer rather than spring, so she lounged in the seat and dozed. For weeks post-pills she had assumed a foetal position when sleeping, to protect herself from the world, not knowing what the morning would bring, apart from pain and self-recrimination. But that seemed a long time ago now.

Cath was woken by children shouting below. It had grown cool, so she went inside and phoned Martha, something she now did regularly on Sundays. Her mother sounded alert and happy, she was doing things with her days and Cath told her she wouldn't be surprised if she met someone. Martha laughed but did not deny it as she wished her luck for tomorrow.

For the next few hours Cath pottered about the flat, not really doing anything, but enjoying the adrenaline that was building up. She'd probably get up far too early and annoy a jaded staffroom with her new enthusiastic face.

For the third time she tried to decide what to wear. She wanted something confident but not pushy, colourful but not garish. Finally the choice was made and clothes were put out ready for the morning.

She was running a bath when the phone went. For a moment she thought it might be Tom. She cringed slightly and wondered if he was going to be a nuisance after all, but it was no-one. The caller hung up and no number was obtainable. She didn't worry about it. It happened quite a lot at this address, wrong numbers, people trying to sell her everything from insurance to membership of wine clubs. It must come with the territory.

The bath awaited her – and her favourite Preisner. She'd run the water as deeply as possible, all the better to luxuriate in, to chill-out in the way Rob used to, often immersing himself for so long his skin became water-wrinkled. At least he'd given her one legacy of comfort. Rob had been with her since she came back from the farm, and she felt ready for a final analysis now, to spend the next few hours sifting their inglorious time together. Perhaps she might even conjure up some thoughts of him that could remain positive.

She had to go right back for the best times, when naïvety mixed with love, and Rob took care to show her what she wanted to see. She'd made up for her blank teenage years then, they had sex everywhere, including the toilet of a moving train – the ultimate rock and roll. Rob painted like a lunatic, his excitement going into overdrive when he thought he'd done something good, dragging her up to look at a new canvas at three in the morning. There was music in everything – he played a lot in between painting – and lots of laughter too, the wry humour he specialised in and which she loved. She sucked it all up, Rob was the perfect antidote to growing up in Clare. Then came the time he made money, quite a lot of it, and spent it like fun, contrary to all he had formerly preached. She remembered him coming home from that first London exhibition and showering her with money, bursting into the bedroom and throwing notes at her, tipping it out of a cardboard box and shouting *I'm on top of the world, ma,* like a demented Cagney. He was so close to happiness then: he could almost feel it, touch it, taste it, smell it, know what it was. Rob, her fantastically flawed man.

Cath dozed again, drifting away in the water, and letting the music play over and over. She dreamt she saw Rob standing over the bath – but not Rob then, Rob now. Wild, dirty, hair everywhere, and what looked like dried blood on his hands. Preisner's

strongest piece supported this image with a Latin chorus and a savage scoring of strings. She blinked but Rob was still there and she wasn't dreaming.

•

Night comes through the window. I like the way light holds on to the edges of the sky until the last moment, then is gone. On the table next to me is the remains of my worldly wealth, less than five pounds. I still dream of passive intervention – the phone rings, it's London, offering riches for my canvases, demanding them all. *Pity your phone's been cut off, Rob.* You've *been cut off, your balls are gone, you're a nobody*, says the voice. *Put it right. Tonight.*

Crossman is cool. I've had the last of the sun, striking my face through the dirty window as it sank in the west, and the fire has warmed me. Who needs food? Eating is overrated, this is a comfortable state. I'm sinking ever lower but I won't make any effort to change things. Effort belongs to yesterday. My inner friend is not saying anything and when he's dumb my thoughts travel along a different route. Maybe this is the end, my final descent into oblivion: to sit here until the spark is extinguished, snuffed out as if it never was. I wonder how long it would take for them to find me, long enough for it to be dessicated Crossman probably, bag-of-bones Crossman. I'd have publicity then alright: artist oddity found dead, gone unnoticed for weeks, police say death is not suspicious, just pathetic. There would be a speech by someone on the breakdown of community values, another might spout off about the place of the artist in society and Tom would say I was a good bloke. Then nothing, I'm over.

I've thought a lot on death lately, I like thinking about it. I had a goldfish when I was a kid, someone brought it home for me from a travelling fairground, a few centimetres of orange in a plastic bag. Presents were rare and I was thrilled. I found a glass bowl for it and George lived, and lived, until he was twenty-two years old, which is probably some kind of record. He went with me to many addresses, got left behind and picked up again, turned from gold to lumpy silver, had a few dices with cats, lay inert on the bottom of his world for days on end but always

recovered. He was the one permanent fixture in my life and witnessed my quick getaway from a soulless home, saw the women come and go, the opportunities blown, watching cold-eyed as my life was dissipated. I was thirty-three when he finally shuffled off his fishy coil, and I swear I was more affected by this than by any human passing. Something that was truly mine was taken away, which brings me to Cath and the man on the hill. Ah, my friend's back, jerking me out of this mood, cutting through this brief moment of calm like one of my axe strokes. I'm getting used to his tone. It's a hectoring rasp, slightly high-pitched, a caricature of my own. *Cath was yours also*, he says, *for ten years, long enough to belong for life.*

I brew some tea from the kettle that's simmering on the fire, it's black and bitter but I'm used to it now. There are a few biscuit remnants left which I try to dunk in it but they crumble and are immersed, so I'm drinking a lumpy kind of biscuit and tea stew.

The axe is watching me. I imagine a pair of eyes in the handle, like something malevolent come to sour the magic of wonderland, chasing all the Little Red Riding Hoods through the forest, all the Caths. And the sky is a sympathetic red tonight, layering the hills with a comforting hue. I pick up the axe, rub my hands over it, pat it with approval and check the time by the clock on the mantelpiece. Its glass cover is cracked and I use it as a mirror sometimes. The cracks divide my face, and I'm cut up into neat sections, the many faces of Crossman. I'm not sure how many I have anymore. We're humming to ourselves as I get my coat... *All of me, why not take all of me, can't you see, I'm lost without you, take my hand...* And I take up my axe.

It's not quite dark yet. The owl must be hungry for it's out early. I wave the axe at it and its heart-shaped head veers away from me. Wise owl. Something much smaller flits past, a bat, blind but still able to seek out food. Spring is well on course now and the air has a warmth; compared to a few weeks ago it feels almost balmy.

The tune stays with us as we trudge up the lane, one from the golden age of song, when music was innovative and exciting, thrusting out confidently in search of new ideas. I imagine myself at the forefront of it, sax blazing. Would I have been a failure then? *Of course you would, Crossman, it's the one thing you*

were born for, unless you do what I say tonight.

I'm outside Tom's farmhouse, on the other side of a wall with the sheep. I'm moving so quietly they aren't disturbed by me. All that's needed to make the night perfect is a full moon, but it's overcast – the sunset lied, the night has turned damp, a fine drizzle drifts into me as I stare at the house. A light is switched on upstairs, then turned off again after a few minutes.

The coat I'm wearing is far too hot but I chose it for its deep pockets. I'm able to put the axe head in one of them so that the handle protrudes upwards, to be clamped by my arm, like walking with a swagger-stick. I could leave it outside and just knock the front door but that doesn't seem right somehow; the back way calls me, there's a door there that leads through to the kitchen.

I knew it wouldn't be locked, Tom's not the type. I open it gently, and am transfixed by the smell of food; it spills from the kitchen, where the air is still redolent with the Sunday roast. Mrs Pearson is a woman of tradition. Very slowly I push the door open. The kitchen is empty, they must be in the living room. I can hear the television, a hymn being sung... *all things bright and beautiful, all creatures...* It fits, the crone has the right blend of sanctimonious meanness for religion; she might even sing along – and I might join her. It's turning out to be a musical evening.

The remains of the joint are on the table. It is lamb. I pick at it like the starving man I am, all else forgotten for a moment as meat is crammed into my mouth and swallowed

I see the shotgun on the wall above the kitchen range. I take it down; it's clean and in good order but I need to find the cartridges. The furthest place away from the heat is the old-fashioned scullery, divided from the kitchen by a half-glazed door. And here they are, in a box on the first shelf. I tip out the contents and find the slim orange cylinders with brass ends quite beautiful. I load each barrel with perfect symmetry and put two more cartridges in a pocket. I feel calmer, more secure. *That's it, Rob, you're doing well.*

There's a noise behind me, and I turn to see one of the collies. I've surprised it but it doesn't bark, it backs away from me, snarling, keeping low to the floor, perhaps because of the gun I'm holding. Where's the other one, I wonder, as I throw it a

piece of meat which it tries to ignore but can't. You're not doing your job, mate, I mutter. Any second now, Tom or his mother is going to come through the door and I have no idea what I'm going to do. I wait for orders as I check myself out in the kitchen mirror. Shotgun over my shoulder, axe protruding from pocket. *Weapons suit you, Rob, they make you larger.*

I step into the darkened hallway and shut the dog in the kitchen. It seems glad I have. In the living room they are striking up another hymn, which I don't know, but it moves along with gusto. I'm tapping the axe handle to the beat, gaining in confidence as the voices swell, feeling I've had one small triumph already and glad of the cover provided by the singing. It lends a certain formality to my presence here, a certain rightness.

The other collie comes out of the darkness at me. This one also snarls, but is the more courageous of the pair. The crone shouts for the dog to shut up as the axe comes alive in my hands. The dog has already nipped my leg and is trying to leap at me again when I catch its head with a swipe, quite a satisfying crunch which stills it instantly. It flops at my feet but is still breathing, its chest rising and falling with rapid bursts. The crone opens the living room door as I'm about to push in. She puts her hand to her face but doesn't scream as I shove her back inside. I'm not surprised she takes a moment to recognise me. Tom isn't here.

Her eyes are on the gun, then the axe. *We have centre stage, my friend.*

You. What the hell's going on? she manages to gasp.

Not a good word, Mrs Pearson, in the wake of your hymns.

The programme is finishing and I turn off the set. There's an eery silence for a moment, then I hear the other collie whining and scratching at the kitchen door.

I knew you weren't right. What have you done to the dogs?

They're alright, one's in the kitchen, one's resting.

I'm standing over her, feeling quite calm. It seems I have all the time in the world to think, to take any action I want. *Yes, that's right, you're in control, for the first time in ages, now make sure you keep it.*

Where's Tom?

He'll be back now. You'd better go.

Tom must be out in the fields, he won't have any idea I'm here. I'll sit and wait for him, with his mam.

Look, what do you want, coming in here like this, with that thing?

She points to the axe and seems more concerned about it than the gun. It's the symbolism it carries, this age-old instrument of retribution. I have to admit she hasn't gone to pieces, she's far too hard for that. I look at her closely for the first time. Her face glows with apprehension, beads of sweat mark it; it's a severe face, but shows evidence of a former beauty. Proportionate bone-structure, eyes that have kept their character, and hair which is still quite lustrous – let down only by the hairs on her upper lip, enough of them to make a slim moustache. It's an unfulfilled face which disappointment has hardened, setting it against the vagaries of life. I wonder how her life has been and think of Cath's mother, Martha, another person who wanted to be someone else. Join the club, girls.

I just want to talk to Tom, I say, nothing for you to worry about.

Look, just go back to your cottage. I'll tell Tom you called.

I love it. I've broken in with an axe, brained one of the dogs and she'll tell Tom I've called. The old bitch has got nerve, I'll give her that. If I did go she'd be straight on the phone to the police.

This house is so warm, with heat from the kitchen range and the well-stocked living-room fire. I'm not used to it – my own fuel has diminished to Bob Cratchitt dimensions lately. Tom cuts his logs with a chainsaw and they are neatly stacked up alongside the voluminous grate. The crone glows, I sweat; it saturates me, sticking my shirt to my back and flushing my face. It's hard to stop my mind wandering – it's as if I'm outside of this action – but I'm jerked back. *Keep alert, you've got a busy night ahead.* Alright, alright, I say out loud, startling my prisoner. She looks at me a little differently after this.

Both of us are straining ears for Tom's quad. At least it will give me plenty of warning. I put down the gun, well away from her, and grasp the axe again, making the old woman shudder. I like this, it's power, and I have her full attention. She'd tell me anything – what a good painter I am; how she's always liked me;

that Tom thinks the world of me. I bet I'd get that loan now.

I'm stalking around the room. The collie's whines turn into a series of yelps, as if it's being beaten. I hear the quad chug into the yard.

Keep quiet, I tell the crone, not a sound, if you want to keep Tom safe.

He'll come in the front way and hear the dog yapping, but he won't suspect anything. I step out into the hallway to check that the inert dog cannot be seen in the darkness, pointing the axe at the crone.

Not a word...

I hear Tom opening the front door. He shouts at the dog, which makes it bark louder. I stand behind the door and wait.

Tom enters and I hit him hard in the back with the axe handle. He's very solid but stumbles as he tries to turn. I hit him again. Tom's on the floor and I'm standing over him, axe raised. *Not yet*, the voice yells, *this is too easy*. The crone screams, the dog barks. Tom's face is completely baffled, like his mother he's slow to recognise me.

Good God, Rob. What are you playing at?

I step back, throw down the axe and pick up the gun and point it at him. Caution is needed.

Get up, Tom, sit with your mother.

I sit down on a chair on the other side of the room. Tom checks his mother is okay. I'm shaking and it's hard to get my breath. Now that I've got him here I don't know what to say. Christ. I'm so fucking alone, it's crushing me, making my actions futile. The speck of Crossman, making a little stir before it's stamped out. *No, don't think like that, you've come so far, you're not alone, I'll never leave you*. I point the gun directly at them and they flinch.

Put it down, Tom says. You're not well, man.

You know why I've come.

No, I don't, I've no idea. This is madness, Rob.

The look on my face tells him he shouldn't have used this word.

What were you doing with Cath, Tom?

Tom's startled by the question, and so is his mother. Comprehension begins to enter her face.

Cath?

For fucksake Tom, don't try to blag me, you'd be the world's worst at it. How long's it been going on?

I've raised the gun and Tom's face looks as if it's skewered on the end of the barrels. The crone is frozen now, tensing herself for the blast. Tom's tongue licks his lips; like me, he can taste his own fear.

My fingers are curled round the right trigger. It feels impossibly large and I wonder how much pressure it will take. I rub gently against the cold edge of the steel. The explosion will be huge, filling the room with noise and smell; my personal film-screen flicks images at me – the Pearsons blown away, bits of them everywhere.

Tom moves forward. I shout at him, wave the gun, and he sits back down quickly. His mother stares blankly at a point behind me.

Nothing's been going on, Tom finally says.

I see the Tom of two years ago, the man I treated with barely disguised contempt. Tom, the guy who was a fixture here, the country bumpkin at my door, eager to please with his persistent friendliness. I used to enjoy the way his eyes followed Cath, pleased that my woman brought such admiration.

The film-screen bursts into life again. Tom and Cath. Cath and Tom, engaged in impossible sex all over the farm, doing it in barns, on bales of hay, like she and I once did. Actions that are stupidly insanely impossible but which I know have gone on. Now I understand about the pills; yes, of course, it all comes clear. Cath's no good at deceit, at subterfuge, at cheating – that's Crossman territory. It fucked her up, made her pop the pills. She's throwing ten years away for some oversized mammy's boy hapless virgin, and my neighbour to boot. My film is becoming quite pornographic but I can't make it disappear. It's a skin-flick and each flick is a knife in the guts. I can't see my prisoners clearly anymore, anguish is clouding my eyes.

Pull the trigger, pull both triggers. End it, fade to black or maybe an endless white, where nothing will ever happen to you again. My index finger jerks, it has to, but I pull the gun up just in time. The force of the blast knocks me back against the wall. I've created instant hell, cordite will suffice as fire and brimstone, and the

crone's screaming as the suffering of the downcast. I don't know who I am, the fallen angel himself perhaps. Tom reacts first, when he realises no-one is hurt. He tries to get up and grab the gun. I yell at him.

That was only one barrel, Tom.

He's standing opposite me, almost touching the end of the gun. I could prod him in the stomach with it and let another finger loose. The crone's screams have subsided into whimpers, like the dog in the kitchen.

Put the gun down, Rob, before this goes too far.

Sit down, Tom, look at the state your mother's in. You should be comforting her.

Tom's fists clench.

You bastard. You're completely off your head.

Better humour me, then.

The ceiling's in a mess, bits of plaster and paper have showered us. The crone's hair is full of it, she looks like a rag doll that has been well used by a child. I bet this is the most emotional she's ever been. She's muttering away between whines – make him stop, Tom, make him go away. If she wasn't so frightened she'd start thinking about Cath and wonder if her empire was being blown apart.

Tom does as he's told and I feel calmer. Using the gun has purged me. Gunpowder is one of the great inventions, no more chop chop, cut cut, thrust thrust with sword and spear, the messy pummelling of bodies – just the curl of a finger and your enemy is gone.

I don't know what made me pull the gun up, maybe I'm embarking on a night of torture, death by a thousand shocks. I look inside for an answer but the voice is mute, perhaps it too is shocked by the events it's caused. I sit down on the chair and keep the gun pointed at them but it's getting heavy. My stomach's churning and I can taste the lamb I've eaten.

Where's Cath? I ask.

I don't know, Tom answers. Look, maybe we can phone her, you can talk to her. Put the gun down, Rob, we can work this out.

What do you mean, *we* can phone her? Are you offering me a share?

Calm is fleeing. Anger returns. Pain returns. Images return.

Tom and Cath. Cath and Tom.

I don't suppose you watch much TV, do you, Tom, or films? Ever been to the cinema? No, what time would you have? It's just you and Mam here. You're doing okay so far. When confronted with an armed nutter, try to stay calm. Talk to him, get on his side by understanding his problems, then catch him off guard and make your move. You've got no chance, and I'm not alone anyway.

Rob, what the hell are you talking about?

I get up and move away quickly without answering. I want to replace the spent cartridge.

Get up, Tom, face the wall. Don't worry, your time hasn't come, not yet.

He does so, moving very slowly, but his adrenaline is pumping just as much as mine. We're overdosing on it – this is the most highly charged point in our lives. Don't you realise this, Tom, that I'm sharing this with you, giving you all the excitement you've missed out on in your life in one savage package?

I snap the barrel open, quite surprised by my expertise, take out the cartridge and load a fresh one. I toss the old one at the crone, making her gasp. Tom turns round but I have both barrels on him.

Sit back down, Tom. Comfort your mother.

Go to the next part of the plan, voice says, *get Cath, bring her here.* My head is thinking possibilities, how to go about this, but he's right, I do need her here to complete the picture, to tell me how she could possibly be attracted to Tom.

Tom moves quicker than I ever thought he could. He throws himself forward from the chair and tries to wrench the gun out of my hand but I react just in time and smash him across the face with it. He falls towards me but I step away from him. I press the gun into his stomach and this halts him. Blood streams from the nose I've mashed. Involuntary tears mix with the blood and there's defeat in Tom's stance, amplified by his mother's non-stop wailing. She seems to have gone into a rapid metamorphosis, from strong to weak-and-beaten in minutes. Her façade has been blown away, by me. *Nice work, Rob, we were ready for him but don't finish him yet, we want them all together. Go and get Cath now, you can use Tom's Landrover.*

·

161

Nice try, Tom, though not very polite, treating a guest like that. I was the only friend you had, remember, the only one that would bother with a tosser like you. Get back in the chair.

Tom tries to stem the blood with his sleeve. There's a handkerchief in my pocket which I throw at him. He manages to clean himself up but blood still trickles from his nose. I'm winning here and Tom knows he's blown his best chance. Now he's battered and I still have the gun. I use the phone that's on the table, dialling Cath's number then hanging up when I hear her voice. She's in. Good.

Get up, both of you.

What are you going to do? the crone manages to croak.

Tom has to support her, she's crumpled, all her haughtiness blown away as I prod them along in front of me. This must be how men in slaughterhouses feel, detached, casual, but always superior, whilst their victims are crazed, desperate and helpless. But this is my first night as a slaughterman, I'm learning as I go along.

I've noticed that the middle room of the farmhouse has no window, and its door is very solid. With a bit of luck it will lock. It does, and the key's in it. Things are going my way: when's the last time I could say that? Whilst the Pearsons stand on the other side of the room I check it out. The door is oak, even Tom will not break it down.

Give me the keys to the Landrover, I say.

Tom is dumb so I point the gun at his mother.

Come on, Tom, don't be stupid, I know you have them on you. Throw the keys in front of me.

He does so and I lock them in the middle room and to be sure I drag the small desk that's in the hall against the door. We don't want any slip-ups. The desk must be the crone's office – receipts and documents fall from it: stock movements, a bill of sale from a meat processor. Cath hated the sheep being herded onto the trucks, nudging each other for comfort, eyes screwed up against the wind. They're growing meat, she'd say to me, hoping I'd give up eating it. Yet she went with Tom.

Once out into the night I'm exhilarated, but locked into what I'm doing. I look in vain for the moon and stars, for their support, but the sky is drizzled out into misty darkness. My face

is cooled, my fire kept in check as moisture brushes my cheeks. Suddenly I'm in no hurry. The Pearsons are not going anywhere, but I am, and I have all the time in the world to get there. All the time in the world.

I stare at the featureless sky for a long minute. All my senses are on full alert, my hearing has always been good but tonight I hear every rustle. Every pattern the wind weaves in the trees has its own sound; I'm smelling the air like a beast. I have the control and skills of the predator I've become; time is standing still for me; I sense each second hanging, each segment of the minute moving at my pace. Wasting time was always a phobia of mine, the more I worried about it, the more time was wasted, but all that's gone now. Crossman is on his final adventure. It will be final – the voice tells me this too. Every twisted road I've been down is colliding tonight, this is my transition to hell, or salvation. No matter, the two are merging and I feel good.

The Landrover fires at the third attempt and I drive clumsily out of the yard. This thing handles like a tank, I'll have to be careful. It's getting late and there's not much traffic on the road; I don't want to draw attention to myself on the way down to the city. The Landrover seems comfortable at fifty so I keep it at that.

•

Cath stared at Rob. She rubbed her hands over her eyes but he was still standing there, looking much larger than she ever remembered him. The bathroom was filled with him as he loomed over her, his overcoat flowing loosely about him like a cloak, and his hair falling all over his face. He glared at her but nothing was said for some time. Rob's eyes burned into her and Cath was suddenly aware of her nakedness, after ten years of sleeping with this man. She propped herself up in the bath, but couldn't reach the towel.

Do you want this? Rob said, smiling broadly.

He threw the towel at her without waiting for an answer and Cath got out of the bath, trying to hold the towel around herself. Her robe was hanging on the back of the door but she was not going near Rob to get it. She tried to get her head in gear, but

this was too unreal. She was surprised she hadn't screamed, maybe it was the way he just appeared, taking on shape and substance as she dreamed about him, as if she'd conjured him up.

Can't you even say hello?

Cath found her voice, but the words came out in a rush.

What the fuck are you doing here? How did you get in?

Rob held up a key.

But you gave that back.

You, of all people, should know what a devious bastard I am.

Cath saw a red piece of wood sticking out of one of his pockets, it looked like the handle of something. Rob looked a mess and he stank, of woodsmoke, and other things, and his smell began to permeate the room. He tracked Cath's eyes to the robe and this too was thrown at her. The towel dropped as she caught it and Rob studied her. Cath put it on quickly, and suddenly she was cold, and afraid. Something told her to keep as calm as possible. Rob leant towards her and the axe fell from his pocket.

She jumped back, as Rob raised his hand, palm upright.

Hey, take it easy, I didn't mean to frighten you. Be cool, I am. Come on, let's go into the living room.

Rob picked the axe up casually, as if he always carried one, and put it back in his coat, moving slowly, almost trance-like. Cath tried to take stock, but it was difficult, she couldn't believe this was really happening, that on the eve of a new chapter in her life she was being presented with this, the past, in the shape of a wild Rob breaking into her flat, with an axe. It was as if she was in a scene from one of the cheap horror films Rob loved. He touched her, quite gently, and guided her into the living room. There was something very eery about the lightness of this touch, like the touch of a lover, a partner. She realised he must have copied the key before he gave it back and this thought was as chilling as the touch.

Rob gestured to the sofa and she sat on it whilst he leant against the wall, one hand resting on the axe handle. He seemed used to it, comforted by its presence.

So, how are you, then? Rob asked. Everything alright? You're not saying much, Cath. I suppose I should have knocked, but it

didn't seem appropriate, not tonight. I knew you were in.

That was you, wasn't it, on the phone earlier?

He shrugged, that old habit that had always infuriated her.

You're looking well, Cath, very well.

Rob sat on his haunches and rocked slightly, rubbing his cheek with the end of the axe handle.

How do you think I look? he asked.

Ill, you look ill, Rob. Look, please go. I'll phone you tomorrow, if you want, see if we can sort this out.

If I want. If I want. When did you ever care about what I want?

He got up quickly, and paced the room, then smiled and calmed down just as quickly.

Sorry, it's been a long day.

His eyes were all over the flat, and all over her. They were hungry eyes, feverish, pleading, ugly, but also determined and terrifying, and his worn sallow face supported them. It was lean, angry, pinched and unshaven, the man she knew was in there somewhere, but she had never seen Rob looking like this, not even when he worked endlessly at his painting, sometimes through the night, hardly eating, but drinking and smoking himself into a frenzy. She thought that was manic overdrive to counteract his bouts of laziness, his schizoid personality bursting out of its corral. Cath had never been afraid of Rob; his tongue had always been a bully – the words it formed had lost their power over the years, but this was something else entirely.

Rob looked like he'd been living rough for weeks – perhaps he had, she wasn't about to ask. It was so stupid to think he'd just go away, she realised. Christ, it was blood on his hands, she was sure of it now, but he didn't look hurt. God knows what he'd been doing. She'd have to try and talk him round.

What do you want? she asked.

How long have we got?

Cath wondered if she should make a dash for it, tearing out of the flat in her robe to scream out in the darkness. Rob might be hindered by his coat, but this area was not the best place for a woman to scream – she wasn't sure it would even flutter curtains. Rob would be seconds behind her, and maybe the axe would no longer be in his pocket. This was bloody ridiculous, unbelievable, but Rob was here, and so was she.

I was looking at a book of prints last night, Rob said, German stuff, you remember, that one Selborne gave me when he thought I was going places and that he'd come too, ha ha. *The Solitary Tree* by Caspar Friedrich, my all-time favourite landscape. Remember? As far as I'm concerned Friedrich was the first guy to put the main subject at the centre of the painting. He rebelled against all that false symmetry, landscape arranged like buildings. That one decaying tree was his testament, his championing of what was important to him. He was an innovator, determined to change things. I wanted to be like that.

Cath wasn't sure where this was leading but she did remember the book. The paintings in it were quite pleasing, but rather ordinary, to her eye. Yet she wanted to keep him talking, about anything. When he was talking he couldn't be doing.

What's important to you, Rob? she asked. After ten years I still don't know.

His face was being worked on by many emotions. It masked a barely controlled rage, and his body language told her he was capable of going off at anytime. Something had broken inside him, maybe he'd been working towards this night all his life and his destiny had arrived, but Cath didn't want him to self-destruct in front of her. She'd served ten years with Rob, and had suffered all his selfishness, tricks and deceit and *still* he craved her audience. He still wanted to unload everything onto her. She sensed his frustration, for the moment he was being kept in check by those conflicting forces inside him, but she knew time was running out. His favourite film featured a preacher with love and hate tattooed on each hand. She saw those two emotions glowing in him, so intertwined they were feeding off each other, vying for control until they split him open. His eyes were on the brink of tears and, despite the way he'd burst back into her life, Cath still felt some pity for him, for his wretched childhood and its non-existent parenting, and his world of dreams that had led him here. She had never been able to counteract this, his scars were too deep.

You were important, Cath, and you left me with nothing. Maybe I could have taken that, let you go, if you hadn't twisted the knife.

What are you talking about, Rob, what's happened to you,

why are you here like this?

Rob jumped up with surprising speed, pushing Cath off the sofa onto the floor. He straddled her and for a second she wondered if he was capable of rape, but he dragged her across the floor and put her on another chair. He knelt in front of her, his stinking breath combining with unwashed body.

I saw you, Cath, today. Everything fell into place then, what's been happening for Christ knows how long, why you hadn't got in touch. It's wonderful, Cath, bastard surreal. Tom fucking Pearson, or should I say fucking Tom Pearson, of all the people in this world.

He wasn't looking at her directly anymore; his eyes weren't focused on anything on the outside, they were turned inwards, on the devils that had been let loose. He must have been losing it for some time, by the state of him, and seeing her with Tom was the last straw. If he wasn't here like this, with an axe, she'd be able to tell him how ridiculous it was, but she *had* considered Tom for a while, and maybe Rob sensed this. It was enough to fuel his savage fantasies. They had both been affected by the fallout of the last ten years. Guilt makes idiots of people. They had both done irrational things, but Rob's irrationality had now taken on deadly proportions.

He looked like he'd been living on the street, he had that same sometimes-lost, sometimes-wild, and always furtive look, desperate for help, for a way out, for someone to use, and to blame. Cath thought of edging towards the mobile which was in her bag on the table but it was hopeless, she'd never get a chance to use it.

Did you initiate Tom, Rob says, into the art of love? Good old Tom, the professional virgin. And how do you cope with the crone? If she knows, that is. She seemed shocked just now.

Just now?

Oh, haven't I told you yet? We've been having a little party, the Pearsons and me, that's why I'm here, to invite you up. You can be the life and soul of it, Cath. Hey, got any pills, my head's cracking open, has been for weeks.

He flicked a finger against his temple.

Lots of activity in here, Cath, messages colliding, thoughts colliding. Pandemonium. A demon is in the heart of that word.

Do you think he's in the heart of me?

You're not well, Rob, you need some help, some rest.

The pills?

There are some in the kitchen.

He pulled her up, gripping her arm so tightly his fingers felt like steel. Cath was dragged into the kitchen where she gave him two tablets and some water. Rob took the tablet box and pocketed it.

That's good wine you've got there, Cath, New World Red. Hasn't that got a nice sound, New World, fuck knows we could do with one. Put the bottles in a bag, we'll take them to the party. Two bottles, not much to go around, but maybe you haven't got Tom drinking yet. You'd cop for the lot, wouldn't you, marrying that clown – all that land, and I bet they've got a shitload stashed away. Farmers. Going back to your roots, eh, Cath?

For once a Crossman diatribe was welcome, Cath thought. Maybe he'd talk himself out, and then subside like he used to. He could get help then – she could help him. But then she looked at him again and knew it was impossible. Rob's face was very close to hers and it mirrored his soul. It was showing itself to her for the first time stripped naked. It told her he had nothing to lose and she knew Rob wasn't coming back from this one. She had to think of her own survival. She knew this.

Fear was replacing shock: multiple images of what axes could do ran through Cath's head. His choice of such a primeval weapon was perfect, and so very Rob; it crushed any thoughts of positive action. She tried to remember how she used to calm him in the past when his rages took hold, but her legs were numbing. She didn't even want to ask him what he meant by *little party*. Her eyes focused on the dark red smudges on his hands again.

The phone rang. They were both startled, and Rob pulled at the handle in his pocket. Each ring contested the silence, stretching Rob's nerves and her fear. His hand gripped the axe handle so tightly all colour was drained from it. Cath imagined skeletons and scythes, and that cheap film would not leave her head now. The phone continued to ring and on the eighth ring Rob told her to answer it. He held her by the shoulder and pushed her to the phone. It was Martha. Momentarily, relief flooded through her, she wanted to tell her everything, to shout for help down the

phone. She wanted her mother to make it better, but she just listened, and tried to control her breathing, with Rob's ear pressed up to the phone with her.

Martha apologised for the lateness of the call and said she just wanted to wish Cath good luck again. Cath thanked her but was not sure how calm her voice was for Martha asked if anything was wrong. Cath said she was just a bit tense about the new job, and was on the way to bed. Her mother apologised again and they bade each other good night.

As Cath put down the phone her upbringing in Clare was transformed into the best upbringing in the world, full of happiness and fertile development, strong family ties and solid love, a wonderland she wanted to plunge back into, away from Rob and all he had brought her.

Good luck for what? Rob asked.

I'm starting a new job tomorrow, I'm going back to teaching.

She said this as confidently as she could, like she had no doubt that tomorrow would happen.

You're joking. Teaching. Jesus Christ, how can you even think of going back to that crap? You were doing well at advertising, could have gone far with that.

Rob was talking quietly again, as if they were still together, having a normal conversation with Rob pushing her towards the money he feigned to detest.

Come on, get your coat.

He didn't object when she took her handbag. They left the flat, and no-one was around outside, no-one was ever around at this time. Rob pushed her in front of him, the bottles chinking together as they walked. She saw Tom's Landrover – she was sure it was his – parked opposite the flat. Her fear flared as she went through awful possibilities in her mind, a second reel of the film flickered into life. Rob opened the Landrover's door, carefully put the bottles in the back and placed Cath behind the wheel.

You drive, he said.

Drive where?

You know where.

To the cottage?

Close. C'mon, Cath, you know where. To loverboy's, that playboy of the western world, that cool hunk of man you've

taken up with.

Rob, you must listen, you've got this all wrong, Tom and me –

He slapped her hard on the side of her face. The suddenness of the blow stunned her; she tasted blood inside her mouth, and her eyes watered. Rob thought they were tears.

See what you've made me do. I don't want to hear any bullshit, alright? Just drive, carefully, and at the right speed.

She did as she was told and worried about what Rob might have done to Tom and his mother, and what he might do to her, bloody hands and an axe did not make for positive thinking. I've caused this, she thought, by driving up to see Tom. Rob must have been on the hillside somewhere, to witness what he thought was the final assault on his vanity.

Cath drove out of the city, crunching through the unfamiliar gears of the Landrover. It smelt of animals and straw and Rob. He stank. He'd lost weight but had become hard and wiry.

Does my aura offend you? Rob said. I can see your nose twitching. I've been very big on fires this winter, Cath, not so hot on baths. There's a lovely routine to an open fire, gathering the wood, storing it, burning it. It takes up a lot of time, but that's not a problem for me.

Rob's flash of violence had calmed him. Cath wasn't sure if he was talking to her or to himself, but she wanted him to continue. She drove on for a few miles, into a night increasingly rainswept, then asked a question.

Are you painting?

It was the wrong question. Rob's mood changed abruptly.

What's the point of that? he shouted. The cottage is full of canvases, finished, half-finished, burnt, abandoned, trashed. Ha, they're a bit like me really.

He grabbed into a pocket and threw a handful of change against the dashboard. A coin bounced back to hit Cath in the face.

There you are, he shouted, that's my worldly wealth – you might as well take that as well, you've taken everything else.

Cath swerved into the next lane of the carriageway, almost causing an accident. Rob snatched at the wheel as someone behind leant on his horn.

Careful, you don't want to spoil the party, do you, our guests

are waiting. A captive audience, you might say.

He told her to keep to a steady forty. The journey seemed to take an age. Endless ideas went through her mind but none of them lead anywhere. She was close to the valley.

Turn up to the farm, Rob said.

It had stopped raining and a moon showed itself.

Perfect, don't you think? muttered Rob. There's something comforting about the moon. It's endorsing everything I do.

Cath parked in the farmyard and Rob pushed her towards the back door of the kitchen. He chuckled as an owl cried out in the darkness. All my friends are out tonight, he said.

Inside the farmhouse a dog started to bark, but it was more a half-hearted kind of yelping, as if it knew who was coming. As they entered the house Cath saw something lying in the passage-way, one of the collies. Rob turned on a light and she saw the gleam of its glassy eyes, and the line of blood trailing from its mouth. She tried to stifle a gasp but it came out anyway.

Don't worry, it's just resting, Rob said, prodding the dog with his foot.

He knocked on the door of the middle room with the axe handle.

Everyone alright in there? We'll be with you now.

He pulled her into the kitchen, and the other collie was there. It cowered away from Rob as he located a corkscrew in one of the drawers.

Get four glasses and put them on that tray, he said.

Cath did so. When she turned around Rob was holding a shotgun.

Don't drop them. Jesus, I never thought you were a party poop, Cath. Don't worry about the gun, it's just for show. My show.

Rob prodded her to the door and turned a key in its lock. Amazingly, he was humming to himself. An old song she couldn't put a name to.

Stand away from the door, Tom, I'm coming in and I've brought a friend, the light of your life.

Rob pushed Cath inside, then followed, a bottle in each pocket, pointing the gun. The room reeked of cordite. Cath looked for corpses but saw Tom sitting with his mother. Mrs

171

Pearson looked ready to collapse and Tom's face was battered, but they were both alive. When Tom saw her he started to get up.

Stay there, Tom, Rob said. Try to contain yourself. I have to admit Cath had the same effect on me, once. So, been happy have we?

Rob stepped smartly to the opposite corner of the room, keeping the gun on Tom, who looked as bemused as he was bloody. His nose was clearly broken, explaining the state of Rob's hands.

Take the wine, Cath, Rob said, offering her his pockets. Put it on the table. Tom will open it, big strong boy that he is. Here, catch, Tom.

Rob threw the corkscrew at Tom who fended it off, unable to catch it. He retrieved it from the floor. For a moment he held it like it was a weapon he might use, but Rob waved the shotgun as a warning, then pointed it directly at Tom's mother. She flinched and Tom put an arm around her. Rob grinned and gestured to the bottles.

Isn't this cosy, Mrs P? Good wine, good company. A slice of life for you. In a minute I think we'll play explanations and consequences. Do you know how to play it? Never mind, we'll make it up as we go along.

Tom opened the wine and Cath poured it out clumsily.

Don't spill it, Cath, give Mrs P a glass, and old Tom, and have one yourself. Cheers, everyone.

Cath's eyes searched Tom's as she handed him the wine. His were desperate but not terrified. She felt so guilty; it had been foolish and selfish to let Tom get anywhere near her. Would Rob have come for her anyway? Maybe, maybe not, but she doubted it would have been with an axe in the middle of the night, and it certainly wouldn't have involved the Pearsons. She didn't know what had been going on in his head for the last three months, but there'd been an explosion there – that was for certain – and she was its epicentre.

Rob leant against the wall, a dirty stringy body with too much clothing on it. The gun gave him power, and had taken Tom's away. The man Cath had seen carrying sheep over his shoulder was now herded into a corner.

You're not drinking, Cath, Rob said. Pick up your glass, all of

you drink.

I can't, Mrs Pearson murmured, I feel sick.

Drain the glasses, all of you. I insist.

Rob's fingers were locked onto the triggers of the raised gun and three people quickly drank. Cath tried to study Rob, as carefully as she could, but their ten years of intimacy did not make him any less of a stranger to her tonight. He was a contortion of the man she knew. She remembered his road rage, his snarling put-downs of people who trod on his ego, the way temper worked its way through his body to take him over. Before, this was just one small part of his character; tonight it had become the whole. There was a twist in his stance, as if mental trauma was taking on a physical presence. Rob was losing control of himself, and wanted a quick fix for the pain.

Thinking of the past, Cath, Rob said, your thoughts are transparent. You see, Tom, we've had ten years together, and you can't change that. You'll never know this woman like I know her.

Put the gun down, Rob, Tom said, for Godsake. Nothing has gone on between Cath and me, she'll tell you herself if you give her a chance.

Well, the master's voice returns. I thought that thump might have damaged your vocal cords. Nah, I don't think so, no more chances. We'll skip explanations and go straight to consequences. Nothing either of you say can be trusted. Guilt's written all over your face, Cath.

No it's not. That's fear, Rob, of a man I lived with who is now capable of doing this. And guilty of what? Seeing someone after we'd finished?

Shut up, Rob shouted, I don't want to hear it.

Despite a whispered warning from Tom, Cath felt anger surge in her. It wanted to get involved, to mingle with Rob's. She knew they would not easily resolve this in their favour; Rob had come too far for that. He'd created the perfect film for himself at last, the one he'd always wanted to write, direct and star in.

Cath stood closer to Rob and poured more wine. It was good quality, meant as a treat after her first day at school, a toast to herself for going through with it. She imagined the disappointment of the Head in the morning when she didn't show; an instant vacancy and another struggle to fill it. More headaches,

feverish re-scheduling and inadequate cover, checking the dates again until retirement day.

Rob seemed uncertain. Cath wasn't sure what he'd do if she got really close to him; the gun was pointing at the Pearsons more than her. Should she continue to plead her case, her innocence, in the face of the warped logic he was using, or keep quiet, sit with the Pearsons and await developments? This was all so unreal. She realised one thing: how much she wanted to live and how much she loved every lousy thing that life had thrown up, its difficulties, stagnation, pain. She was savouring bitter disappointments like they were triumphs now, and maybe Rob sensed that he could snuff this out with the curl of a finger. Maybe he saw this as some kind of payback.

Tonight was linked to millennium eve, and the pills. She'd given Rob an insight into extreme behaviour then and he'd been impressed. He'd led a life devoid of responsibility, and had taken no decisive actions. She thought she had got away with it, that her attempt on her life had cleansed her, given her a new focus for the rest of her life, but that life didn't include Rob and he couldn't tolerate it. In his head he was still in control. What was she talking about, in his head? He *was* in control.

Rob was whispering to her, but everyone in the room could hear what he was saying.

How could you, Cath, with this fucking nerd?

For a moment he looked like the time they first met, all the hate melted away to reveal a glimpse of the man she'd seen then: hopeful, brimming with childish nonsense but also good ideas, and with enough talent to take them forwards. Worth taking a chance on, for an unworldly Irish girl.

How could you, he repeated, his voice dying slowly as he gazed past her. How could you, Cath? Then he reached for the wine and started humming again. This gave Mrs. Pearson a jolt and she looked at Rob in genuine fear. Cath recognised the song now. *All of me, why not take all of me...*

•

I'm not sure who's working my tongue, me or my new friend – or are we one and the same? I don't fucking know. Well, talk to me, then, I've got Cath here, got them all here, like you wanted, now what do I do? My head is mush, but I'm still in control. *That's right, Rob, you are.* Oh, back are you? You were quiet in the car. Look, don't leave me alone like that again. *I won't, but look at them, Rob, look at the effect you're having.*

Tom is phased, there's a look of blank denial on his face, and his mother's out of it completely, worrying her nails with her mouth, her eyes glued to the gun. But Cath, I'm not sure about Cath. She was terrified in the flat but she's standing up to me now, in that crazy brave way she's always had. I've got the gun, the power. A few minutes ago it was racing through me, the best drug in the world, but now Cath's telling me that it's all shit, that I can't win, or get free of what gnaws at me. *Yes, you can, Rob, you can,* they're *what gnaws you. Do what you have to and all the pain will go away. I'll take it away from you. Trust me.*

Christ, I want to sleep, in a way I never have, not even as a kid. Then, nights were broken up by nightmares, my own and my mother's, until I became entangled in a black void of screams and sweaty fear. Her neuroses always on hand to feed it. I always wanted something I couldn't have, what no-one ever gave me; to be like other kids whose parents were around, whose fathers watched them play games, running up and down the touchline screaming advice, in tune with their own flesh and blood, taking a fucking interest. Some of them even offered me sympathetic encouragement when I played, which made me cringe and wonder what it must have felt like for the other boys, to go some-where with a dad and a mum, to eat meals together. To go somewhere with even one parent. I always ate on my own, all through my childhood, and I thought this was fucking normal. I thought it was better: no fuss, only me, my food prepared and left for me to eat, until it didn't appear at all. Then my mother herself began to dwindle, growing further and further away, until one day she was gone. I was on my own at sixteen – a hard-bitten little sod with his guts carved out, knowing all there was to know about rejection, and the pain that trying to deny it brought. Jesus, I haven't thought about this stuff for years. I thought I'd written off the past as a waste of time. I know now it's always had me in

its sights. My attempts to get away from it have been laughable.

The Big Sleep, that's it, that's what all this is about. I want what Cath was looking for when she popped those pills, to dive into nothing, three somersaults and a tuck, into a white emptiness, where all problems cease, where I can be a good guy. I only need to turn the gun on myself.

Don't be stupid Rob, none of this is your fault, don't let them get away with it. Fight back. I can feel my lips working as I start to debate with him but I'm careful not to do so out loud. I don't want Cath to think I'm mad.

Better stay here, voice says, see this through, there's no turning back now. They'll put us away. I'll be with you in a cell somewhere, just the two of us, and I won't like that. I won't stop talking. Punish those who've hurt you, then torch the farm. There, I've worked it out for you. There won't be much left of them if you do it right and why should anyone suspect a shooting? If they do find a few toasted pellets inside Mrs P the blame would fall on Tom. Lonely mother-bound anorak meets girl, mother won't have it, son won't have that. Loses it in a spectacular way. Bam bam. First the women, then himself. Sorted. They'll find witnesses who'll have seen Cath and Tom together but you won't be in the frame, you haven't been near either of them, and it's Tom's vehicle that was outside the flat. They'll question you, of course, former boyfriend, living near, but it will be a great acting opportunity and you'll have a few days to clean yourself up, clean the cottage up. Then you can sign on for state help, come in from the cold at last. Yes, it will have to be a fire, to obliterate your prints. It all makes sense, doesn't it? Doesn't it?

Tom's talking to Cath, but it seems to be coming from another room. My own conversation is taking me away from them. I step back against the wall. The gun is heavy and I'm exhausted but I shake myself back into alertness and shout at them.

Don't think I'm not paying attention. Pour me some wine, Cath, I think I'll join you.

They are trying to concoct something. I think of every scene like this in every movie like this, how the good guy always manages to get the gun off the bad guy. They don't know how close I am to pulling the trigger; my fingers are stuck to it with sweat, afraid to detach, afraid to squeeze. I'm surprised that inner voice doesn't do it for me – both barrels would take every-

one out at this range – but he won't take responsibility. He wants me to do it.

Cath puts a glass of wine on the table near me. Tom watches, wondering how I'll pick it up. He's looking at a chance to rush me, play the hero, maybe take the blast himself in the hope that the others can get away. Looking at his mother I doubt she can walk at all – her hard shell has been shattered, exposing all the mush underneath.

Bring the wine to me, Cath, but don't get in front of me.

Tom doesn't make a move as I crook the gun in one arm and take the glass. Cath makes sure her hand doesn't touch mine. She won't meet my eyes – I'm not sure I want her to, they might tell her I want to turn the clock back ten years, to start again with another Rob, but she knows it needs to be turned back forty years, so that I can have another stab at everything.

The wine is good, but I gulp it down quickly, without respect. I want it to hit home as soon as possible: alcohol might push me into a decision, a solution, an end. I'm a stubborn bastard, always have been. Why is it so fucking hard, why is it always so fucking hard to do what is necessary? It was necessary to suck arse in London – as it has been for every artist in every city in every fucking era – but I couldn't; I was too vain, too full of myself, thinking there would always be another chance to do things my way, to find people who would lap up my talent, prostrate themselves in front of my canvases. The Crossman talent, which I knew in my guts was never more than adequate.

I could put the gun down and walk out. Tom's capable of keeping quiet about this, if it meant he'd get Cath – but not the crone. They'd never persuade her. It would mean prison – and worse, enforced therapy, with some half-arsed failure shrink with problems of his own. *You're wavering, Rob, you must be strong, come on, think of all that pain removed at a pull, a gentle squeeze. It's prison if you do or don't, so why not do? Go on, Rob, lean a little weight on that trigger, just a little squeeze.*

Tom makes his move. He tries to spring up, but is not quick enough. His bulk hinders him. He's sprawled on the floor, making a desperate attempt to grab my ankle. I put the shotgun to my shoulder and aim at him. Cath screams and the crone tries to emulate her, but it's more of a croak as she falls to her knees

177

from the sofa.

This is getting boring, Tom, I shout.

Tom is static for a few moments, he thinks I will fire but I can't. My fingers are releasing their grip on the trigger. All those who excuse their vile actions by saying they don't know what came over them, that they can't remember what they did, the voices-in-their-heads crowd, it's not bullshit after all, I know that now. Half a day ago I'm quietly going about my business of wasting away, then I see Cath with Tom and – *shazzam* – the evil warlock whisks me into this.

Already parts of this night are fading, it's an effort to remember how I came to be here. Panic is starting to paralyse me and I'm beginning to go from action man to nothing.

Tom sits back on the sofa. He doesn't know what to do now – he's had two shots at it but he's not suited to this. There's no mean streak in him – self-preservation is potent, but it needs a touch of native malice to fire it. I'm a natural, Tom's not. I wonder if he feels like one of his animals, smelling the slaughter-house as it's pushed down from the cattle truck.

Cath is standing near me but doesn't know I'm close to falling over. Where's the crone? She's no longer in front of me but it's not important. I think back to that time I tried to borrow money, when she dismissed me as a nonentity. The ice-hearted matron had been in control, ruining her son as she probably ruined his father. Things have changed for her now. If she survives this night they'll be changed for all time.

•

Tom lunged at Rob but failed to get the gun away from him. He was like a cow trying to corner a fox. Cath's eyes closed for the explosion but Rob just stepped away. This might have been his idea of torture or he might have been running on instinct – as much in the dark about his next move as they were. Everyone in the room was strung out, stretched close to breaking-point. Cath was still searching for the right words. Whatever she said might sound like a challenge to him. If the night wasn't so crazily out of control it might be funny that Tom Pearson could be the cata-lyst for all this. Tom, the ultimate unworldly man, nosediving into

life at the sharp end, and dragging his mother with him. Her reception earlier had been ice-cold, yet Cath felt for her now. She was a whimpering mess, behaving completely out of character, Rob's dementia was exposing a secret part of her, paring away emotions that had been cloaked by the harshness of the farm. Cath saw the similarities with her own family, farming people not able to connect with anything other than the land and the fight to bring life to it. But she had regained lost ground with her mother and achieved a few fertile sproutings that might grow into something worthwhile, if given the chance. That was the irony of it, she thought: Rob had brought mother and daughter back together.

Mrs Pearson had fallen to the floor in the wake of Tom's action. Cath wanted to help her but dared not make a move. She was on all fours as she turned round to catch Cath's eye. Suddenly, all the fear was gone from her, replaced by resolve and her former hard look. It told Cath to say and do nothing as she continued to whimper and move on the floor, getting closer to Rob. Cath knew she must talk to him, get his attention.

It's not too late, she mumbled.

What? Speak up, Cath, it's getting a little noisy in here.

I said it's not too late to stop this. I won't say anything, I promise. Just put the gun down and go home.

His face softened for a moment and she saw the wretched tiredness in it. He was running down the last of his adrenaline now.

Home? Not a good idea, Cath. And you don't really think these two will leave it there, do you? Nah, the police will be straight in for me, madman runs amok and all that. I could barricade myself into the cottage, though, go out in a blazing firefight. Hey, you could take charge of the paintings, they'd sell like crazy then. There's only one thing better than dying young for an artist, and that's to die violently and spectacularly. It would be a nice little earner for you, Cath, a start-up gift for you and this clown.

Look, Tom has been a friend to me, like he was to you, that's all. Can't you understand that? There is nothing more, Rob, you must believe that, I'm begging you...

No explanations, Cath. I told you earlier. I want out, *we* want

179

out, from all this fucking mess.

What do you mean, *we*?

His voice dropped to a hoarse whisper.

I can almost smell my own end now, and savour my passing. Does that make any sense to you? I want some peace, to turn this off for good.

Rob tapped his head like it was an exhibit. His fingers were no longer welded to the trigger and he held the shotgun much more loosely.

I want that time between sleep and waking, Cath, you know? When you're at perfect peace, drifting in the calmest fluid imaginable, before alertness starts to tug at you, to pull you second by second into the waking world with all its fucking devils.

This was still all about him, Cath realised. Tonight was the climax to all his selfishness. The abused little-boy-lost had finally accepted that nothing good was coming his way, no-one was going to do him any favours, deals were not going to be offered, and there were no free tickets to a better life. Cath didn't dare tell him this, yet she felt for his failure and her involvement in it.

There's still time to find that peace, Rob, if you leave now, I'll come with you, we can go down to the cottage, or the flat, if you want. Don't drag other people into it. The Pearsons have nothing to do with all this. It's about us, about the last ten years, about your whole life.

Tom looked up anxiously as she said this. Rob stepped towards her, away from the wall. Mrs Pearson had crawled behind him now, still whimpering. He threw her a quick glance, but nothing more. She had something in her hand, something that glinted silver in the light. For a moment – surely crazier than all that had gone before it this night – Cath wanted to warn Rob. But it was too late. Mrs Pearson sprang up and plunged the silver into Rob's side. He turned and grabbed at himself as he fell to the ground, the gun falling harmlessly from his hands. This was immediately picked up by Tom, who stood over Rob with it. She'd used a pair of scissors; they were stuck up to the hilt in Rob's side.

Cath crouched down beside him, ignoring Tom's warning. Rob's face was a film of sweat. He had trouble focusing on her.

Phone for an ambulance, Cath shouted.

And the police, Mrs Pearson added.

She turned to Cath, glowing with triumph.

I fooled him, she cried. I fooled him all this time. He's paid for it, coming in here like this, the bloody madman.

Tom was on the phone and he asked for the police first.

We're lucky, very lucky, Mrs Pearson said, I always told Tom not to bother with him.

Cath shouted at her to be quiet. Rob was trying to say something and she put her head close to his as bloody spittle escaped from his lips.

Never thought I'd be grateful to the crone, he whispered.

He looked at her but she wasn't sure what he was seeing for his eyes were somewhere else.

I'm looking for tunnels and shining lights, Cath, but I don't see them yet. I don't see anything.

Rob's hands had closed around the scissors, as if he was holding them in place with a kind of pride. Pain trapped his words, they struggled to escape through clenched teeth. His eyes were getting glassy, like the dog's in the passageway. Cath felt like she was looking through them into Rob's soul; she shivered, and brought a kinder image of Rob into her mind. He was on her beach in Clare, the first time she'd shown it to him, running towards her, wild hair streaming behind him, jumping over rockpools and laughing as he got out of breath. So full of life and the living of it, telling her all his dreams and hopes, making her believe he could do anything; making her happy.

It will take ages for an ambulance to get up here, Mrs Pearson said.

Get her out, Tom, Cath said. I want you both to get out.

Tom looked at her helplessly. He was still trapped between two women. Cath felt Rob was not going to make it, she knew Mrs Pearson's blow had been hard and precise, slipped between Rob's ribs. She hated her for doing it, but couldn't blame her – violence usually ended violence, and maybe she had saved them. She did not want to think of alternative outcomes, that she might have talked Rob round, that this could have been resolved and four people could have lived happily ever after. Now she had to watch him slip away. She had enough belief left to hope to God that he was going to a better place. Tom took his mother outside.

Shall I pull the weapon out? Rob gasped. Die with a flourish

and a few fine words, maybe an appeal to humanity and the things children suffer. That would be a fine end to the film.

You and your films. Made your own tonight, didn't you? You shouldn't talk, just lie as still as you can.

Nothing could ever stop me talking, Cath. Try not to blame me. At least he's gone.

What?

He led me here, but he's silent now. It's such a relief.

Why didn't you tell me what was happening? You weren't well, Rob. We could have got help.

Help. No, not for me. I needed it years ago, Cath, years and years ago.

He pulled her down to him, with surprising strength. For a moment she thought Tom was right, that Rob may yet harm her. But he just wanted to focus on her, to know that she heard his choked words.

Just like Jesus, eh, Cath?

What?

He got it in the side too, but I've had to make do with a pair of scissors.

It was a struggle to hear him now. After all the years of shouting, his voice had dwindled to almost nothing, a whisper of its former self.

Am I going out with you hating me?

No, of course not, and you will be okay. Tom's phoned for help.

You never could lie worth a damn, Cath. I wouldn't have hurt you, not really, or them. I was coming out of it, fighting off the demons.

I know.

But she was not sure she did, she'd never be sure what Rob might have done.

Come closer, Cath.

Her head was almost touching his.

I'm still waiting for that damned tunnel to appear, at last I have all the time in the world, all the time...

Rob died propped in Cath's arms. She didn't realise it for a few seconds, but his eyes were fixed on her face in a way they had never been in life. Tom came back in.

Mam was acting all night, he said, just waiting for her chance. I had no idea that she was capable...

His words dwindled to a halt as he realised Rob was dead.

Good God, poor man. I'm not sure what's happened tonight, but it's an almighty mess.

Tom sat down heavily and looked at his hands.

The word *mess* seemed so inadequate, Cath thought, but it took on an aptness as she gently let Rob rest on the floor, closing his eyes with her hand after she looked into them one last time. *Mess*, a good Tom-word, better than chaos, turmoil, disaster – they were Rob words, to be used simultaneously. A mess, yes, mixed with the tragic waste of an unfulfilled life. She didn't want to think of what Rob might have gone through this year, nor to wonder if he deserved it or not. She didn't want to think of anything for a while. Like Rob, she just wanted emptiness, to be numb until her thoughts could stabilise and perhaps even be trusted. She heard a siren, a cruel, insistent sound, getting nearer and nearer, until it was bursting into her head. Blue light streamed through the window, as if the moon had gone mad, and was reaching out to its mad, dead son.

They're here, Tom, Mrs Pearson shouted.

•

What to do now. There's no advice coming from within. Suddenly you are silent, you bastard, releasing the reins and letting me go it alone, just when I need you most. I can't believe he's gone. I wait for him to rise again, to fill my brain with his resonating words. But no, nothing, only silence. I think he's finished with me for good, leaving me on my own.

Something wells up in me, an overwhelming sensation that grips me as firmly as *he* did. I think it's shame mixed with pity, for my victims, for myself, for every fucking thing. I want to turn back the clock to this afternoon, when I saw Cath with Tom. I'd approach them, bid them good day and apologise for my appearance, ask Cath how she was doing, chit-chat with Tom about the farm, respond positively to Cath's nervous questions and lie a little to make it easier for her. Yes, I'm fine, commissions are rolling in again. I wish you well, Cath. I wish you well, Tom.

Then say goodbye casually and enjoy the relief written on Tom's face, and the incredulity on Cath's. But that's another film, Rob, one you could never appear in.

It's been a long long day. I've surfed every emotion. Now my choices are stark: to continue with this madness, even as it now drains from me, to walk away and wait for them to come for me, or do something very final and finish what Cath started that millennium night.

For a second I glimpse Van Gogh with his pathetic little pistol, glaring at the landscape that never supported him, never repaid his care. I'm tapping into his thoughts. I can understand the guy, his lifelong despair turning to sudden action as he anticipates peace, and a shining compensation for all the pain. Just a trigger-pull away for a mad bugger. My hands grasp the gun firmly again, and try to turn it towards me, but there's a blur of movement on the floor. The crone rears up at me like an apparition, her face just under mine, distorted by its closeness. Her eyes are veiny and smudged, her skin dry and brittle. I wonder what she's doing, but say nothing as I fall over. Something has seared into me, and amazing pain follows. The room's twisting, faces twist with it and I think I see a smile on the crone's face. Things are being said, shouted, and the gun's no longer part of me.

The pain is coming from my side and I put a hand there. It touches something metal and traces the shape. It's a pair of scissors. Perfect, Mrs Pearson, perfect, you've done well, you're the best actor here; with a performance like that you deserve to be in my film. The pain changes down a gear, it permeates all of me now, but not so sharply. Something is flowing out of me, I feel it on my hands, soaking through my fingers as I hold onto my wound. It's life, Rob, and it's going.

Cath bends over me and I wait for her to tap me, to wake me up and tell me I'm having a bad dream, as she's done many times before. She has never looked more beautiful and my eyes drink all of her in, dwell on every aspect, try to keep her in focus as I attempt to talk to her. For once the words coming calmly and free of all artifice. I am calm. I've finally got there. I want to tell Cath that this has all been a mistake, that I would never really hurt her, but words are getting harder to assemble. I'm not sure I'm talking at all now. The pain is gone.

The room is turning blue; it's flooding through the windows, coming for me. My cue. I still see Cath but can't hear her; she's getting smaller, fading down to a cameo before my eyes. Everything is fading. The spool's running out. Fading to black. Black.

• • •

It was late August, a warm day. Cath was on her Clare beach, walking barefoot in the sand, with Tom and Martha some way behind. She heard Tom's earthy voice combine with her mother's soft burr as they talked. He was here as a friend, for both of them, his first getaway from the farm.

Cath never made that first day at school, but still kept the job. They were understanding, they had to be. What happened at the farm that night must have kept the staffroom chatting for weeks. Monday was the first of the autumn term, and she'd finally take her place there then.

It had been a hectic time: dodging the tabloids, the flurry of publicity, and the fantastic tales of Rob which many people she'd never heard of offered up. The inquest was over, the inquiry was over, and a line had been drawn under that night. It was now an incident officially closed, to be stored in the system somewhere and brought alive at the touch of the button by any interested party. Crossman, a very suitable case for treatment.

Rob was buried in the village graveyard, within sight of the cottage. Cath and Tom paid for the funeral. Victims coughing up, indeed, Mrs Pearson said, but she let Tom go ahead; even she understood the need for closure, if not penance. Selborne, Rob's old contact, appeared – one of the handful of uncomfortable mourners. Afterwards he looked through the cottage with interest. Cath let him take most of the canvases back to London with him, where they sold quickly. Selborne sent the money to her but she didn't know what to do with it. Rob left no will, and they were still searching for any distant relatives. In death, Rob was accumulating a sizeable sum. How he would have loved the irony, Cath thought. She hoped he was smiling now, somewhere. God knows, he'd found it hard to do in life.

Before she took Tom to Clare, Cath went up to the cottage for the last time. She looked through its meagre rooms, and smelt

the residue of smoke and damp, even in high summer. She stood in the centre of the main room, and heard their fractured history reverberate around the stone walls, each stone shaking with angry words as her mind crowded with images.

Cath took a few things to keep, a photograph of their first weekend together, when Rob was wild and she was innocent; and a small print of *The Solitary Tree*, which was on top of the woodpile by the fireplace. She took it to the window where sunlight lit up its faded colours, and studied it carefully, as if it might solve the mystery of Rob. The tree at its centre had been sheared by lightning but still had plenty of growth lower down. Like Rob, it was imperfectly split, but strong. It was still just a pleasant scene to her, yet the thought that Rob had intended to use something so important to him as fuel brought tears to her eyes. She cried for him for the last time, for all his wasted years, and the ruined upbringing that put her own into perspective. Rob had been lost a long time ago. Cath changed her mind about the print and put it back. Let it be his marker and watch over his memory. Then she was gone, turning the key in the lock of his front door and not looking back.

Cath turned back to see Martha catching up with her. She had gone on ahead as they talked, walking quickly over the familiar beach. She waited for them, until three figures stood on the shore and watched as the waves pounded it. They had been growing all day as the wind got up, now they were blue-green monsters edged with white froth. The monsters of her childhood that seemed to shake her very soul as they gathered up all their strength to smack down on the wet sand. As Cath viewed them she realised the waves had been steady fixtures in an edgy past. Like the beach, the sky and the Moher cliffs, they were no longer a threat. Her roots no longer entangled but freed her, telling her who she was, and how to go forward. Each wave thumping down heralded this new chapter in her life.

Cath stood at the fringe of the sea, letting the water caress her feet. She felt Tom's hand lightly on her shoulder, a faint trace of warmth that spoke of all the emotions he had kept bottled up for so long. Clouds piled high on the horizon as they always had,

while overhead a flock of gulls headed down the coast to Moher. Their cries had always struck her as empty and forlorn, but now they welcomed her. They too belonged.

What a great place, Tom said. So much open space, air to breathe, and just look at that sea, going all the way to America. I've never seen such green, it takes your breath away.

Tom looked about him, wide-eyed as a child, in love with elemental things, in love with her. Martha sensed his mood and smiled softly. They were all looking ahead.

God it makes me feel like a new man, Tom cried, as he reached for Cath's hand.

Also by Roger Granelli...

Crystal Spirit

"A moving and grittily honest account of what it was really like for the Welshmen who risked their lives to fight fascism in the Spanish Civil War." **Elaine Morgan**

"*Crystal Spirit* is a novel of testimony, and, praise be, it is a good read." **Professor Ian Bell,** *Planet*

"In *Crystal Spirit*, Granelli offers a skillful portrait of a man caught up in forces larger than himself." ***Publishers' Weekly***

£6.95 pbk, ISBN 1-85411-332-1

Out of Nowhere

White British guitarist Frank Magnani arrives in fifties New York to break into the smoky world of Jazz. Caught up in the violence of the city, Magnani flees on a journey through the southern states; his personal odyssey is complete when he returns to the New York club-scene in a dramatic climax to his career and this atmospheric novel.

£6.95 pbk, ISBN 1-85411-120-5

Dark Edge

"Roger Granelli's *Dark Edge* is a novel where the personal echoes the political. The dramatic events are played out against a backdrop of proportions so large that the memory of those twelve months of struggle remains undimmed."
Tony Heath, *Tribune*

"*Dark Edge* is a gem amidst the slag-heaps of Thatcher's legacy." *Big Issue*

"Roger Granelli writes with conviction about the strike. He also understands and can capture the complex, hopeless agony of men battling for an industry that they half love, half loathe."
Catherine Merriman, *Planet*

"Granelli has a gift for making character emerge, for letting actions speak for themselves... this is a serious and intelligent book." **Victor Golightly,** *New Welsh Review*

£6.95 pbk, ISBN 1-85411-204-X

Status Zero

"Granelli's brilliant *Status Zero* is one of the best two books I've read this year."
Phil Rickman, *The Book Programme*, **BBC Radio**

"Granelli paints a powerful and poignant portrait of Mark Richards' condition and thought processes which inform his actions." **Harold Williamson,** *Young People Now*

£7.95 pbk, ISBN 1-85411-255-4

www.seren-books.com